Acadiana

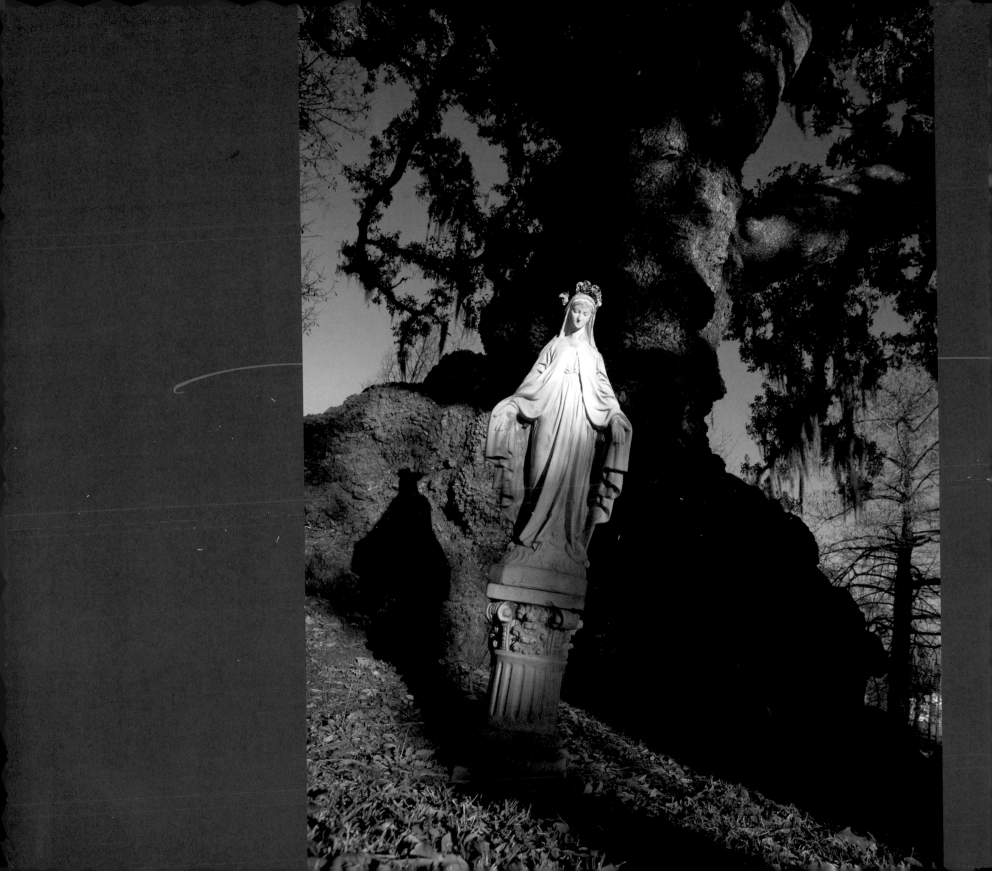

Acadiana

Louisiana's Historic Cajun Country

Text by Carl A. Brasseaux

Photographs by Philip Gould

Louisiana State University Press

Baton Rouge

Publication of this book is supported by DeeDee and Kevin P. Reilly, Sr.

Published by Louisiana State University Press
Text copyright © 2011 by Carl A. Brasseaux
Photographs copyright © 2011 by Philip Gould
All rights reserved
Manufactured in China
Second printing

Designer: Laura Roubique Gleason
Typeface: Minion Pro
Printer and binder: Everbest Printing Co., through Four Colour Imports, Ltd.,
 Louisville, Kentucky

Frontispiece photo: Statue of Mary and reputedly the real Evangeline Oak, just
downstream from the official one in St. Martinville.

Photographs taken at Avery Island are reproduced with the permission of McIhenny Co.

This project is made possible in part by a grant from the Lafayette Convention and
Visitors Commission.

LIBRARY OF CONGRESS CATALOGING-IN-PUBLICATION DATA

Brasseaux, Carl A.
 Acadiana : Louisiana's historic Cajun country / text by Carl A. Brasseaux ; photographs
by Philip Gould.
 p. cm.
 Includes bibliographical references and index.
 ISBN 978-0-8071-3723-9 (cloth : alk. paper) — ISBN 978-0-8071-3964-6 (pdf) —
ISBN 978-0-8071-3965-3 (epub) — ISBN 978-0-8071-3966-0 (mobi)
 1. Louisiana—Description and travel. 2. Louisiana—History. 3. Cajuns—Louisiana—
History. 4. Louisiana—Pictorial works. I. Gould, Philip, 1951– II. Title.
 F369.B814 2011
 976.3—dc22

 2010021246

The paper in this book meets the guidelines for permanence and durability of the
Committee on Production Guidelines for Book Longevity of the Council on Library
Resources. ∞

*To Ani, Joe, Addie, and Hannah, my four beautiful and
precocious grandchildren, who have enriched my life beyond
words*
 —CB

*To my wife, Margot Hasha, and my two sons, Colin and Daniel
Gould, true sons of Louisiana*
 —PG

Contents

Crawfish in a trap

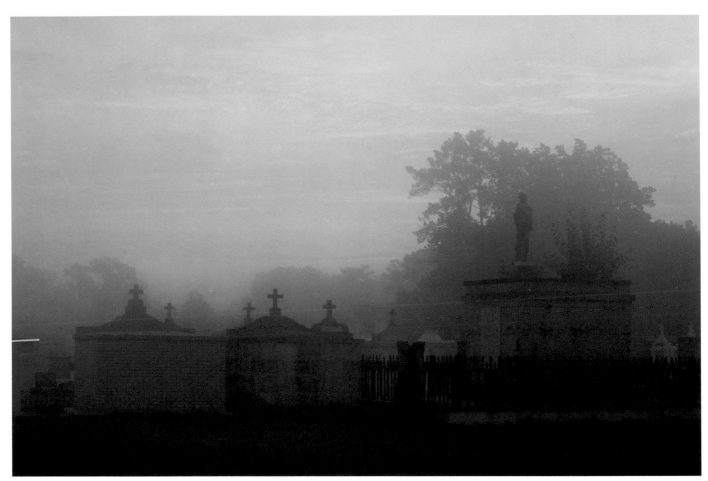

Cemetery, Donaldsonville

Acknowledgments

Projects like this one become long, massive, and joyful endeavors. Along the way, many people provided invaluable help, advice, and generosity. They shared their homes, their knowledge, their private collections. They provided that vital tidbit of information. They waited patiently for the photographer to finish. In alphabetical order, we would like to thank: Acadian Village, Glenn and Dana Armentor, Butch Bailey, Marge Barker, Paul Begnaud, Shane K. Bernard, Ben and Ann Blanchet, Glenda M. Brasseaux, Ryan André Brasseaux, Gerald Breaux, Diana Buckley, Ed Cazayoux, Madeleine Cenac, Brian J. Costello, Ed Dubuisson, Emile Dumesnil, Patrick Dunne, E. D. White State Park, Kim Gattle, L. J. Geilen, Laura Gleason, Greg Guirard, Michael Hensgens, Jack Holden, Marjorie Hollensworth, Patricia Kahle, Dr. Thomas Kramer, Eddie LeCompte, Lanny Ledet, Burnell Lemoine, Margaret Hart Lovecraft, Norman Marmillon, Dan Michel, Susan Murray, Walter and Lucy Parlange, Billy Patout, Glen Pitre and Michel Benoit, Andy Reaux, Dr. Will and Christine Robichaux, Marc and Ann Savoy, Amanda Scallan, Steve and Cynthia Schneider, Bertha and Thomas Shanklin, Hunt Slonem, Robert E. Smith, Steve Sterling, Vermilionville, John and Jane Vidrine, Robert Vincent, Yvette Voorhies, Kim Soprano Walden, Frances Winstead, and Meaghan Winston.

Spanish Lake, New Iberia

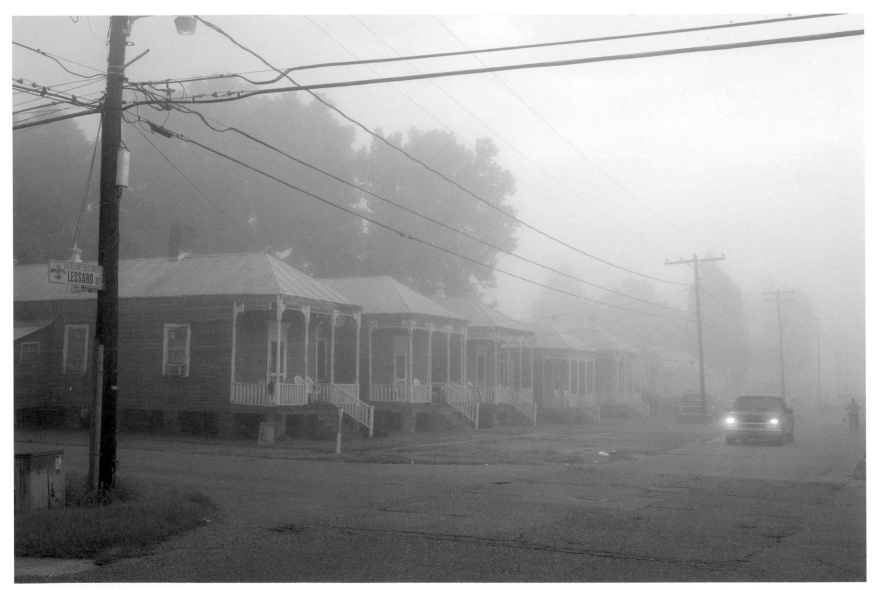

Historic shotgun houses, Donaldsonville

Acadiana

The Twenty-Two Parish Area Called "Acadiana"

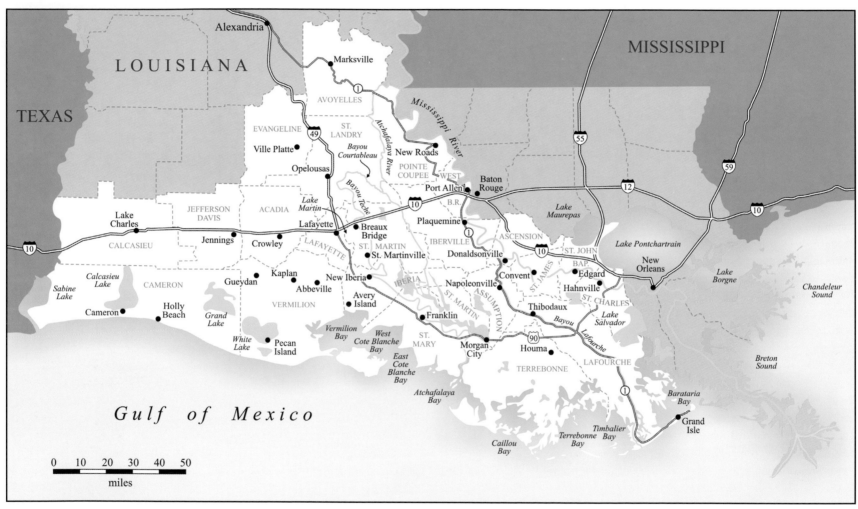

Map by Mary Lee Eggart

Introduction

The term "Acadiana," signifying a twenty-two-parish area encompassing Louisiana's so-called French Triangle, is the result of a fortuitous misnomer, according to an oft-quoted, perhaps apocryphal story widely circulated by Lafayette television station KATC. This tale, as retold by local journalist Jim Bradshaw, maintains that "Dr. Paul Kurzweg, founder of KATC-TV in Lafayette, and William Patton, the station's general manager, apparently used the word first in 1963 after a typist for the General Electric Co. in Schenectady, New York, added an extra 'a' in addressing an invoice to the TV station's parent Acadian Television Corporation. 'Acadiana' originally applied to the KATC viewing area, which was Lafayette and the surrounding parishes."

Whatever the term's origins, "Acadiana" became an official designation at the conclusion of Louisiana's 1971 legislative session. Sponsored by state representatives Armand J. Brinkhaus, Carl W. Bauer, J. Richard Breaux, J. B. Broussard, H. B DeJean Jr., P. J. Laborde Jr., and Robert G. Jones, as well as state senators Edgar Mouton Jr., J. E. Jumonville, and Jesse M. Knowles, House Concurrent Resolution No. 496 declared an area variously identified as "Acadiana" and "the Heart of Acadiana" as an official "cultural region of Louisiana." After noting that the "state of Louisiana" had "long recognize[d] this cultural area" and "constantly attempted to maintain and strengthen the French Acadian culture and language"—an outrageous claim by a state government whose constitution still officially banned the French language from its public schools—the resolution's authors candidly articulated the real intent of the legislation. The designation of an official "cultural region," the legislators maintained, "would best serve the state of Louisiana and the region involved to be so designated by the U.S. Travel Service and by other maps and publications for international distribution which would help promote Louisiana as a tourist attraction and Acadiana as part of that attraction." The resolution further specified that the state government send "a copy of this Resolution . . . to the United States Travel Service, to United States international airlines, to foreign airlines servicing the United States, and to major organizations, such as the National Geographic Society, which are involved in the production of maps."

The cultural region to be delineated in the much-anticipated maps was to include the following parishes: Acadia, Ascension, Assumption, Avoyelles, Calcasieu, Cameron, Evangeline, Iberia, Iberville, Jefferson Davis, Lafayette, Lafourche, Pointe Coupée, St. Charles, St. James, St. John, St. Landry, St. Martin, St. Mary, Terrebonne, Vermilion, West Baton Rouge, "and other parishes of similar cultural environment." Despite this open-ended addendum, the official state map has always delineated only the twenty-two parishes specifically identified in the resolution.

Despite the blatantly self-serving motive behind the legislation, the residents of the newly proclaimed Acadiana responded in a generally very positive way. For many in Acadiana, the legislation was a source of ethnic and regional pride, an important palliative to those who had experienced more than a century of denigration at the hands of demagogues, the Americanized local elite, the popular media, religious institutions, and the state's public education system. Today, the region's residents proudly fly the Acadiana flag, designed by Thomas Arceneaux of Lafayette in the early 1970s, from their homes, business places, and government offices.

But the term "Acadiana" also evokes—for Louisianians and outlanders alike—images of ancient moss-draped trees, languid cocoa-colored bayous, subtropical wildlife, and, most exotic of all, the region's Cajun and Creole inhabitants. This imagery is the product of carefully crafted, decades-old regional and state tourism campaigns designed to exoticize the physical and cultural landscapes of Louisiana's French Triangle region once looked down upon for its very exoticism. These now ubiquitous images mask and ultimately distort the underlying complexity that more accurately characterizes the Pelican State's French-speaking region, whose popular name Acadiana ostensibly harks back to its Acadian pioneers. And, while it is true that thousands of Acadian exiles carved a new homeland within the confines of the twenty-two-parish region, they were not by any means the only immigrants to call the area's bayous their own. Indeed, the region is populated by the descendants of at least a dozen major French-speaking groups, as well as tens of thousands of individuals who proudly trace their ancestry to indigenous Native American nations, African slaves, free persons of color, Rhinelanders, Alsatian religious exiles, Isleños (Canary Islanders), Malagueños, Anglos, fugitives from the Irish potato famine and Germany's 1848 revolution, German and East European Jews, transplanted midwesterners, Lebanese Christians, Sicilians, German Catholics fleeing the Prussianization of the Fatherland, Texas and Oklahoma oil workers, Laotians, Vietnamese, and a host of other groups. The

ethnic diversity behind the façade of homogeneity created by promotional literature has led some modern ethnographers to identify the Acadiana region as the home of North America's most complex rural society. It is precisely this complexity that we seek to explore through this publication.

In order to comprehend Acadiana's cultural landscape, one must first understand the physical landscape that molded societal development across Louisiana's French Triangle. Acadiana has been profoundly shaped by water. Vernal overflows of the region's major streams over several millennia resulted in the annual deposition of vast quantities of sediment, creating a series of riparian ridges, called natural levees, along the riverbanks. The posterior edges of the natural levees slope back gently toward the swamps, usually approximately a mile away from the banks of major waterways. The back slopes, used primarily for agriculture, are frequently subject to inundation by floodwaters emanating from the swamplands. The human population along streams consequently congregated along the front edges of the natural levees, which have the highest elevation in the riverine settlements. Because the habitable strips were so narrow, resulting in long, linear settlements along the banks of bayous and rivers, population densities were quite high.

The local topography that ordained settlement along natural levees also dictated the use of the Norman long lot in colonial settlements. This French land system, employed first in Canada, provided pioneers with equitable distribution of critical resources. Measured in arpents (192 linear feet per side), Louisiana's Norman long lots were generally long, narrow ribbons of land fronting streams and extending nearly one-and-a-half miles into the interior. Along major Acadiana watercourses, a typical land grant measured 4 to 6 arpents frontage by 40 arpents depth. This configuration provided early settlers with equal access to the streams, which were the region's principal communications arteries; the extremely fertile natural levees; and the cypress swamps occupying the backlands. (Not only was cypress the most easily workable local wood, but its lumber was resistant to both dampness and termites.)

The initial benefits of the long-lot land system were quickly offset by its deficiencies. Under Louisiana's forced heirship laws, which have remained virtually unchanged from colonial times to the present, equitable distribution of property was mandatory for heirs in successions. Land grants, which were initially adequate for most colonial-era families, were quickly reduced by forced heirship to narrow ribbons measuring only a few feet of frontage by 40 arpents of depth. Some heirs responded by selling their slender bequests and moving to more marginal lands toward the swamps, the coastal marshes, or the prairies where real estate was cheap and readily available; others remained on their family properties, living in ever-closer proximity to their neighbors.

Over numerous generations, the progressively narrower waterfront land-

holdings resulted in ever-greater population density. Living "cheek by jowl," settlers of different racial, ethnic, and linguistic backgrounds were compelled to interact with one another on a daily basis. The result was extensive cross-cultural pollination and the rapid development of new, synthetic cultures based on the cultural legacy of the socially and economically dominant group in each subregion. The products of this evolutionary process are seen most clearly in modern Cajun and zydeco music, as well as modern Cajun and Creole cuisine, all of which are products of the last century.

This evolutionary trajectory was also evident in the backwater areas—the swamp ridges, the coastal marsh ridges (*chênières*), and the prairies where the population was far less dense. But, because of the great differential in income levels and technological access between the region's rural and urban populations, cultural diffusion proceeded at a markedly different tempo in each of Acadiana's principal settlements, even in neighboring communities. The processes that spawned and sustained such dichotomies are many, complex, and varied.

The great complexity of Acadiana's rural sociocultural landscape is compounded still further by the racial and ethnic diversity of the region's urban communities, whose makeup frequently contrasts sharply with that of areas immediately outside their respective corporation limits. In earlier times, when certain groups tended to dominate specific socioeconomic strata, the lines of demarcation between urban and rural communities were even more pronounced. In the late antebellum era, for example, the communities lining upper Bayou Teche were typically populated by European immigrants, who dominated the professional and mercantile sectors, and free people of color, who dominated the trades. The comparative complexity and fluidity of these small urban populations contrasted sharply with the relative simplicity and rigidity of the neighboring rural plantation societies.

The gulf dividing rural and urban neighbors from one another grew progressively over time because the townspeople had greater access—thanks to better communications and a generally higher local standard of living—to technological innovation as well as modernizing and Americanizing influences. This not only accelerated the pace of evolutionary change within Acadiana's towns, but it also widened the gap between the divergent evolutionary trajectories of town and country residents. In early twentieth-century Acadia Parish, for example, Church Point residents enjoyed all of the amenities commonplace in small-town America—including municipal water, electricity, and telephone service—more than a generation before their Pointe Noire neighbors only five miles away. Acadiana is consequently an intricate sociocultural mosaic, one that demands an understanding at the microcosmic level before the big picture can be revealed.

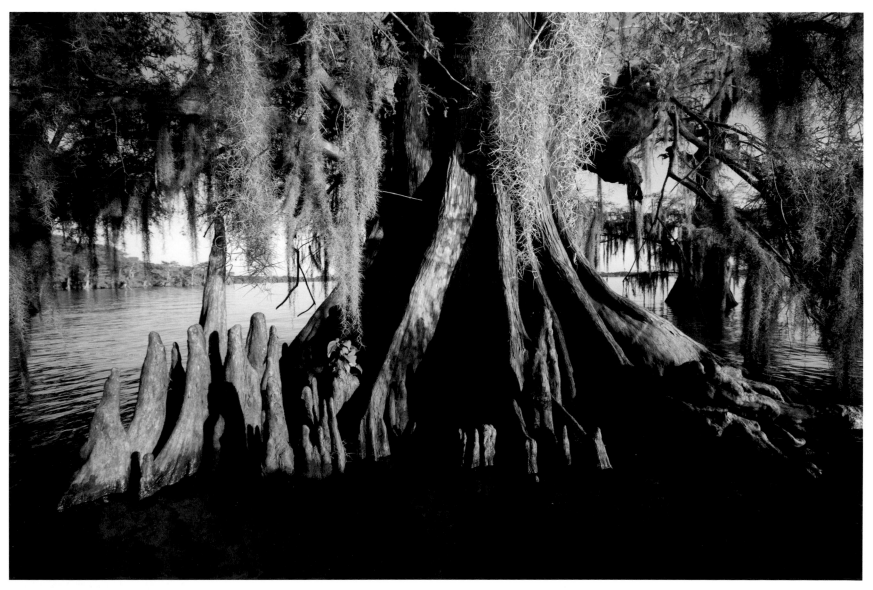

Acadiana's subregions are paradoxically divided and bound together by a labyrinth of waterways that, for much of the region's historical existence, constituted the principal local communication and transportation arteries as well as vitally important sources of food and cypress timber. *Above:* Lake Dauterive.

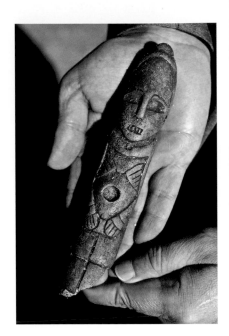

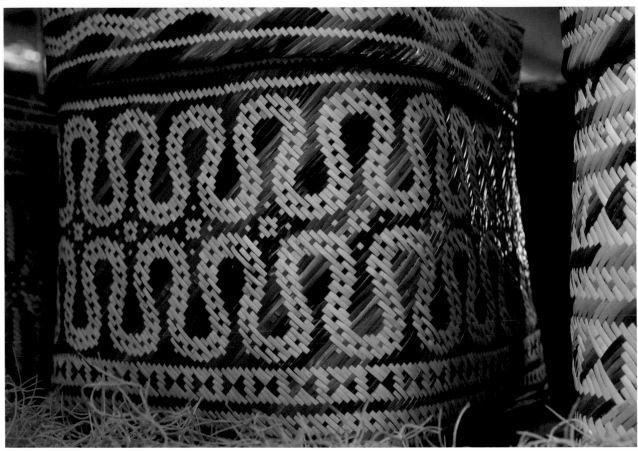

Native Americans have left an indelible imprint of their historical presence, manifested perhaps most conspicuously in myriad artifacts, place names, culinary traditions, and terminology that have become an integral part of the local lexicon. *Above:* A Chitimacha basket with a serpent design, reflecting the origin of the name "Bayou Teche." "Teche" is the Chitimacha word for snake. *Left:* A human effigy carved from an antler recovered from a prehistoric site at Pecan Island in Vermilion Parish.

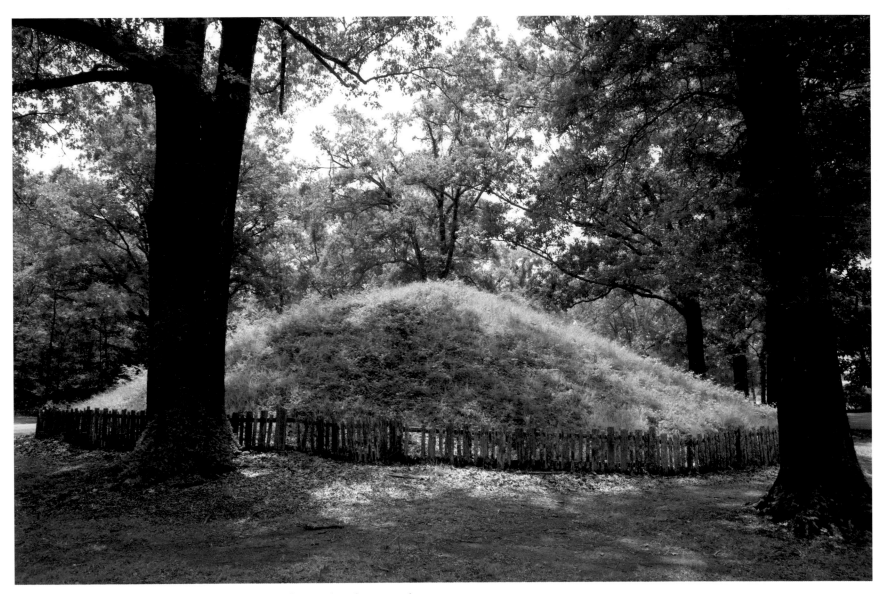

The burial mound near present-day Marksville is part of a complex of seven earthen structures at the Marksville State Historic Site. The site, located along Old River, is a showcase for artifacts of the southeastern variant of the Hopewell culture, an ancient society centered in what is now the Midwest. The U.S. Department of the Interior designated the site a national historic landmark in 1964.

A rice field near Kaplan will soon be flooded for planting.

Acadiana is a birder's paradise. Scientists and birders have documented more than 450 avian species in Louisiana, a disproportionately large percentage of which pass through Acadiana on their annual migratory treks, as seen in this flooded rice field near Crowley.

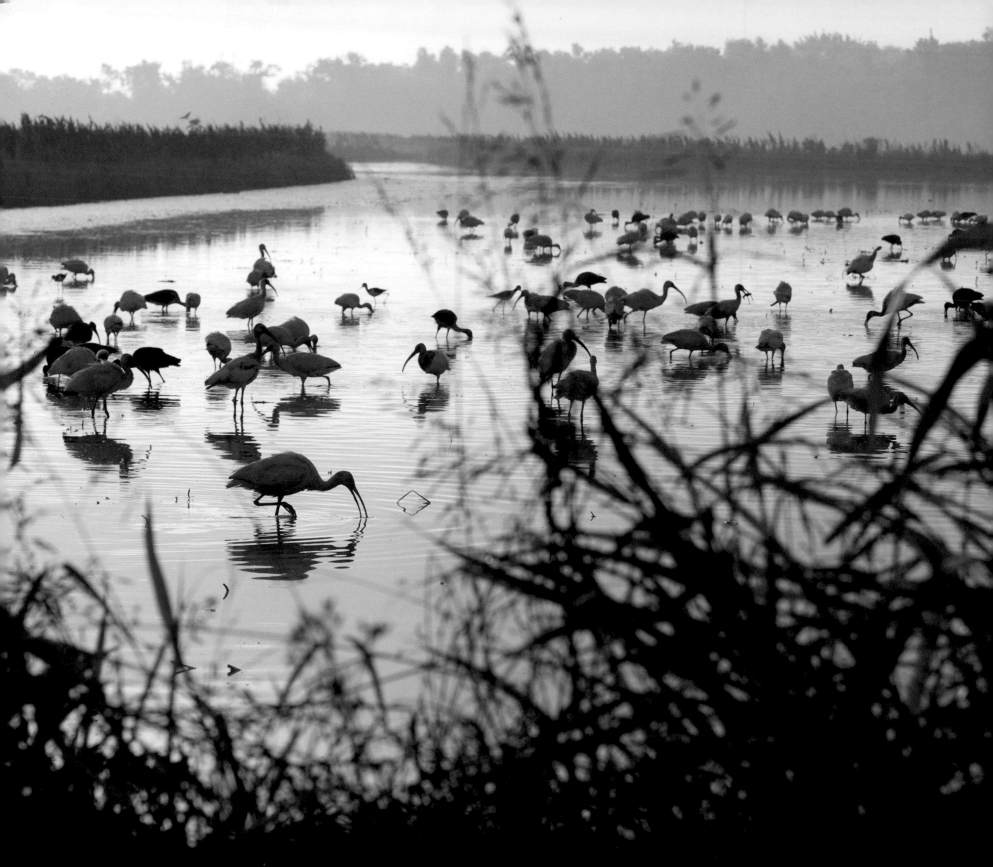

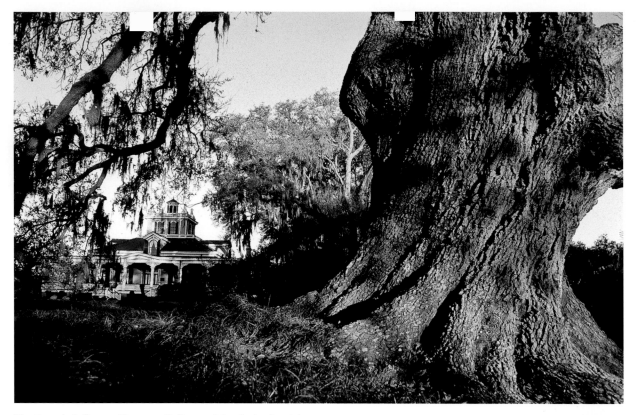

The Joseph Jefferson House at Jefferson Island, the Louisiana retreat of perhaps the most famous nineteenth-century comedic actor in America, Joseph Jefferson.

A Virgin Mary statue in front of an antebellum Acadian-style house upstream from Thibodaux along Bayou Lafourche.

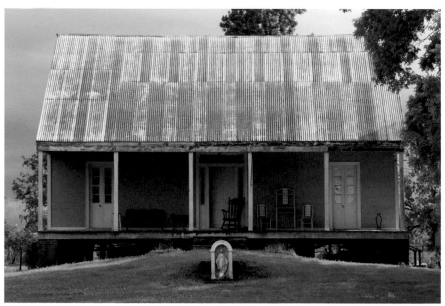

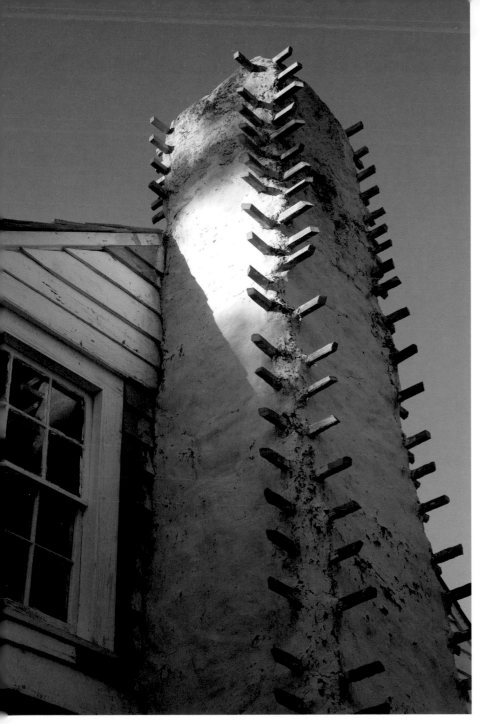

A replica of a traditional Acadiana chimney built at Vermilionville, fashioned from *bousillage,* an adobe-like mixture of mud and moss or deer hair.

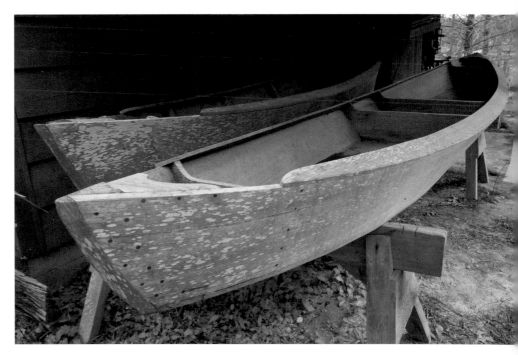

A second-generation cypress pirogue. Once commonplace on Acadiana streams, pirogues replaced the cypress dugouts used by Native Americans and colonial settlers into the nineteenth century.

Overleaf: The coastal marsh near Leeville (Lafourche Parish) during a storm. As a result of natural subsidence, sea-level rise, and rapid erosion resulting from man-made changes to the regional hydrology, Louisiana's critically important coastal marshes and their adjoining estuaries have been steadily shrinking for more than a half century. Indeed, since 1930, Louisiana's coastal wetlands have lost an area roughly twice the size of Connecticut.

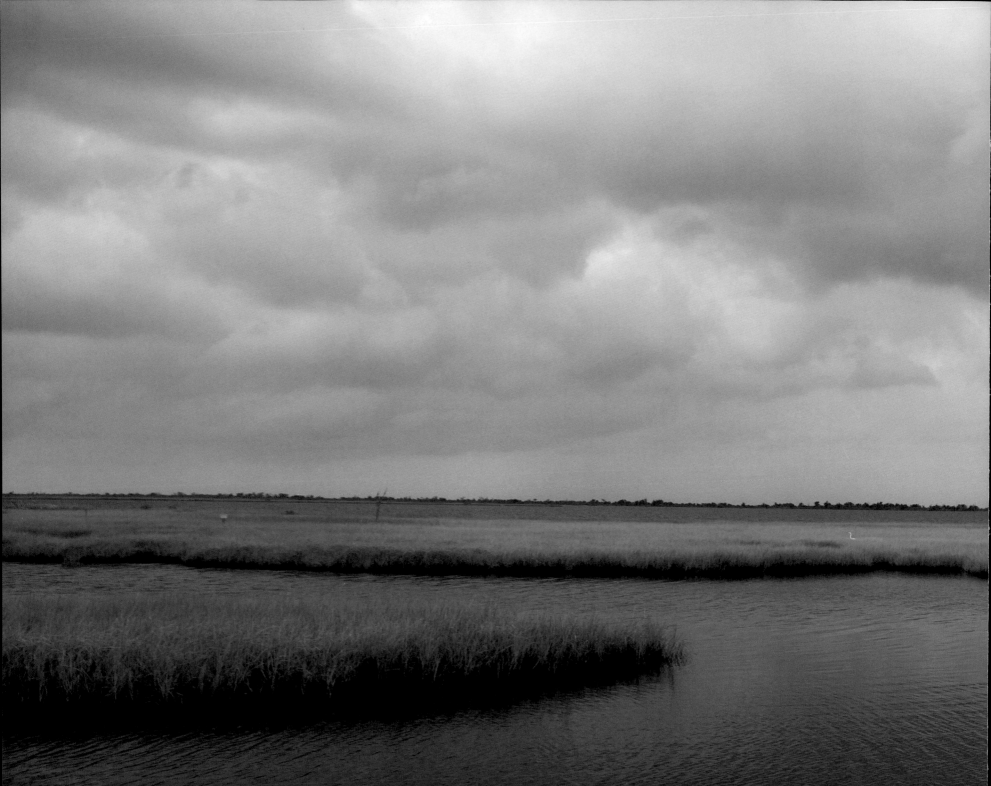

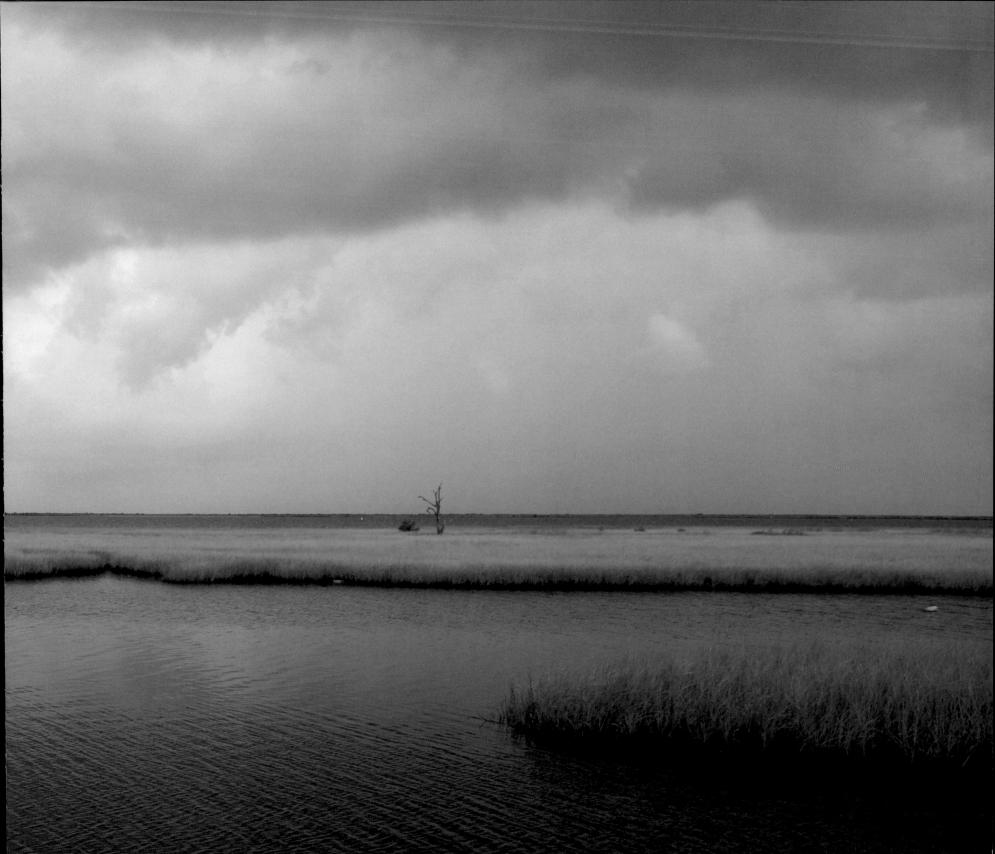

1 Pointe Coupée and Avoyelles Parishes

Pointe Coupée and Avoyelles parishes together form the apex of Louisiana's so-called French Triangle. These adjoining parishes share a riparian plain created and watered by the Mississippi, Red, and Atchafalaya rivers. As they are located at the intersection of Louisiana's three most important waterways, it is hardly surprising that their historical development has been profoundly shaped by these streams.

Humans were first attracted to the area by the ready availability of resources provided or sustained by the rivers. Native Americans occupied the natural levees along the streams in the areas that presently comprise Avoyelles and Pointe Coupée parishes. These Paleo-Indians evidently practiced agriculture and frequently erected earthen mounds that appear to have served as burial and elevated temple sites on the edges of their settlements. The region's prehistoric residents, however, are remembered not for their surviving mounds, but for their excellent pottery, unearthed by twentieth-century archaeologists at Avoyelles Parish sites. The largest extant cache of artifacts, the so-called "Tunica Treasure," once in private hands, was repatriated to the Tunica-Biloxi people in the late twentieth century, and the tribe is currently constructing a cultural and educational resources center to house the collection.

At the time of the initial European contacts with the indigenous inhabitants of modern Avoyelles and Pointe Coupée parishes (ca. 1542–1699), the region was sparsely populated, perhaps because of the area's frequent flooding. Only the Avoyelles tribe continuously occupied lands between the eastern Rapides Parish line and the Mississippi River in early historic times. After intertribal strife drove the Houma, who occupied the present Angola Prison site, southward around 1706, the Avoyelles remained the region's sole Native American residents until 1764, when several tribal fragments that had been displaced in the early eighteenth century because of their alliance with France migrated with the colonial government's blessing from their temporary homes near Mobile, Alabama, to the lower reaches of the Red River. Most of the migrants congregated in present-day Avoyelles Parish, where the Tunica-Biloxi have maintained their cultural viability to the present.

At the time of the 1764 influx, the Avoyelles and Pointe Coupée areas had been open to white settlement for more than four decades. The region's first colonial community, the St. Reyne concession, was established along the Mississippi in present West Feliciana Parish around 1721. The concession soon failed, and the local focus of French colonization shifted to the west bank, both along the Mississippi River and along an oxbow then in the making, now known as False River.

Rivers like the Mississippi continuously seek the shortest route—and the steepest gradient—to the sea, and this natural process results in frequent changes in river courses. Such a change in course had already begun in 1699, when the French explorer Pierre Le Moyne d'Iberville, the future governor of Louisiana, and his party discovered a "six-foot-wide" waterway running through a large point of land created by a great westward bend of the river. By the mid-1720s, the Mississippi had completed the process of scouring a new, shorter channel and abandoning the original crescent-shaped loop. The point, now cut off and virtually surrounded by water, gave birth to the region's three most prominent place names: Pointe Coupée, the Island, and False River. The term "False River," however, does not appear in the documentary record until the 1760s.

The newly formed oxbow and the natural levee along the east-west segment of the Mississippi River to the north would become the focal points of colonial-era settlement and economic development. In 1726, colonial census takers recorded four families numbering seventeen persons in the area. This pioneer community was augmented by an undetermined number of refugees from the 1729 Natchez massacre, in which the Natchez tribe killed approximately two hundred in a preemptive strike against their French neighbors. The French military response to the incident demonstrated Pointe Coupée's strategic value in campaigns against powerful Native American tribes threatening French control of the Lower Mississippi Valley, and, in 1733, approximately ten soldiers were assigned to a redoubt erected in the area along the Mississippi.

In the wake of the French victory over the Natchez in 1731, the Pointe Coupée settlements experienced significant growth as colonists began to congregate in the area to exploit the region's abundant natural resources. In 1731, the nascent colonial district boasted 111 settlers, including 53 African and 3 Indian slaves. Fourteen years later, Pointe Coupée's free population included 260 whites, 3 Native Americans, 406 slaves of African ancestry, and 20 Indian bondsmen. The district also boasted a military post with a modest garrison of 18 men.

The post's population, as these figures suggest, was surprisingly diverse,

and no segment of local society was monolithic. The white pioneers, for example, were drawn from quite varied backgrounds. Of the 74 people whose birthplace is identified in the post's ecclesiastical records for 1737 to 1750, 44 percent came from assorted French provinces, 31 percent were Louisiana natives, 8 percent were German, 7 percent were born in Flanders, and 6 percent were Canadian. Other individuals were natives of Switzerland, Ireland, and the French Antilles. These disparate groups, however, quickly coalesced into a Creole community that dominated the region's sociocultural landscape for generations.

Steady demographic growth continued after Spain acquired the colony by treaty in 1763. For example, the regional census of 1766 reveals a population of 509 whites and 690 slaves, who together occupied 117 farmsteads. Perhaps more important than the post's demographic advancement is the emergence—as the large slave population indicates—of a local plantation economy. By 1785, slaves outnumbered whites by a ratio of more than two to one. Plantation development was particularly pronounced along the Mississippi and False rivers. Less affluent farmers—to whom the epithet "Cajun" was sometimes attached despite their lack of Acadian ancestry—tended to congregate in the flood-prone "island" area along False River's east bank.

The rise of Pointe Coupée's plantation system and its periodic inundations provided an impetus for a small-scale migration of white yeomen to the adjoining region then opening to settlement. As indicated above, Louisiana's colonial government dispatched several Native American tribal bands to the lower Red River valley in 1764. These immigrants made a home in present Avoyelles Parish, and white settlers were not long in following, the first, according to local lore, being Joseph Rabalais, who obtained a land grant along Grand Ecore Bayou near present-day Mansura.

Growth in the white immigrant population led directly to land disputes between whites and their Native American neighbors. The resulting outcry resulted in the establishment of the Avoyelles governmental district. Jacques Graugnard, the district's first commandant, effectively restored order, and, under his leadership, an agrarian settlement took root.

In Avoyelles, as in Pointe Coupée, the local economy was based on cultivation of the two staples encouraged by the Spanish government—indigo and tobacco. For much of the mid- to late eighteenth century, Pointe Coupée was a center of livestock production. The neighboring settlements differed markedly, however, in terms of economic scale.

By the dawn of the nineteenth century, the plantation system had become so deeply entrenched—and so obviously repressive—that it produced a major, if abortive, slave insurrection. The instigator of the uprising was Joseph Bouyavel, a Walloon immigrant who spread the gospel of revolution to

ACADIANA'S INDIGENOUS ARCHITECTURAL STYLES

Louisiana's three most significant indigenous architectural forms—each the product of long experimentation aimed at perfecting designs suited to the region's notoriously hot, humid weather—are showcased in Acadiana's towns and countryside. The Raised Creole Cottage was the first to evolve. These homes typically feature Norman-style hip roofs, front and rear galleries, and an asymmetrical room arrangement. (The Avoyelles and Pointe Coupée homes boast double-pitched roofs reminiscent of French architectural styles commonplace in the upper Mississippi Valley and Canada.) Most Creole-style homes in the floodplain were raised on pillars to protect them from periodic inundations. While the Creole style matured, a second indigenous form emerged as Acadian immigrants struggled to reinvent the house designs they had carried with them from their Maritime Canadian homeland. The Cajun house type, the product of their architectural experimentation, features prominent gables on the two side walls, a front gallery, and, traditionally, an external staircase to the cockloft (garçonnière) in the attic. Cajun-style houses are found throughout rural Acadiana, unlike the third common architectural form—the shotgun house—which is seen more frequently in urban spaces. The shotgun house, which developed in New Orleans from uncertain (and hotly debated) architectural antecedents, is a long, narrow structure designed to maximize space in tiny urban lots. Shotgun houses lack interior halls and usually feature a front gallery.

the local slave population. Bouyavel disciple Antoine Sarassin, a slave on Julien Poydras's Pointe Coupée plantation, then began to organize bondsmen throughout the False River area for a proposed armed uprising. White planters learned of the anticipated insurrection, and governmental authorities intervened. Prosecutors filed charges, and, in the ensuing trials, fifty-seven slaves and three whites were found guilty of complicity in the conspiracy. At least twenty-three of the convicted slaves were hanged and then decapitated; their heads were displayed on spikes along the Mississippi River to serve as a deterrent to other potential revolutionary agitators.

The failure of the Pointe Coupée slave insurrection assured the success of the local plantation system for two more generations. In 1860, for example, the parish boasted sixty-three plantations with slaveholdings in excess of fifty bondsmen, and eighteen plantations with more than one hundred slaves. The local plantation regime, however, continued to evolve in the forthcoming decades as staple-crop production shifted to sugar and cotton in the wake of the War of 1812.

The economic development of neighboring Avoyelles Parish was more complex. From colonial times, the local population had engaged in small-scale agricultural production. As in Pointe Coupée, colonial-era farmsteads had produced tobacco, indigo, and cattle, but on a far more limited scale due initially to the absence of a large enslaved work force. The plantation economy would

not establish roots in Avoyelles Parish until the antebellum era, and even then, it existed on a more limited, localized basis. Until the Civil War, the parish would remain dominated by yeoman farmers and small slave owners, who, after the War of 1812, abandoned tobacco and indigo production for cotton cultivation. There were, however, a few notable plantations—twenty-two with "large" slaveholdings, according to historian Karl Joseph Menn—and most were concentrated along Bayous Boeuf, Rouge, and Huffpower, and the fifty-mile-long Bayou des Glaises loop, extending from Simmesport to Cottonport. The local economic metamorphosis eventually produced modest surplus incomes that, in turn, permitted local yeomen to participate in the region's burgeoning cash economy and emerging materialism. This economic revolution transformed late antebellum central Louisiana, as farm families began to buy ever-greater quantities of manufactured items on credit.

The flowering regional economy attracted to the area surprisingly large numbers of enterprising merchants and farmers. Many of Avoyelles's new merchants were recent French immigrants (known throughout Francophone south Louisiana as the "foreign French"), who saw in the area not only opportunity, but also a congenial cultural landscape. The foreign French were joined in the parish by Anglo-American transplants in the Bayou Boeuf and present Bunkie areas.

The Civil War shattered the waxing economic fortunes of Avoyelles and Pointe Coupée parishes. After Union forces occupied New Orleans and Baton Rouge in the spring of 1862, military operations around the strategic junction of the Mississippi and Red rivers became inevitable. In 1863, months of gradually intensifying skirmishing culminated in a pitched battle between Confederate and Union forces along Bayou Fordoche. Stung by a Confederate victory on the Fordoche, Federal forces subsequently burned Morganza.

The intensity of the fighting then eased until the spring of 1864, when Union forces mounted a major offensive—the Red River Campaign—intended to displace the area's Rebel defenders and capture the state's Confederate capital at Shreveport, thereby effectively ending Louisiana's participation in the war. On March 12, 1864, Gen. Andrew J. Smith's Union army landed at Simmesport. After overrunning Fort DeRussy, a nearby Confederate bastion, and driving off diverse bands of Rebel skirmishers, Smith's force rendezvoused with other Union naval and army units before attempting their ultimately unsuccessful conquest of northwestern Louisiana. Ultimately meeting defeat at the hands of Confederate forces in DeSoto Parish, the Union army hastily retreated through Avoyelles Parish, thereby precipitating another flurry of skirmishing. In May 1864, the Union forces made a stand at Morganza, establishing an earthen fortification and a military presence that would endure there for the balance of the war.

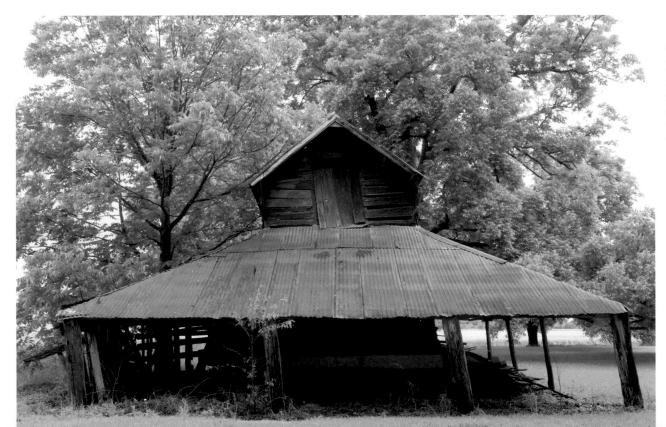

This modest, now rickety barn near Moreauville (*left*) and the stately *pigeonnier* at Parlange Plantation (*right*) accurately reflect the social and economic dichotomy dividing the yeoman farms of the Avoyelles Parish area from the plantation culture of the False River area.

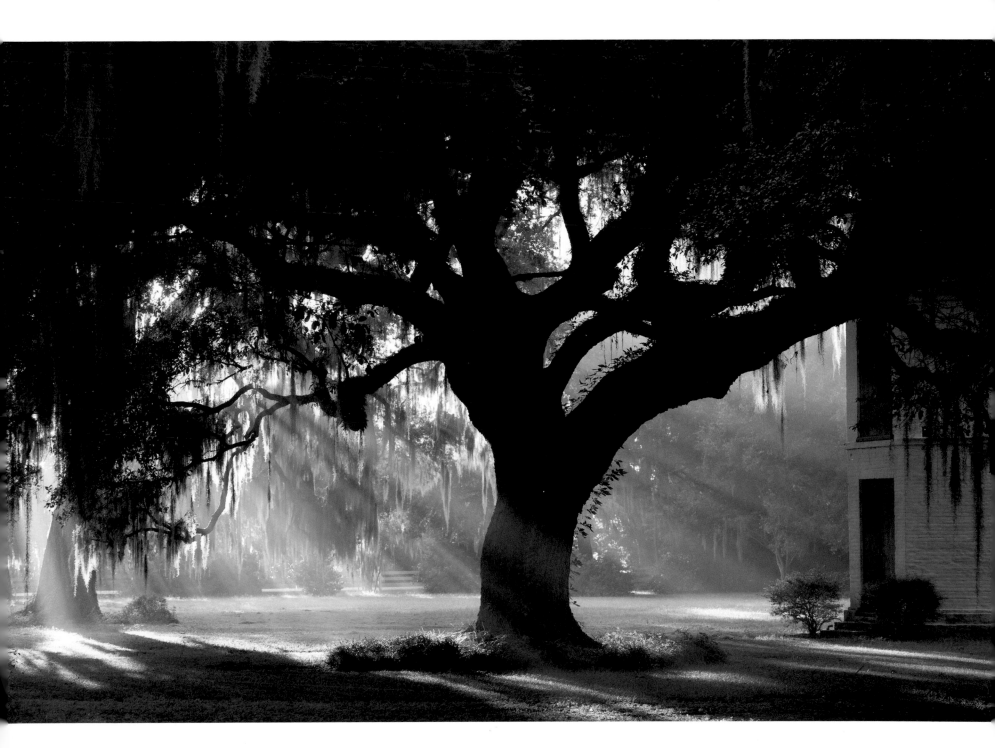

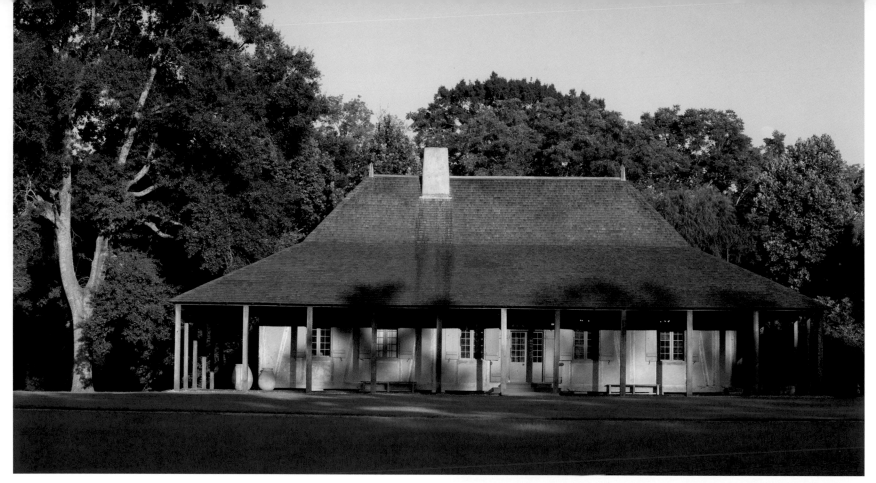

The Nicolas LaCour House, now located at Rougon in Pointe Coupée Parish, is believed to have been built before 1761, perhaps as part of the district's French outpost. As such, the house would be one of the oldest surviving buildings in the Lower Mississippi Valley outside New Orleans.

The LaCour House, which measures approximately 25 by 61 feet, has an asymmetrical floor plan typical of colonial-era Creole structures. The unusually large "salle," or dining room, however, is distinctive.

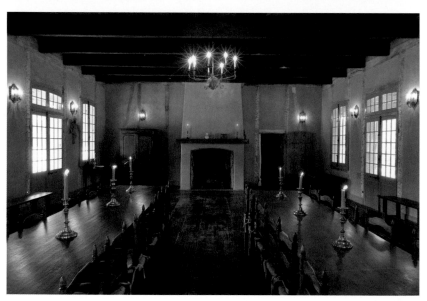

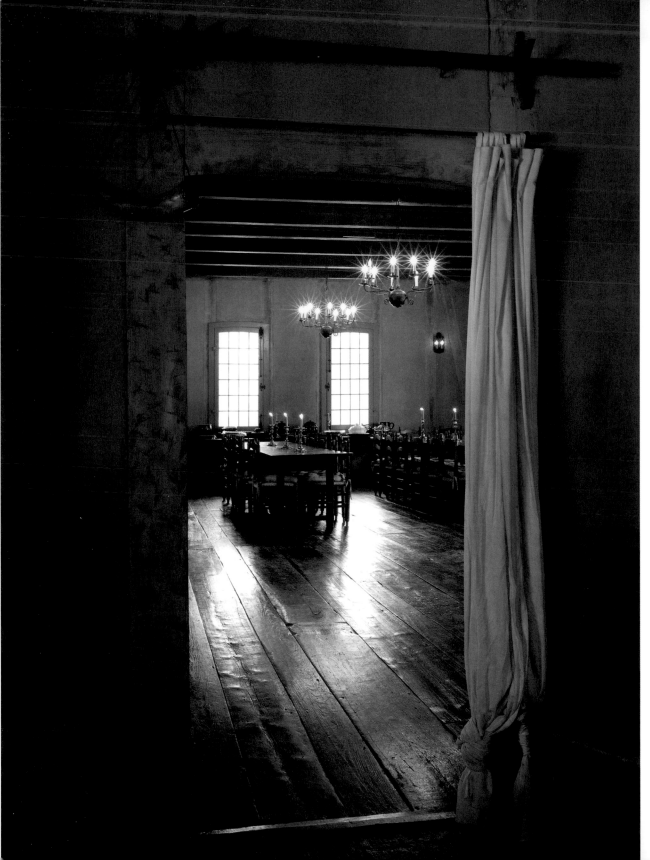

Many architectural historians believe the house was one of the original structures of Poste de Pointe Coupée, a French military fort. If so, its military role was brief before it became the LaCour House.

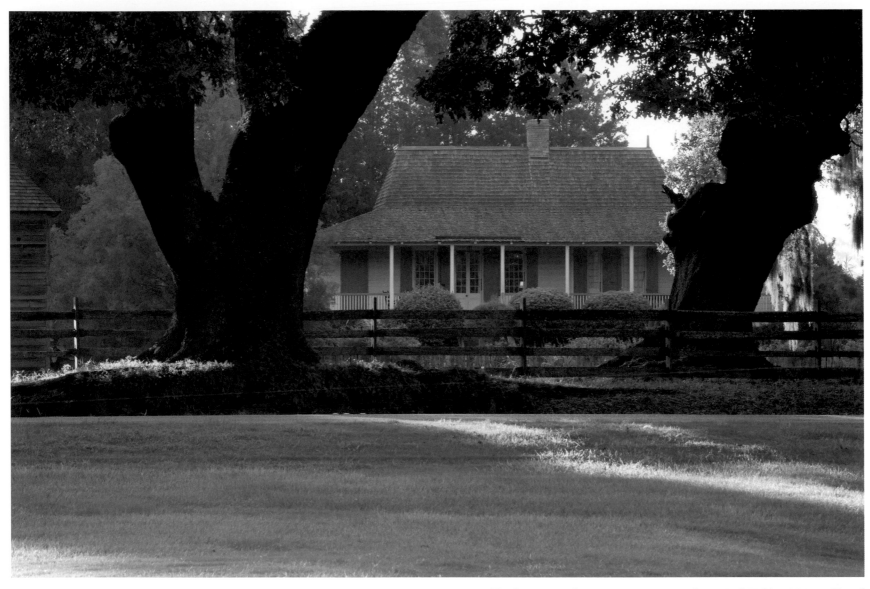

Restored by the renowned preservationists Dr. and Mrs. Jack Holden, Maison Chenal is a classic late eighteenth-century Creole-style structure located at Rougon.

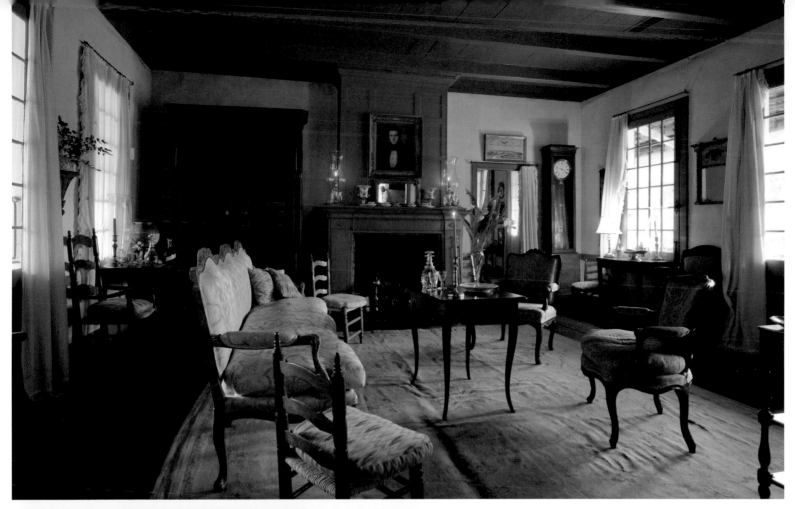

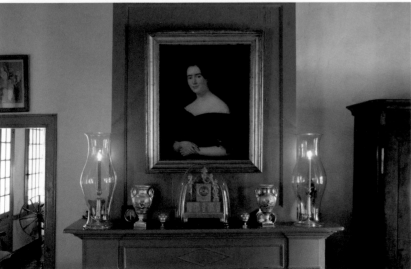

Built by the famed Louisiana businessman, poet, politician, and philanthropist Julien Poydras (1746–1824), Maison Chenal is decorated with the simple but elegant furnishings typical of the residences of the region's elite families.

The identity of the woman in the painting by Jean-Joseph Vaudechamp that hangs over the fireplace mantel at Maison Chenal remains a mystery.

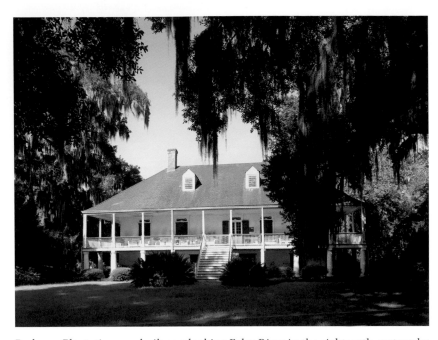

Parlange Plantation was built overlooking False River in the eighteenth century by Vincent de Ternant, marquis de Dansville-sur-Meuse. The Creole house is considered by many to be the best extant example of French colonial plantation architecture. The house eventually came into the possession of the French military officer Charles Parlange through his marriage to de Ternant's widow, Virginie Trahan.

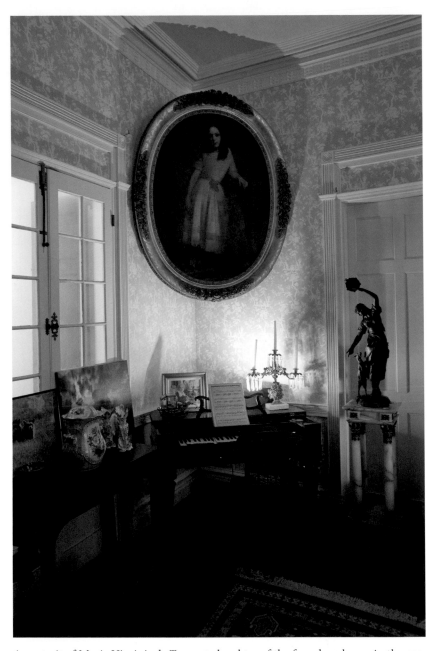

A portrait of Marie Virginie de Ternant, daughter of the founders, hangs in the corner of the salon. Parlange Plantation was designated a National Historic Landmark in 1970.

In the colonial and antebellum eras, Louisiana's great houses consistently numbered *pigeonniers* (dovecotes) among their ancillary buildings. The pigeons raised in them were a source of food and fertilizer, but the residents of these estates prized these structures more for their symbolic importance. In pre-revolutionary France, which provided a societal model for Louisiana's emerging elite, only members of the aristocracy had the right to erect *pigeonniers*. The interior view of beams and ceiling in one of the *pigeonniers* flanking Parlange Plantation's tree-lined entryway appears above.

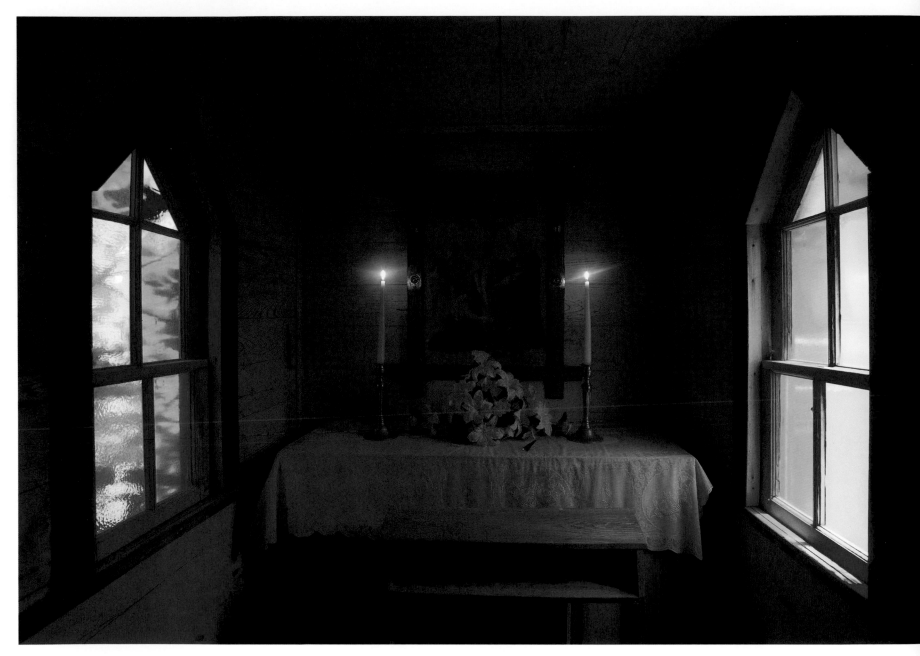

Above and right: A small prayer chapel rests behind the Hypolite Bordelon House (now a tourist center in Marksville). The chapel was originally located in the cemetery adjacent to St. Joseph's Catholic Church.

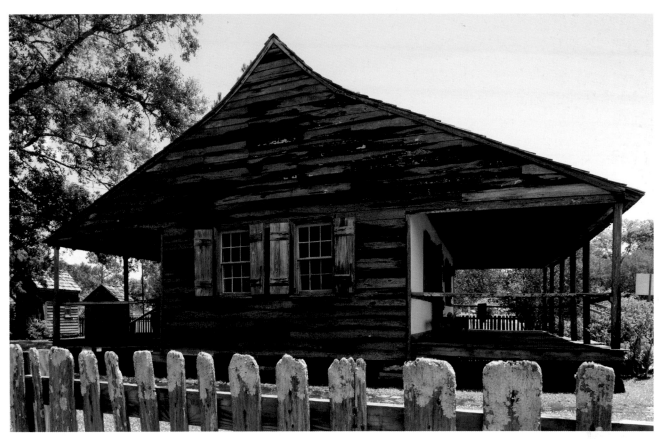

Recent historical research suggests that the Hypolite Bordelon House was probably built by Hypolite's father, Valerie Bordelon, along modern La Hwy 1192 circa 1800. The home remained in the possession of the Bordelon family for several generations. In the late 1970s, Mrs. Virginia McLelland, a Bordelon descendant, donated the house to the town of Marksville, which had the structure moved to its present location.

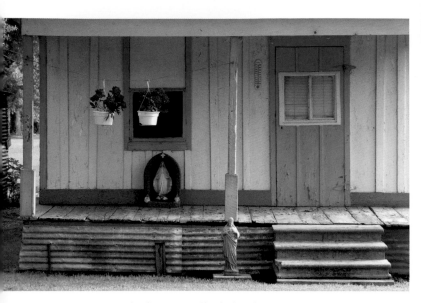

A vernacular home is still inhabited along False River.

Only two Cherie Quarters cabins remain on River Lake Plantation along False River in Pointe Coupée Parish. Built circa 1840, these frame structures were originally slave cabins. The quarters are best known as the birthplace of the acclaimed author and Nobel Prize–nominee Ernest J. Gaines.

This shotgun house shell, located near New Roads in Pointe Coupée Parish, is typical of day-laborer and yeoman-farmer residences of a later era.

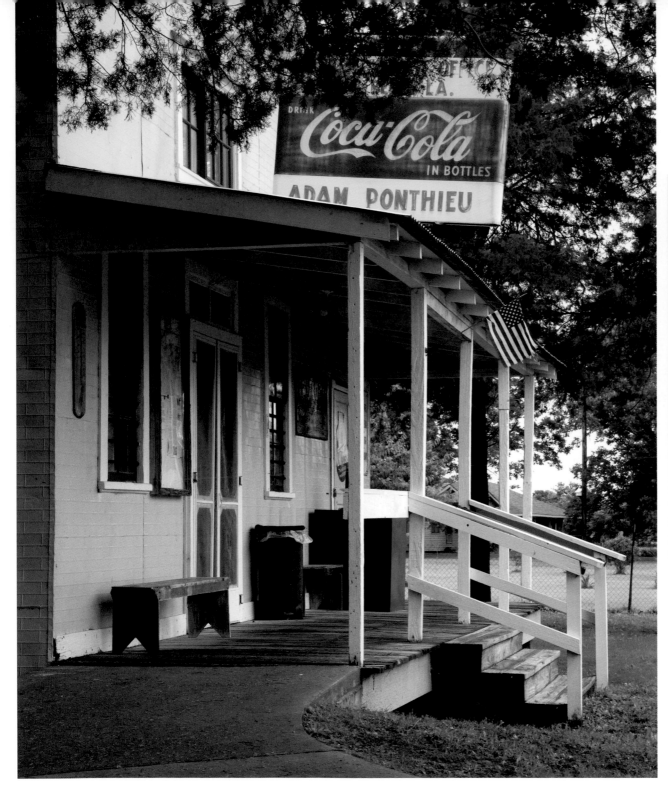

The Adam Ponthieu Store, located at Big Bend in Avoyelles Parish, was a focal point of the local community's economic and social life.

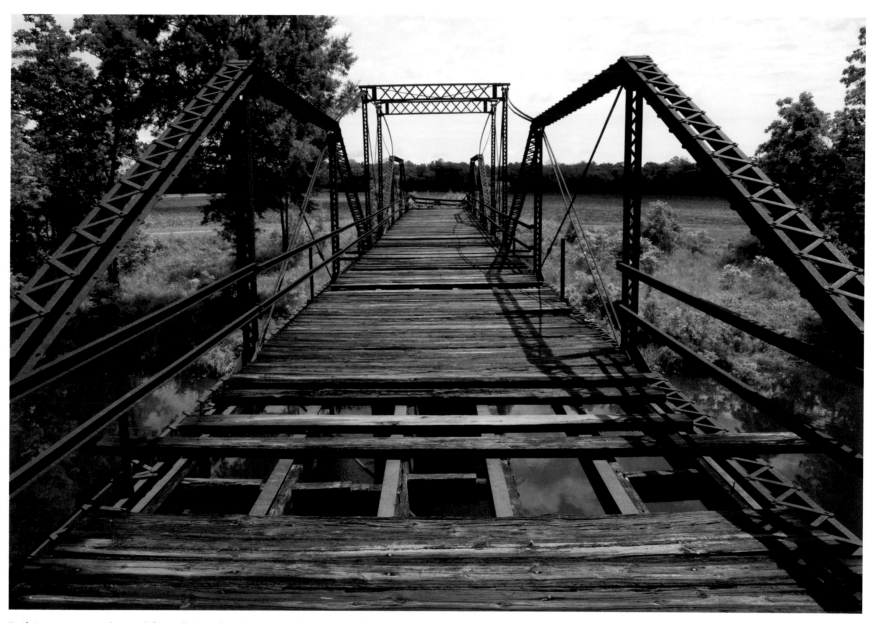

Built in 1916 across the road from the Ponthieu Store site, the Sarto Bridge is a steel
swing truss structure traversing Bayou des Glaises.

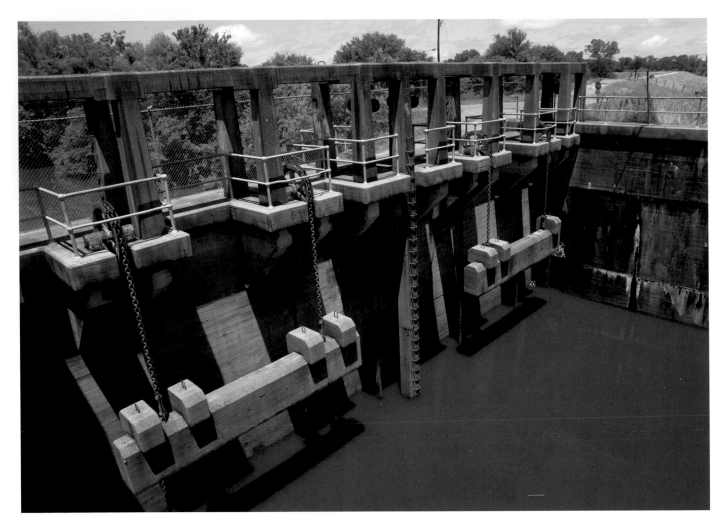

A levee failure along Bayou des Glaises was one of the major factors contributing to the inundation of central Acadiana during the catastrophic 1927 flood. The disastrous deluge prompted Congress to fund a massive flood-control program, resulting in the construction of formidable levees and control structures like the one pictured here in Big Bend. Subsequent flood-control projects included construction of the Morganza Spillway, completed in 1954.

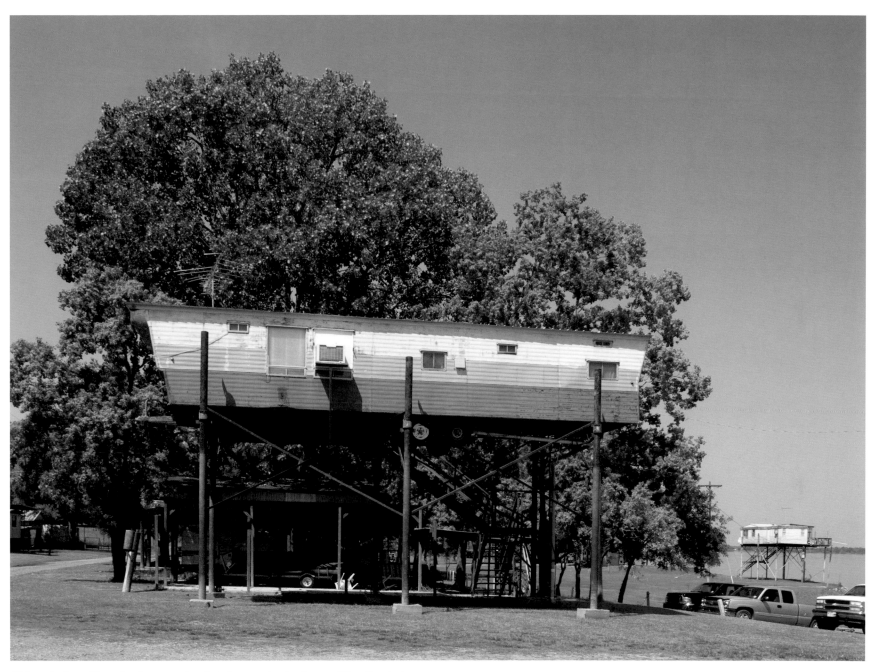

Although the spillway has been used only infrequently, the threat of flooding in low-lying areas persists, as this elevated trailer at Old River indicates.

2 The German and Acadian Coasts

The German and Acadian coasts—extending along the Mississippi River from West Baton Rouge Parish to St. John the Baptist Parish—are among Louisiana's oldest settlements, in part because of historical events that decimated the area's indigenous population, thereby opening the area to European and African immigration. In 1699, the French explorer and future Louisiana governor Pierre Le Moyne d'Iberville encountered a village that the Bayougoula tribe shared with the Mugulasha people. This settlement, reportedly capable of mobilizing 200 to 250 warriors, existed along a small waterway about a quarter-mile from the Mississippi's riverbank near the present Iberville Parish hamlet of Bayou Goula. In the spring of 1700, the Bayougoula virtually exterminated the Mugulasha, perhaps because of their friendly relationship with the Houma, traditional enemies of the Bayougoula. In 1706, the Bayougoula invited the Taensa (Tensas) tribe, which had recently abandoned its traditional home along Lake St. Joseph, to fill the void formerly occupied by the Mugulasha. The Taensa accepted the invitation, but within months of establishing themselves at the village, they followed their hosts' reprehensible example and killed most of the Bayougoula. The Taensa did not long enjoy the spoils of victory; they relocated to the present Mobile, Alabama, area in 1715.

Meanwhile, after a period of wandering, a few dozen Bayougoula survivors eventually settled temporarily along the Mississippi River below present-day New Orleans. By the late 1730s, this tribal fragment had reportedly been absorbed by the Houma, who, like the Bayougoula, had been uprooted by intertribal warfare. After first moving to the banks of Bayou St. John, they migrated to settlement sites near present-day Burnside, where they resided for several decades before relocating to the coastal plain (see chap. 3).

The lack of long-established territorial claims by a militarily powerful tribe made the extremely fertile banks of the Mississippi River above New Orleans attractive to early Louisiana settlers. As in Pointe Coupée Parish, European occupation of the German Coast resulted directly from the colonization efforts of the Company of the Indies, Louisiana's corporate proprietor from 1716 to 1732. Having acquired the colony from the French crown and having made Louisiana the primary collateral undergirding the value of its hyperinflated stocks, the French corporation launched an unprecedented public relations campaign to lure to Louisiana the human and financial capital necessary to develop the backwater colony as rapidly as possible.

The propaganda campaign found a receptive audience in Germany, particularly the Rhineland, where centuries of border warfare had driven the population to despondency. However, the hardships already experienced by the German volunteers for Louisiana colonization were merely the prelude to fresh horrors that awaited them en route to their new homes in the Mississippi Valley. Gathering at the French port of Lorient, the German recruits died by the hundreds while awaiting transportation to Louisiana. Many eventually returned to their homeland out of desperation. Those "fortunate" enough to eventually secure passage to Louisiana soon had ample cause to rue capricious fortune's favor.

Approximately seven hundred Germans—and a few German-speaking Swiss—made their way to French Louisiana in 1721. Most were destined for properties owned by John Law, the chief executive officer of the Company of the Indies, at the Arkansas post and along the Mississippi River. However, Law and the company failed to provide Louisiana's government with adequate logistical support for the anticipated influx of new colonists, and, in June and July of that year, more than half of the immigrants died of starvation, exposure, and illness on the beaches at Biloxi, a principal colonial port of entry.

Not until December 1721 did Louisiana's government mobilize its meager resources to rescue the approximately three hundred German survivors. On December 15, Governor Jean-Baptiste Le Moyne de Bienville commandeered all serviceable flatboats in the lower colony as a means of transferring the Germans to a Company of the Indies tract approximately thirty miles upriver from the newly established village of New Orleans. Charles Frederick D'Arensbourg, a former Swedish officer who had led the German contingent aboard the *Portefaix*, which had landed at Biloxi in early June 1721, was designated commandant of the settlement. Under D'Arensbourg's direction, the relocation operation was conducted successfully in January and February 1722.

The German settlement site, in present-day St. John the Baptist Parish, had originally served as a Native American village site, occupied most recently by Taensa and Ouacha Indians, and, later, as Michel Delaire's Company of the Indies concession. When Delaire abandoned the property, it became available to the immigrants. In occupying these riverfront properties, two important changes occurred. First, Louisiana's proprietary government elevated the status of the immigrants, who had been transported to the colony as indentured

servants (*engagés*), to that of *habitants* (free settlers), perhaps in compensation for their travails. Second, according to the historian Reinhart Kondert, Company of the Indies representatives entered into an agreement with the transplanted Germans to "clear and cultivate their farms in an intensive manner and sell their surpluses to the Company of the Indies at predetermined prices."

The immigrants' new role persisted unaltered until 1732, when the company relinquished its colonial proprietorship, and the Germans became freeholders. However, the colonists' established role as truck farmers supplying New Orleans, now the colonial capital, persisted for decades.

The apparent stability of lower Louisiana's German settlement belied the internal changes that transformed the Teutonic community in the years following their settlement in present St. John the Baptist Parish. The 1722 census indicates that the immigrants, drawing upon their European experience, had established three villages—perhaps with the assistance of eighty company workmen—on the property assigned to them by the company. These villages were evidently named for the birthplaces of many German immigrants. Hoffen stood atop the natural levee along the western bank of the Mississippi River, while Marienthal and Augsburg were established on the natural levee's back slope, a half mile and three-fourths of a mile respectively from the river. D'Arensbourg evidently occupied a separate homestead, variously identified in colonial cartography and documentation as Karlstein or Charlesbourg. This settlement pattern quickly proved impractical because of local topography. In September 1722, a hurricane devastated New Orleans and the embryonic German settlement. The storm's tidal surge caused water levels to rise in the lake—now known as Lac des Allemands in the pioneers' honor—and swamps directly behind the villages. Marienthal and Augsburg, located on the back slope—and thus situated at a significantly lower elevation than their waterfront neighbor—were literally washed away, as were the immigrants' reportedly promising crops.

This experience profoundly affected the area's future development. By mid-November 1724, the Germans had dispersed, occupying farmsteads fronting the Mississippi River on the higher adjacent natural levee. Once surveyed, these properties would assume the Norman long-lot configuration that became the colonial standard. Although the movement benefited the settlers by providing them with marginally better protection against inundations, it required the settlers to face the backbreaking rigors of land clearing. It is thus hardly surprising that the Germans experienced a hand-to-mouth existence for at least three years before the settlement witnessed significant economic growth.

This economic growth evidently resulted directly from the pioneers' acquisition of a slave labor force. According to Kondert, the settlement's sixty-eight farmsteads owned 120 bondsmen in 1731, and the local slave population would increase incrementally over the coming decades as the region assumed a trajectory leading to plantation development. This developmental path inadvertently produced several significant results. First, the settlement's increasing prosperity and ready availability of prime farmland gradually attracted French-speaking settlers to the area, and the resulting intermarriage between the two groups engendered extensive cross-cultural pollination and the rapid linguistic assimilation of Louisiana's Teutonic minority by the Gallic majority. Gallicized Germans frequently changed their names—or had them altered by French-speaking scribes and priests—to conform to French linguistic or phonetic conventions. Examples of this Creolization process abound: Dubs became Toups, Buerckel became Percle, Steiger became Echetaire, Zweig became LaBranche, Achtziger became Quatrevingt, Hoffman de Bade became Badeau, Himmel became Hymel, Heidel became Haydel, Wichner became Vicnaire, Foltz became Folse, Trischl became Triche, and Wagensbach became Waguespack.

Second, natural population growth and continued immigration into the area—now known as the Côte des Allemands (German Coast)—resulted in the occupation of additional riverfront lands on both banks, and the district's upper boundary migrated progressively upstream. By the 1750s, the German Coast had expanded territorially and demographically to such an extent as to warrant establishment of a new church parish to complement St. Charles Borromeo Catholic Church, which had been erected in 1722 near present-day Destrehan to serve the German immigrants. The new ecclesiastical parish—St. John the Baptist—and the strong demographic growth it represented constituted a double-edged sword. Increased population pressure caused a corresponding increase in local land values. This problem was compounded by the effects of forced heirship, which dictated the equitable distribution of real estate among surviving heirs in probate proceedings, rapidly reduced French long lots—and consequently farmsteads—into long ribbons of land too narrow to cultivate. The resulting pressures were alleviated by the ready availability of unclaimed lands upstream, but this safety valve disappeared with the onset of the Acadian influx in 1764.

Expelled by the British from their Maritime Canadian homeland in 1755 in a massive ethnic cleansing exercise, thousands of Acadian exiles generally were held captive in the Eastern Seaboard colonies or deported to Europe for the duration of the French and Indian War. A small contingent of resistance fighters and their families who surrendered to British military forces only in 1758 were held in prisons and concentration camps until 1763, when the Treaty of Paris provided the Acadians with an eighteen-month grace period in which to relocate. Over the following decades, the surviving Acadians

migrated throughout the northern Atlantic rim in search of a new home. The largest assemblage of survivors—approximately three thousand—made their way to lower Louisiana in successive waves of immigration within two-and-a-half decades of the treaty's ratification.

The influx began in April 1764, when a group of twenty Acadian exiles from New York arrived at New Orleans, Louisiana's colonial capital, where they fortuitously encountered acting governor Charles Philippe Aubry, who had met Acadian detainees when he had been a British prisoner of war in New York. Moved with pity for the exiles, Aubry, working in cooperation with other high-ranking government officials, arranged to have the displaced Canadians settled on the upper fringe of the Second German Coast, along the present boundary between St. John the Baptist and St. James parishes.

Louisiana's first known Acadian immigrants were followed by members of the Acadian resistance movement, who reached the colony in February 1765 via Halifax and Saint-Domingue (present-day Haiti). This group, whose numbers were swelled by the arrival of other Acadian immigrants at New Orleans in the spring of 1765, was dispatched to the Bayou Teche region in the Attakapas District, where they evidently disembarked in May. Over the course of the summer, an epidemic decimated the Attakapas Acadian encampments, forcing the surviving exiles to disperse. One group of Acadians migrated across the Atchafalaya basin, arriving in present St. James Parish in mid-September 1765. The arrival of this Acadian subgroup provided the impetus for the establishment of a governmental and, later, an ecclesiastical infrastructure in the area, which would quickly come to be known as the Acadian Coast.

The Acadian Coast developed quickly in the 1760s as additional waves of Acadian immigrants found their way to Louisiana. This phase of Acadian Coast settlement, however, was not voluntary. The Treaty of Paris (1763) had partitioned Louisiana between Britain, which received the trans-Appalachian region, and Spain, which acquired Louisiana west of the Mississippi and the Isle of Orleans. Louisiana's first Spanish governor, Antonio de Ulloa, who arrived at New Orleans only in early March 1766, immediately confronted the dilemma of defending Louisiana's vulnerable and porous eastern boundary—the Mississippi River from its source to its mouth—from possible British incursions with substantially fewer than one hundred soldiers. Ulloa consequently felt compelled to oblige the Acadian immigrants reaching Louisiana after 1765 to settle strategic riverfront sites he personally selected. As a result, exiles were settled in present-day Ascension Parish in 1766, Iberville Parish in 1767, and Concordia Parish (just below modern-day Vidalia) in 1768.

Spanish officials enforced this involuntary settlement policy by threatening recalcitrant immigrants with arrest, incarceration, and subsequent deportation. The Acadians, on the other hand, viewed such heavy-handed enforcement as a second forced dispersal. Increasingly disgruntled, they joined with other equally disaffected south Louisianians, including German Coast settlers and New Orleanians, to drive Ulloa from the colony in one of America's first political revolts against European political authority. Spain sent an army to restore Spanish rule in the sprawling colony in late August 1769, but the new Spanish governor and his successors were conciliatory toward the Acadians, and, as a result, the Acadian Coast gained considerable additional population. The Acadians in present Concordia Parish were permitted to migrate to the Coast to join established relatives there, and, when approximately 1,600 Acadians from France migrated to the colony in 1785, many chose to settle along the Mississippi River, usually between existing settlements or, more frequently, above the previous lines of settlement. As a result of these late eigh-

teenth-century influxes, the Acadian Coast settlements extended from present West Baton Rouge Parish to St. James Parish by the turn of the nineteenth century.

Although exiles predominated in the Acadian Coast, they were not the region's exclusive settlers. Numerous German and Irish families—including the Kleinpeters, Orys, and Conways—migrated to the area in the late eighteenth century. This continuing immigration, coupled with natural population growth and the local impact of forced heirship, engendered an exodus of young persons who found local land increasingly scarce and unaffordable. Acadian Coast emigrants, who were joined by German Coast settlers displaced by the same causes, generally sought cheaper lands and greater opportunities along Bayou Lafourche. Those who remained were compelled to adapt to a changing economic landscape. When farmsteads were reduced to impracticably narrow ribbons of land, entrepreneurs with means—both locals and, increasingly after America's acquisition of Louisiana in 1803, affluent immigrants from the tidewater regions of the Old South—acquired and consolidated adjacent properties into large plantations. By 1810, a majority of the remaining settlers in the Acadian Coast owned slaves, and, after the successful introduction of sugar cultivation into the area in the early nineteenth century, both plantation income and slave ownership increased exponentially. By 1860, the "coasts" collectively constituted one of the nation's most affluent regions.

Local wealth was concentrated increasingly in the hands of a few. According to the 1860 census, for example, sugar planters (persons owning at least ten thousand dollars in real estate and twenty slaves) possessed 80 percent of all wealth in Iberville Parish, and 91 percent in neighboring Ascension Parish. Total planter wealth was equally great in the German Coast, where St. John the Baptist and St. Charles parishes boasted respectively twenty-three and thirty-one plantations with at least fifty slaves.

This unprecedented affluence was reflected in the region's home and funerary architecture. The established Acadian and Creole families on the "coasts" erected impressive plantation homes, perhaps the most famous of which were Valcour Aime's fabled Petit Versailles and Pierre Auguste Samuel Fagot's Uncle Sam. The grandest houses, however, were built by the Anglo-American newcomers, particularly Virginians, who flourished in their new surroundings. Belle Grove, a seventy-five-room residence built by John Andrews, and Nottoway, the South's largest surviving plantation house, built by John Hampden Randolph, are perhaps the best examples of these virtual palaces.

The affluence of the occupants of these palatial homes came at a terrible cost in human misery, for there was a direct correlation between income and the size of a plantation's slave labor force. In 1860, the Ascension Parish planter Duncan Farrar Kenner alone owned 473 slave "hands," and he was only the eleventh-largest slaveholder in Louisiana. Expansion of slaveholdings brought with it an accumulation of debt and the continuous need to increase productivity to extinguish those financial obligations. It is thus hardly surprising that in 1811 this plantation belt engendered the nation's largest slave revolt. As in Pointe Coupée Parish, the insurrection was fomented by an immigrant agent of revolution, Charles, a slave reportedly from Saint-Domingue. Charles, at the time owned by Veuve Jean-Baptiste Deslondes and rented by Col. Manuel Andry, began coordinating a slave insurrection on the Andry plantation near present-day Norco sometime before the evening of January 8, 1811, when slave insurgents attacked Colonel Andry and his son, killing the latter and wounding the former. The rebels then joined other slaves and an undetermined number of fugitive slaves (maroons) at a predetermined rendezvous site. Marching along the river road toward New Orleans, Charles's band grew into a small army estimated by eyewitnesses as numbering between 150 and 500 men. After killing another white planter and putting much of the local white population to flight, the insurgents occupied and looted the Jacques Fortier plantation some five leagues (approximately 12.5 miles) closer to Louisiana's capital the following day. Meanwhile, Colonel Andry had mobilized the local militia company, and he led eighty militiamen into battle against the insurgents—evidently on the morning of January 10. The insurrectionaries, armed according to the historian James H. Dormon "with cane knives, axes, hoes, and other tools, and a few small arms," were no match for the militiamen, who routed the rebels and pursued them into the nearby cypress swamps. When United States Army units dispatched to the German Coast from New Orleans and Baton Rouge to suppress the uprising by military force arrived on January 11, the insurgents "had [already] been decimated": military sources list sixty-one dead slaves, seventeen slaves missing in action, and sixteen alleged insurgents detained for trial.

During the ensuing trial at Destrehan Plantation, twenty-one persons were accused and convicted of insurrection. They were summarily shot by a firing squad and decapitated, and their heads were placed on spikes "as a terrible example to all who would disturb the public tranquility in the future."

As in the Pointe Coupée region, the bloody suppression of the slave insurrection helped preserve the "peculiar institution" locally until the Civil War era, and slavery remained the engine driving the robust local sugar economy throughout the antebellum era. But slavery's days were numbered, and the institution's demise during the Civil War era brought the dynamic regional economy to its knees, despite the fact that the "coasts" were spared much of the destruction that ravaged neighboring plantation areas to the south and southwest.

The Acadian and German coasts were shielded from the worst effects of the war by their strategic location along the river, which made them prime Union targets during the early months of the conflict. Following the Union occupation of New Orleans and, later, Baton Rouge in the spring of 1862, the civil parishes of the Acadian and German coasts fell under Union military control. In the fall of 1862, Union forces invaded the area while en route to the Bayou Lafourche region, and, before July 1863, Federal naval units regularly patrolled the river below the Confederate bastion at Port Hudson. And, finally, in the winter of 1862–63, Union forces established Fort Butler, a military base near Donaldsonville, to preserve Federal control over the strategic confluence of the Mississippi River and Bayou Lafourche.

Because the Confederate government had dispatched thirty-five thousand Louisiana volunteers to the eastern military theater in the early months of the conflict, the Pelican State's Rebel commanders lacked the human resources to challenge effectively the continuing Union military dominance in the region. They were consequently forced to content themselves—with one notable exception—with sniping against Federal shipping, which resulted in the Union naval bombardment and the fiery destruction of Donaldsonville, guerrilla warfare, and the operation of assassination squads targeting local collaborators with the forces of military occupation. The most noteworthy exception to the monotony of this nasty *petit guerre* was the confrontation of Union and Rebel forces at Fort Butler on June 28, 1863—one of the first Civil War battles in which African Americans played a prominent role. Fort Butler, a star-shaped earthen fortification surrounded by a moat and armed with six siege guns, was constructed by Union soldiers during the winter of 1862–63. In June 1863, during a short-lived and ill-starred Confederate offensive into the area, one thousand Texans under Gen. Thomas Green assaulted the fort, then occupied by several companies of the Twenty-eighth Maine Infantry Regiment and members of the First Louisiana Volunteers (Colored), who were convalescing from wounds received during the siege of Port Hudson. Despite their great numerical advantage, the Confederates were soundly trounced—defeated by the garrison's stout resistance, the timely assistance of the Union gunboat *Princess Royal,* and the bravery of the installation's defenders.

The sporadic fighting that punctuated the Civil War years came to an end with the surrender of Confederate forces in the Trans-Mississippi theater in May 1865. With the war's conclusion, the region's social, cultural, economic, and political landscapes changed radically. Real estate values plunged 90, 70, 63, and 86 percent respectively in Ascension, Iberville, St. James, and West Baton Rouge parishes between 1860 and 1870, and the social and political changes then concurrently transforming the region were equally stark.

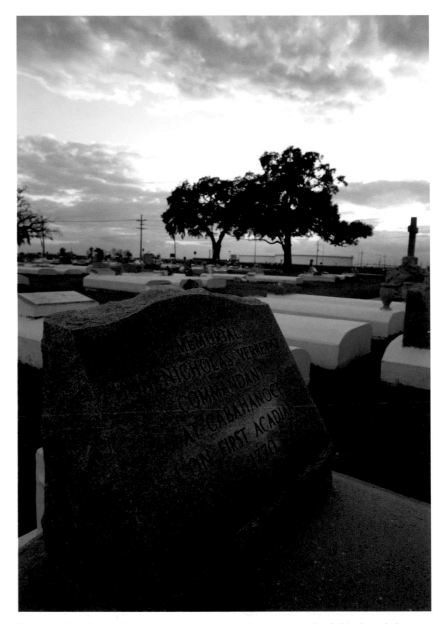

By 1770, Acadian settlements along the Mississippi River had developed distinct geographic and political identities. The earliest riverine settlements in present-day St. James and Ascension parishes became known as the First Acadian Coast, while the Acadian parishes upstream (Iberville and, eventually, West Baton Rouge) became identified as the Second Acadian Coast. *Above:* A memorial grave marker honoring Nicolas Verret (1725–1775), who served as commandant of the Cabahanocé post (present St. James Parish) on the First Acadian Coast from 1770 until his death.

The Mississippi River, as seen near Plaquemine, provided vital transport for residents on the Second Acadian Coast.

The imprint of the past remains quite recognizable on Acadiana's modern landscapes
as witnessed by the ruins of a nineteenth-century Acadian-style yeoman's house.

The outlines of colonial land grants are
easily recognizable in properties border-
ing the Mississippi River.

St. Gabriel Catholic Church contains the skeletal frame of the settlement's original house of worship, erected by Acadian exiles in the early 1770s.

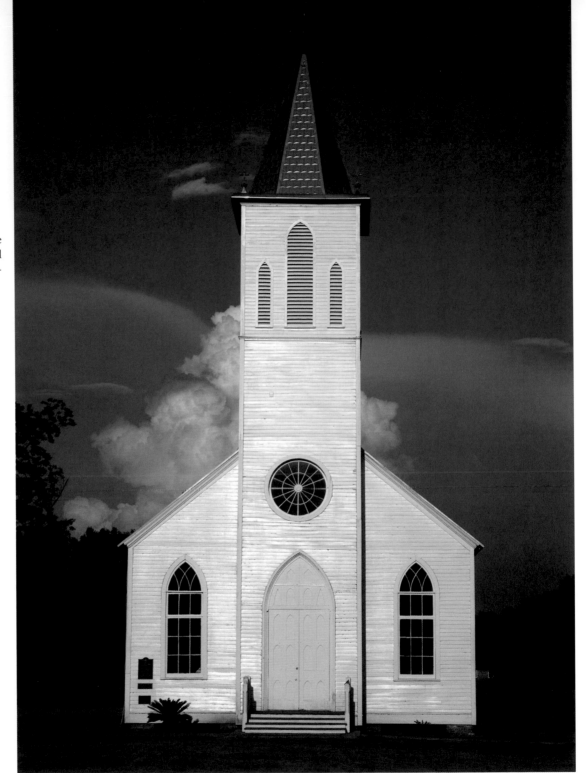

Plaquemine was once a bustling steamboat port situated at the principal eastern access point to the Attakapas and Opelousas districts. The Middleton House, pictured above, was built at the corners of Eden and Plaquemine streets between 1835 and 1845—just as the town began to realize the full benefits of its strategic location. St. John the Evangelist Catholic Church, seen in the background, was built in 1927.

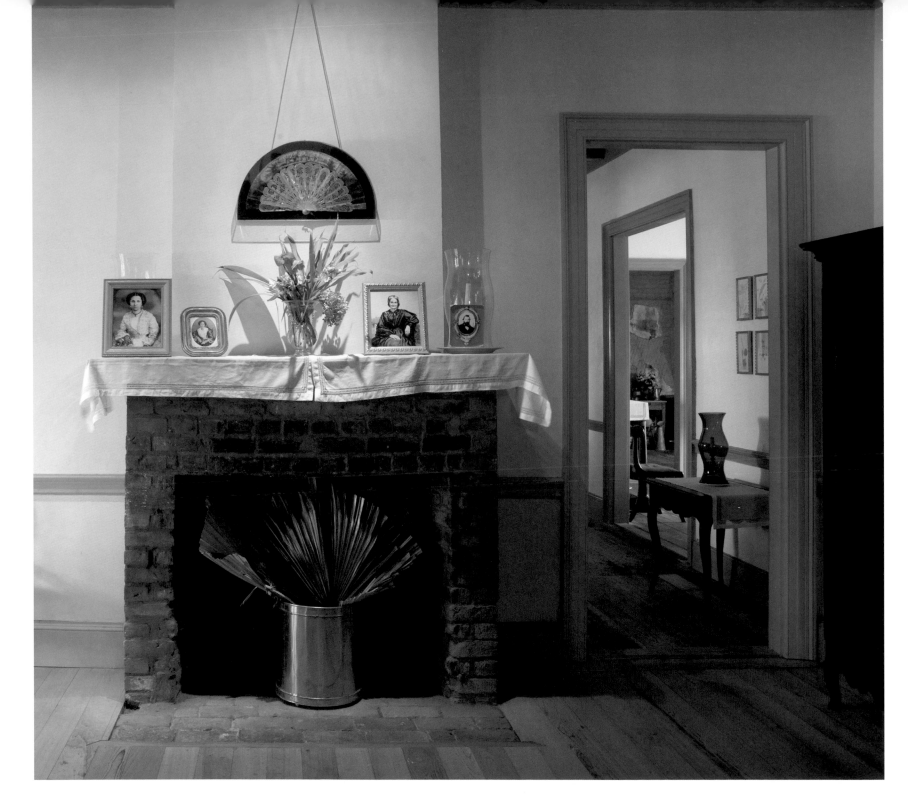

Located in St. James Parish just above the town of Vacherie, Laura Plantation boasts one of Louisiana's most complete extant historical Creole plantation complexes. The plantation is now a major heritage tourism site.

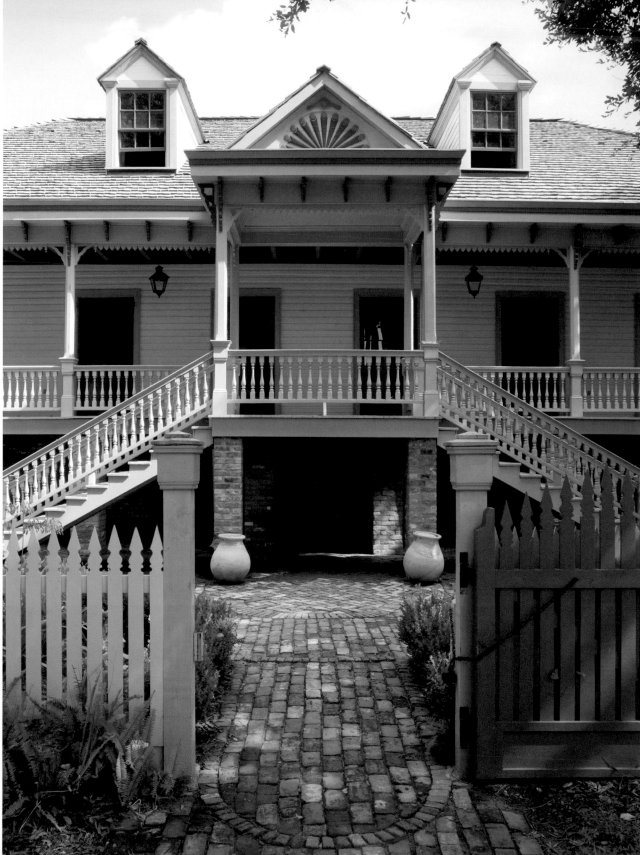

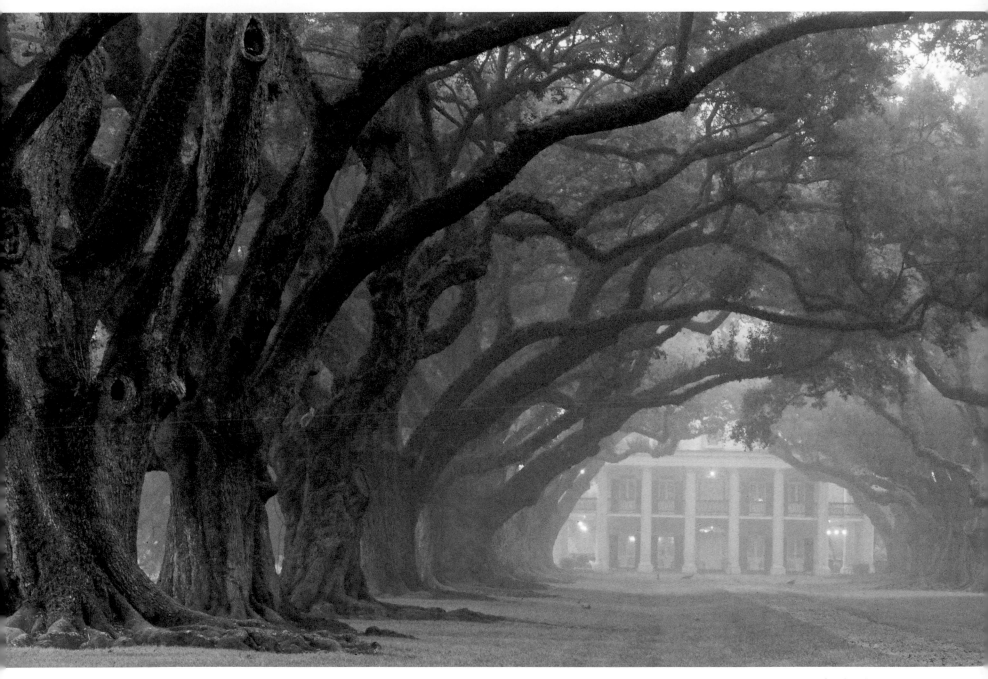

Oak Alley Plantation was built in 1837–39 by George Swainey for the planter Jacques Télésphore Roman. The site's signature oak alleyway, approximately 800 feet long, consists of trees planted before the current home was constructed.

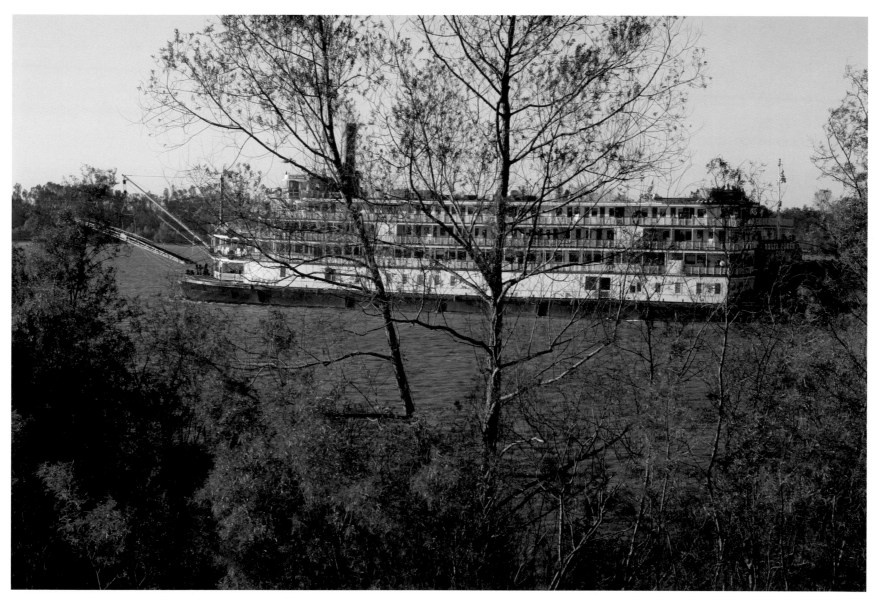

As Roman's plantation home rose from its foundation, steamboats much like the *Delta Queen* were bringing a transportation revolution—and unprecedented economic growth—to the region.

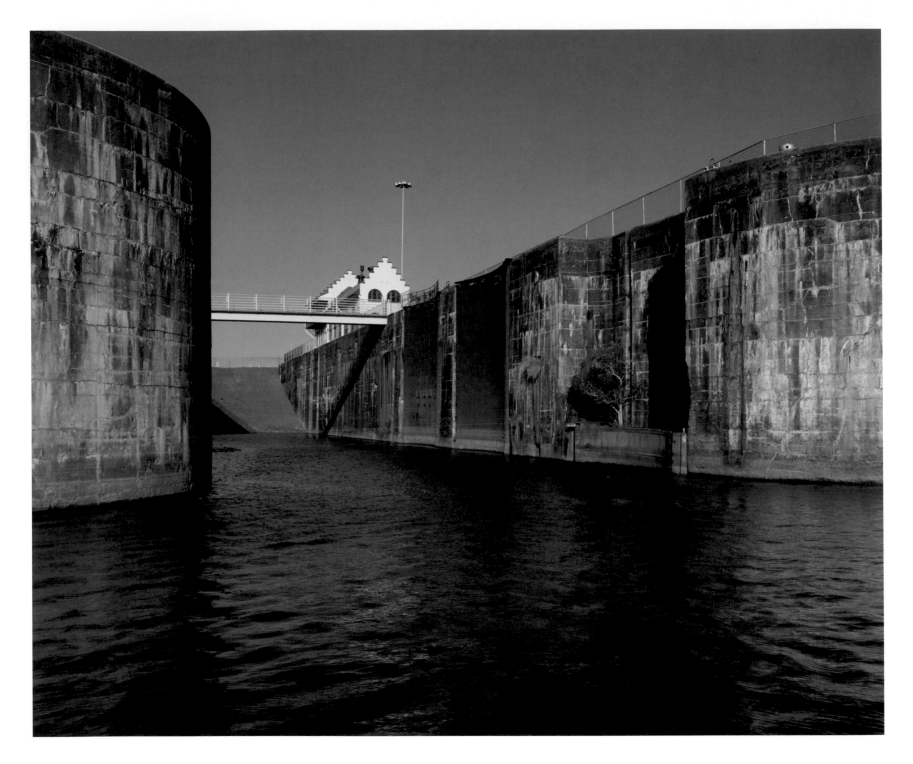

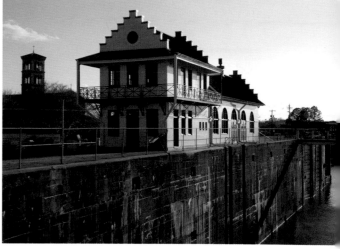

From the mid-eighteenth century until the Civil War, Bayou Plaquemine was the principal gateway to western Acadiana. Because of its importance to the regional economy, the notoriously treacherous bayou was the frequent object of public works improvements projects. The bayou nevertheless remained dangerous and only seasonally navigable. The ultimate solution was the massive Plaquemine Locks, constructed between 1895 and 1909.

3 The Lafourche-Terrebonne Area

As in the neighboring regions along the Mississippi and Atchafalaya rivers, the local environment profoundly influenced the early historic settlement of the Lafourche-Terrebonne area. Because human habitation has historically been confined primarily to the banks of the region's major waterways, Bayou Lafourche has played a prominent role in framing south Louisiana's history; yet, despite its geographical significance, the Lafourche basin and the neighboring Terrebonne region were sparsely settled by indigenous peoples and occupied relatively late by Euro-Americans.

Sustained regional contacts between Native Americans and Europeans, which resulted in the decline of the former and the ascendancy of the latter, began in 1699 with the founding of Louisiana. At the dawn of the eighteenth century, three American groups occupied the banks of Bayou Lafourche. The Yagenechitos, an obscure people who may have been related culturally to the Chitimacha, occupied a village site near the junction of the Mississippi River and Bayou Lafourche. The Washa tribe lived near present-day Labadieville, and the Chawasha nation lived farther downstream. Owing to the lack of a direct interrelationship between the French explorers and the local indigenous population, our knowledge about these first peoples is based largely on hearsay. The anthropologists Fred Kniffen, Hiram F. Gregory, and George A. Stokes maintain that the Washa, the Chawasha, and the Okelousas, a small tribe residing in present-day central Louisiana with whom the "people of the fork [Lafourche]" forged a short-lived military alliance, collectively numbered approximately seven hundred individuals.

By 1731, warfare, disease, and the migration of the Washa and Chawasha tribes to the Mississippi River's banks had reduced the established tribes to a mere handful, leaving the area open to immigration and settlement. The first immigrants were members of the Houma tribe, which intertribal warfare in 1706 had displaced from their original home in present West Feliciana Parish. After briefly relocating to the banks of Bayou St. John, in present-day New Orleans, the Houma migrated to a village site near what is now Donaldsonville. Over time, the tribal organization would fragment, and tribal bands would occupy lands in modern Ascension Parish near present-day Burnside, on the east bank of Mississippi River, and along upper Bayou Lafourche.

The Houma remained largely undisturbed in their new home until the late 1760s and 1770s, when the upper Lafourche became a gateway for migrating Louisiana colonists and a sanctuary for immigrant refugees, particularly the Acadian exiles for whom the Lafourche Valley became a new homeland. The first Acadians to settle along the bayou had been forcibly established on the First Acadian Coast (St. James and Ascension parishes) in 1766 by Antonio de Ulloa, Louisiana's first Spanish governor, as discussed in chapter 2. Ulloa's arbitrary and unpopular settlement policies resulted in the Acadian participation in a popular uprising that drove the Spaniard from the colony in late October 1768.

During the interim between Ulloa's unceremonious departure and the restoration of Spanish colonial rule in August 1769, numerous Acadian families—at least seventeen—migrated into the upper Lafourche Valley, between the modern communities of Donaldsonville and Labadieville. Establishing themselves on the west bank, which, unlike its eastern counterpart, was not subject to frequent inundations, the Lafourche Valley's Acadian pioneers quickly began carving new lives for themselves from the old-growth forests lining the bayou.

These pioneers were soon joined by some of their Acadian Coast neighbors who also disliked Spanish interference in their daily lives. Many other new immigrants wished to establish their numerous progeny on lands adjacent to their own—an option generally unavailable in the increasingly congested Acadian Coast settlements.

German Coast settlers followed their Acadian neighbors into the upper Lafourche region. Like their predecessors, the Creoles and Gallicized Germans residing in the now well established European riverfront settlements above New Orleans were attracted by the frontier area's abundant vacant lands. These immigrants came into contact with other recent migrants, particularly members of the Houma tribe, which, in the early to mid-1700s was becoming ever more fragmented. In the late 1770s, the region's polyglot population became increasingly diverse as Louisiana's Spanish government introduced hundreds of Canary Island (Isleño) immigrants intended to Hispanicize the colony's overwhelmingly Gallic population. Contingents of the Spanish-speaking immigrants were assigned to different lower Louisiana locations. In the Bayou Lafourche region, most of the Isleños were settled at Valenzuela, a bayouside district with its center at present-day Plattenville, established in the spring of 1779. In 1782, the Valenzuela District included fifty-three Isleños.

Below Valenzuela settled a new wave of Acadian exiles who reached Louisiana in 1785 courtesy of Spanish-subsidized transportation to the Mississippi Valley. These Acadians had resided in France—often as homeless persons— for most of the period following the Grand Dérangement of 1755. The colonial government permitted the 1,598 immigrants to select their own homesites, and 600 refugees (37.5 percent) established themselves along Bayou Lafourche, between modern-day Labadieville and Lafourche Crossing. An additional 277 Acadians who had originally settled along Bayou des Ecores (present-day Thompson's Creek above Baton Rouge) joined their friends and relatives along the central Lafourche after a powerful hurricane washed away their farms in August 1794. The 1785 immigrants helped the Acadian community maintain its position as the dominant cultural group in the Lafourche Valley. In 1788, for example, the exiles constituted 61 percent of the Lafourche District's total population.

The dominant Acadian demographic and cultural position was briefly reinforced by the departure of the Houma people for the lower Lafourche and, later, the Terrebonne region following the local smallpox epidemic of 1788, but the local demographic void created by the departing Houma tribesmen was quickly filled by African bondsmen. On December 3, 1775, Louis Judice, who served as commandant of the Lafourche des Chetimachas (now Chitimachas) District for more than two decades, informed Louisiana's Spanish governor that the portion of Ascension Parish along the upper Lafourche was home to forty-four African slaves. The African population along the upper Lafourche grew rapidly over the following decades, and, by 1797 black slaves had come to constitute approximately 15 percent of the total population in the Lafourche de Chetimachas post, which then included present Assumption, Lafourche, and Terrebonne parishes. By 1860, the regional slave population had mushroomed to 21,276 (51 percent of the total populace).

The introduction of African slavery into the Lafourche Valley caused several fundamental changes in local society, not the least of which was the establishment of perennial racial tensions, evidenced by the institution of slave patrols in the wake of an abortive local slave uprising in 1785. In addition, farmers burdened with heavy financial obligations resulting from slave purchases, which were almost universally made on credit, were forced to abandon the traditional practice of subsistence farming for extensive staple-crop production in order to meet their loan payment schedules. Lafourche-area slave owners initially produced cotton for export to New Orleans, but, after the War of 1812, sugar cultivation slowly supplanted cotton farming on slaveholding estates. Between 1829 and 1850, the number of Acadian sugar producers in Assumption and Lafourche parishes increased 300 percent, and by the eve of the Civil War, sugar was easily the region's dominant staple crop. This

is seen most clearly in the region's exports. For example, in 1860, steamboats plying Bayou Lafourche transported to New Orleans 41,785 hogsheads of sugar and 71,681 barrels of molasses, as opposed to only 1,192 bales of cotton.

The economic prosperity engendered by the highly labor-intensive sugar industry attracted Anglo-American entrepreneurs from the southeastern states. Perhaps the most notable of these Anglo immigrants were W. W. Pugh, the owner of Madewood Plantation; William J. Minor, the builder of Southdown plantation house; the future Confederate militia general R. C. Martin; and the future Confederate generals Braxton Bragg and Leonidas Polk.

The Anglo-American influx peaked as the local sugar economy matured during the antebellum era. Like the Acadian and Creole planters before them, the Anglo immigrants acquired and consolidated small landholdings into sprawling plantations. Plantation development was most pronounced along the upper and central Lafourche, where the soil was sufficiently fertile, and the natural levee was sufficiently broad, to sustain plantation development. The 1860 census indicates that 37 percent of the free families owned slaves in Assumption Parish, with 31 percent owning slaves in neighboring Lafourche Parish. Plantation culture also developed in the prime water bottoms of Terrebonne Parish. In 1860, 27 percent of all free persons there owned slaves.

Non-slaveholding families in the plantation region frequently developed a symbiotic economic relationship with the burgeoning local plantation system. Most of the Acadians, who came to be known as Cajuns over the course of the nineteenth century, maintained their status as yeoman farmers, but, during the antebellum era, an increasing number either became artisans catering to local plantations or seasonal day laborers working in the sugar fields, particularly during the grinding season, cutting cane for $1.25 a day.

Day laborers were much more common in Terrebonne Parish, where the Acadian standard of living was far lower than in the upper Lafourche region, largely as a result of local topography that militated against the development of large commercial farms. On the eve of the Civil War, fully 51 percent of all Terrebonne Cajuns owned no real estate whatsoever. Most of these landless individuals worked as manual workers, possibly to acquire funds for land purchases, or, more likely, to satisfy residential and land rental charges.

The plight of the Terrebonne Cajuns reflects a pervasive socioeconomic trend in the antebellum Lafourche-Terrebonne region. The emergence of a plantation system along the upper Lafourche and along the major waterways of northern Terrebonne Parish resulted in the rapid escalation of property values, and the migration of poor whites from the highly desirable natural levees to significantly less desirable settlement sites. Some of the migrants occupied ridges on the eastern periphery of the Atchafalaya basin or in the Chackbay swamp between the Lafourche and the Mississippi. Others migrated to the

lower reaches of Bayou Lafourche, to the banks of Terrebonne Parish's minor waterways, or, far less frequently, to southwestern Louisiana's prairie region. These migratory patterns persisted over the course of the nineteenth century as persons displaced by forced heirship or poverty were compelled to seek ever more marginal homesites in the wetlands or the notoriously inundation-prone Lafourche-Terrebonne coastal zone.

These early nineteenth-century migrations profoundly altered the entire region's economic development and demographic landscape, creating in the process a sociocultural paradigm that persists to the present. Locals routinely identify the roadway along Bayou Lafourche as "the longest main street in the world" with more than a little justification. From the nineteenth century to the present, a practically unbroken line of settlement has extended from Donaldsonville to Golden Meadow, and a journey from the stream's source to its mouth along the "world's longest main street" has traditionally exposed a cross-section of the area's economic hierarchy—represented at the polar extremes by opulent antebellum plantation homes to the north and by crude trappers' cabins to the south. (The drive from Houma to Dulac reveals a similar pattern.) As the cultural geographer Don Davis has observed: "Settlement succession is a gradation from sugarcane plantations, to linear villages, to 'nearly' isolated fishing and trapping communities that [respectively] represented a strict hierarchy of social classes. This pattern is also evident along the five bayous south of Houma—Bayous Dularge, Grand Caillou, Little Caillou, Terrebonne, and Pointe aux Chien."

These socioeconomic circumstances profoundly influenced the course of the Civil War in the Assumption-Lafourche-Terrebonne region. Because the Louisiana sugar industry was heavily dependent upon national sugar tariffs for survival, the local political power structure, dominated by sugar planters,

THE SHRIMP INDUSTRY

Shrimp historically has been Louisiana's most important commercial seafood product. The Pelican State's shrimp industry dates from the mid-1870s, when New Orleans entrepreneurs perfected the process of canning shrimp for commercial distribution. By 1880, Louisiana processors were distributing more than seven hundred thousand cans of shrimp per year. A half century later, the focus of shrimp harvesting and processing had shifted to Acadiana's coastal parishes. The industry reached its apex in the late twentieth century, when refrigeration and improved transportation opened the local industry to international markets. In recent years, however, Acadiana shrimpers have fallen upon hard times as a result of habitat degradation, fluctuating market prices, increased international competition, and rapidly escalating operating costs (particularly fuel).

initially opposed secession. In fact, in the 1860 national election, the Assumption and Lafourche parish electorates gave pluralities to Stephen A. Douglas, the northern Democratic candidate for the presidency. In neighboring Terrebonne, southern Democratic candidate John C. Breckinridge earned a one-vote victory over Constitutional Unionist candidate John Bell, who promoted national unity. Even in the ensuing secession convention, the nine-member Lafourche-area delegation unanimously supported cooperation—the cooperative secession of all the southern states only if a negotiated settlement with the North failed.

The local opposition to the war failed to avert the state's secession juggernaut, and Louisiana became part of the Confederate States of America in 1861, shortly before the Confederate bombardment of Fort Sumter sparked the American Civil War. At the outset of the war, the scions of planter families rushed to volunteer for Confederate military service, and their companies were later consolidated into the Twenty-sixth Louisiana Infantry Regiment. Following the Confederate defeats at Forts Henry and Donelson (February 1862), most of the regular troops in lower Louisiana were rushed northward to bolster the Rebel defenses in the Upper South. This left the Pelican State's lower tier of parishes exposed to invasion by Union forces poised off the Gulf coast. The Lafourche-Terrebonne area was particularly vulnerable, being defended by only small contingents of raw troops manning two insubstantial earthworks: Forts Guion and Quitman, located respectively near the mouths of Bayous Lafourche and Grand Caillou. But the defenders abandoned even these remote outposts following the Union occupation of New Orleans on May 1, 1862.

The region subsequently had no effective impediment to Union incursions, and the weak Rebel position was exacerbated by the fact that the local white population, particularly the French-speaking population at the lower end of the socioeconomic spectrum, was generally unsympathetic to the Confederate cause. Local poor whites consequently resisted efforts to conscript them into Confederate service and to participate in local home guard units, organized in the early days of the war as a last line of local defense. Confederate sympathizers, who privately feared Union reprisals and who secretly lobbied against resistance, were thus unable to mount any effective opposition to Union incursions into the region in 1862.

Union forces first ventured into the Assumption-Lafourche-Terrebonne region by means of the New Orleans, Opelousas, and Great Western Railroad, an 80-mile-long railway extending from Algiers to Brashear City (present-day Morgan City), with depots at Boutté Station, Bayou des Allemands, Raceland, Lafourche Crossing, Terrebonne (now Schriever), and Tigerville (now Gibson). In early May 1862, a Union contingent under the command of Col. James W.

McMillan traveled the length of the railway on a reconnaissance mission. The Northern troops soon returned and disembarked at Terrebonne before proceeding to Bayou Grand Caillou to capture the Confederate blockade runner *Fox*. The Union raid resulted in an unsuccessful effort to mobilize the Rebel militia, the partisan bushwhacking of a small Union party near Houma, and the subsequent taking of Confederate hostages by Union troops as they withdrew from Terrebonne Parish.

Over the next several months, the Lafourche-Terrebonne region was a de facto no-man's-land. A Confederate local government maintained nominal control, but the opposing armies were concentrated in the New Orleans area to the east and the Bayou Teche region to the west. Union forces made frequent incursions into the area, and despite the occasional dispatch of regular and partisan forces to the Lafourche-Terrebonne region, the Rebels were largely powerless to prevent them.

The military contest over the Lafourche-Terrebonne region began in earnest in the fall of 1862, when Gen. Benjamin F. Butler, commander of Union forces in Louisiana, mounted a three-pronged offensive. An army under Gen. Godfrey Weitzel was dispatched to Donaldsonville to lure Confederate forces from the Teche area to the upper Lafourche region's defense. Meanwhile, another land force traveled the rail line from Algiers to the central Lafourche region to drive the Rebels toward Berwick Bay, and a Union naval force was ordered to Berwick Bay to cut off the Confederate retreat at Brashear City. Butler's strategy initially worked very well. On October 27, 1862, a small Confederate army under Gen. Alfred Mouton confronted Weitzel's invaders at Georgia Landing, two miles north of Labadieville. The Northern army, which enjoyed great numerical superiority, forced the defenders to withdraw, but the pursuing Union army and naval units failed to entrap and destroy Mouton's force as planned, although Union forces did occupy Brashear City.

In the wake of this failed campaign, the Union army bivouacked troops along Bayou Lafourche just below the present Nicholls State University campus near Thibodaux. The biv-

Row houses on Laurel Valley Plantation near Thibodaux

ouac, dubbed Camp Stevens, helped establish a firm Northern military presence in the Lafourche-Terrebonne area. Northern forces in Louisiana, now commanded by Butler's successor, Maj. Gen. Nathaniel P. Banks, again attempted to drive the weak Confederate forces from south Louisiana by means of an invasion of the Bayou Teche region in the spring of 1863. Ascending the Teche, Banks's army traveled to central Louisiana before turning east and besieging the Confederate bastion at Port Hudson, one of the two most important remaining Rebel positions along the Mississippi River.

In a desperate attempt to lift the Union siege of Port Hudson, Confederate authorities in Louisiana dispatched a small force of raiders under Maj. James P. Major to the Lafourche-Terrebonne region in an attempt to convince Union authorities that New Orleans was threatened and, later, seize Brashear City. While traversing Lafourche Parish, Major's troops engaged a Union force at Lafourche Crossing on June 20–21, 1863, before pushing on to Brashear City, destroying rail bridges along the route. On June 24 at Chacahoula, Major's force fought a short, but intense rear-guard action against a Union force sent to intercept them. The intensity of the Chacahoula skirmish persuaded Union military authorities that Major's force was much larger than it actually was, and the Union command responded by withdrawing all Federal units from the Lafourche-Terrebonne area to New Orleans.

The cautious Union reaction to the Confederate invasion of the Lafourche-Terrebonne area prompted the Confederate leadership to send a second, far more substantial force into the region in another attempt to lift the Northern siege of Port Hudson. On July 13, approximately 1,550 Rebels under Gen. Tom Green defeated a Federal force twice its size at Cox's Plantation along Bayou Lafourche, between Donaldsonville and Plattenville. The following day, Green's force withdrew in response to news of the surrender of Port Hudson. By the end of July 1863, the Lafourche-Terrebonne region was again under Union control, and it would remain so until the end of the war. For the duration of the conflict, military activity was confined to sporadic skirmishes between Confederate guerrillas and the Union occupiers.

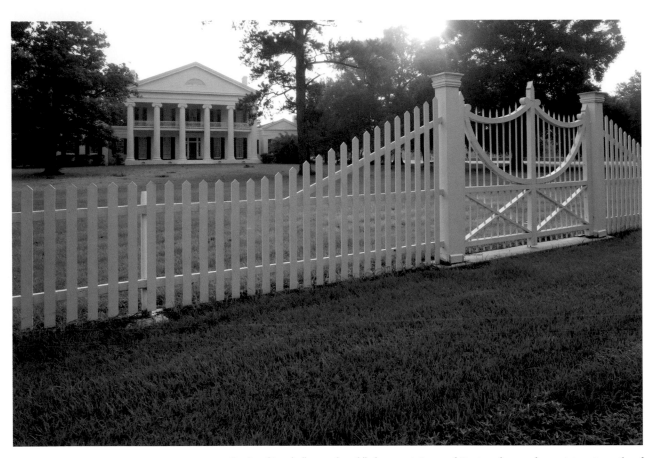

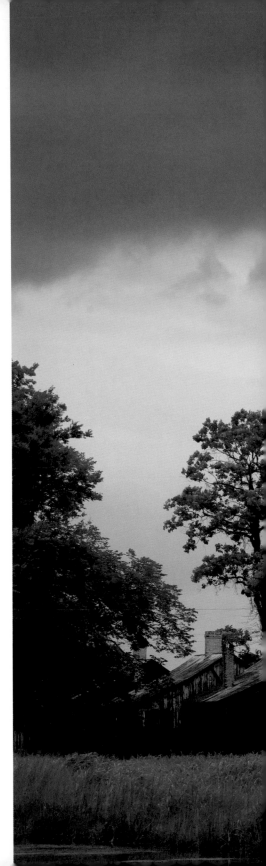

In Acadiana's "sugar bowl," the surviving architectural record consists primarily of structures at the polar extremes of the local socioeconomic hierarchy, as is the case here with antebellum buildings on the upper Lafourche. *Above:* Built by Thomas Pugh between 1840 and 1848, Madewood plantation home near Napoleonville was designed by the architect Henry Howard. The palatial Greek revival home has twenty-three rooms. *Right:* Laurel Valley Plantation, located near Thibodaux in Lafourche Parish, is home to one of the most extensive extant historic plantation complexes in the South—approximately eighty buildings on five hundred acres.

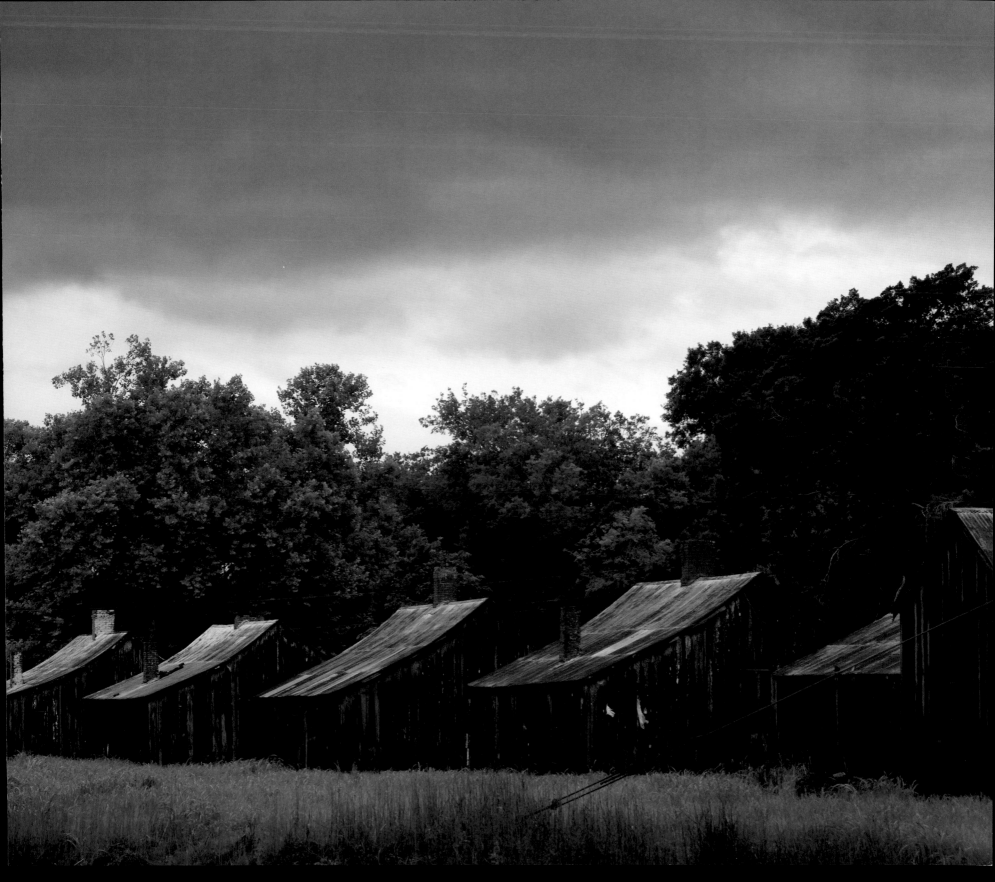

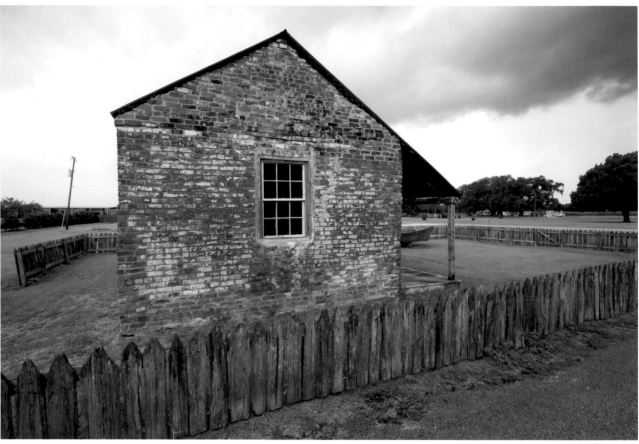

The property upon which Gheens Plantation, now better known as Golden Ranch, is located was originally used for cypress logging and ranching. Over time, the owners converted the property to sugar cultivation, and the plantation boasted a large brick sugarhouse and numerous two-room brick slave cabins with front galleries. The post office sign was later affixed to one of the buildings. An adjoining structure was used as plantation store and post office.

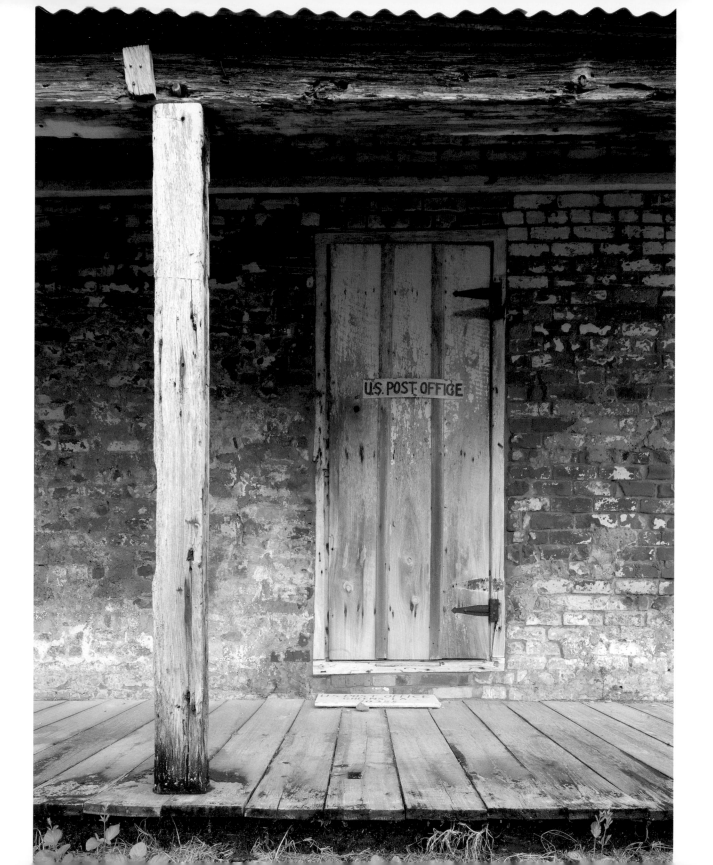

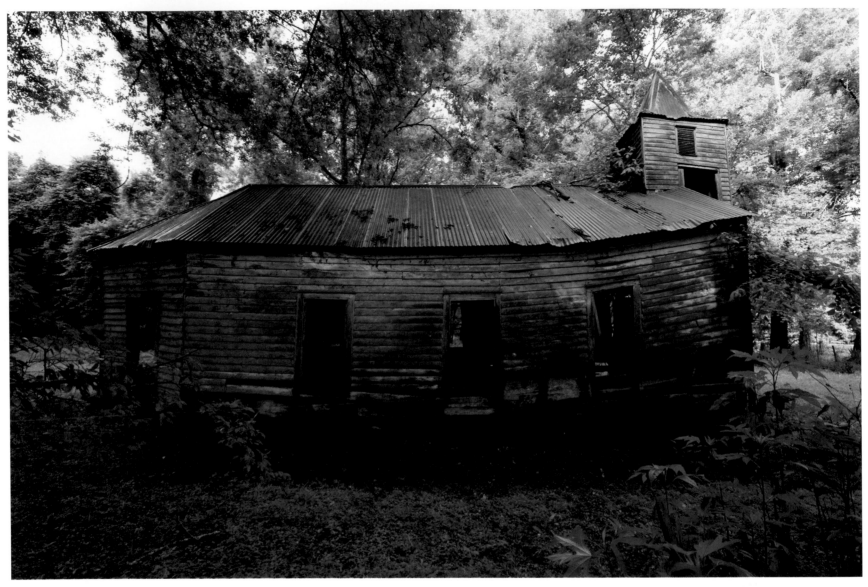

St. Luke (aka Little Zion) Baptist Church was built in the 1880s by former slaves from Cleona Plantation, located between Thibodaux and Chackbay. According to Bertha Shanklin, the daughter of the congregation's last preacher, the church remained active until the 1950s.

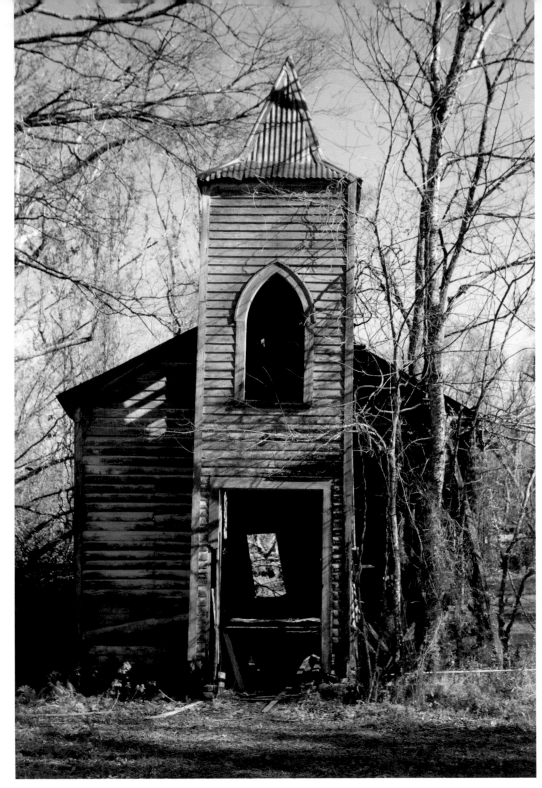

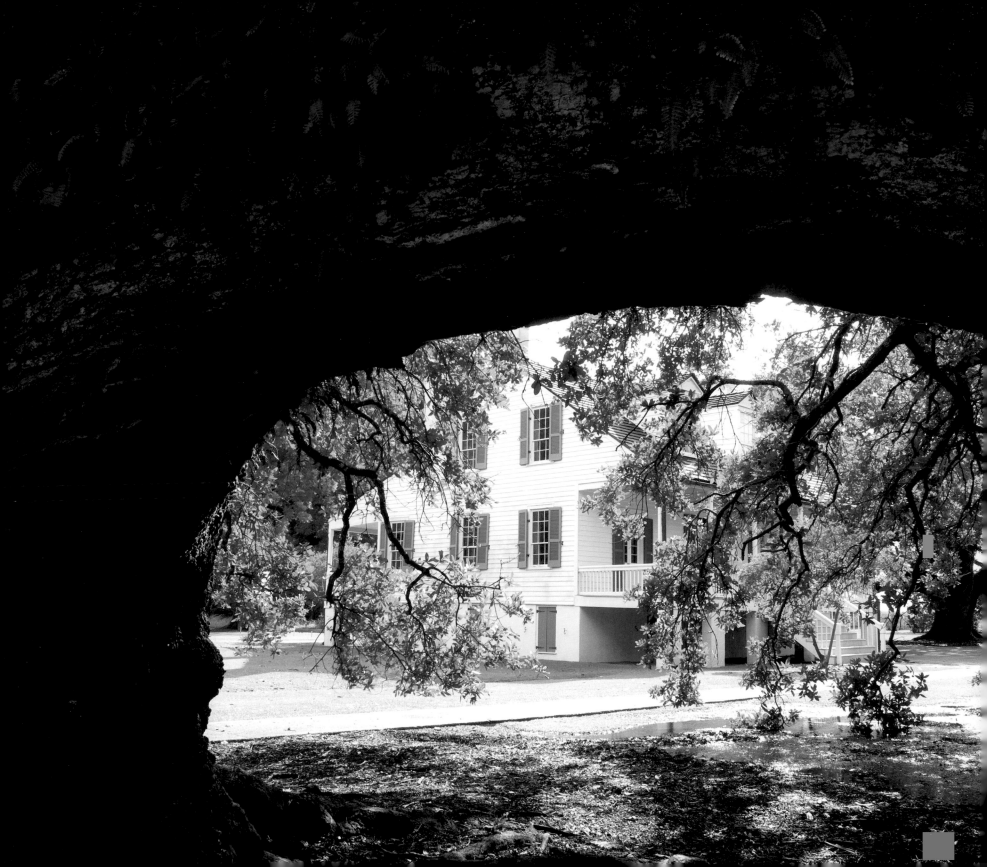

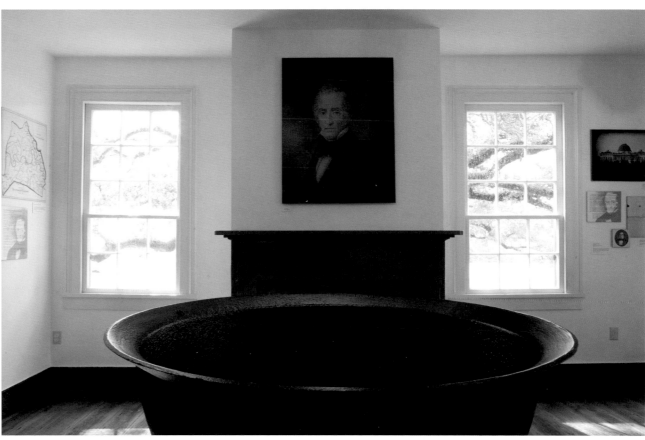

The Edward Douglass White House was built in the late eighteenth or early nineteenth century of hand-hewn cypress and peg-and-mortise construction. White, a future chief justice of the U.S. Supreme Court, was born in the house in 1845 and lived there until the age of six. The state of Louisiana acquired the structure in the late 1950s and incorporated it into the state park system. A portrait of Governor Edward Douglass White Sr. (father of the chief justice) hangs in an exhibit room at the home.

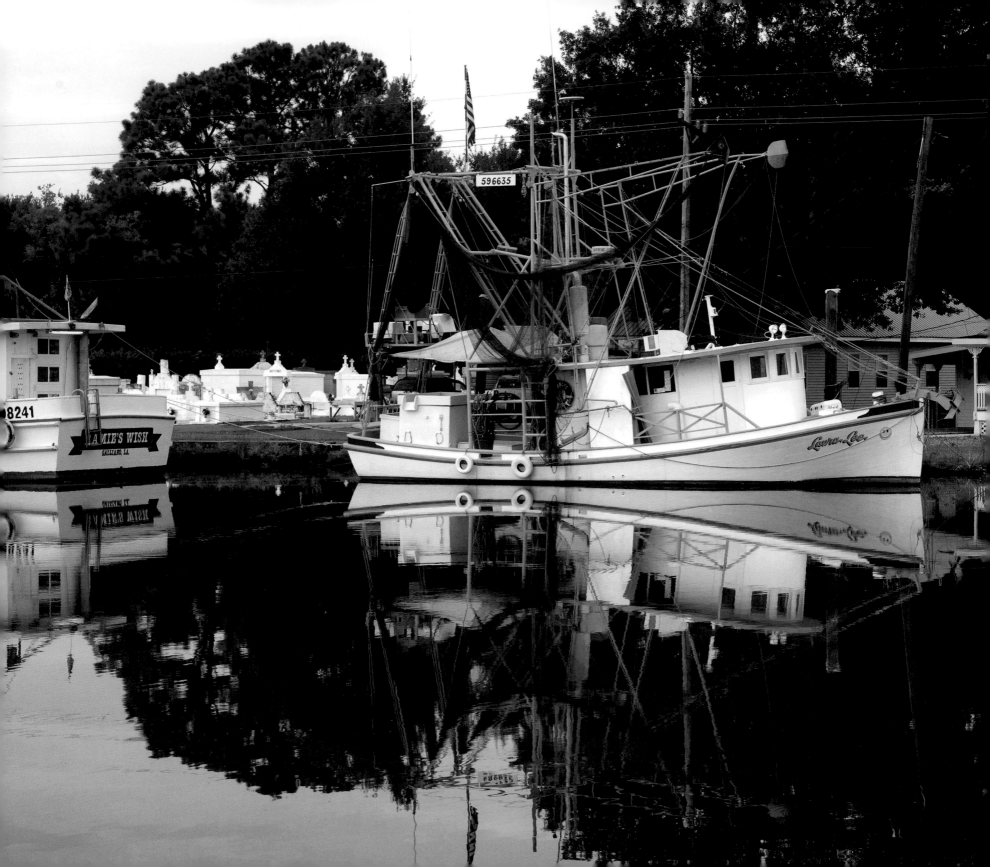

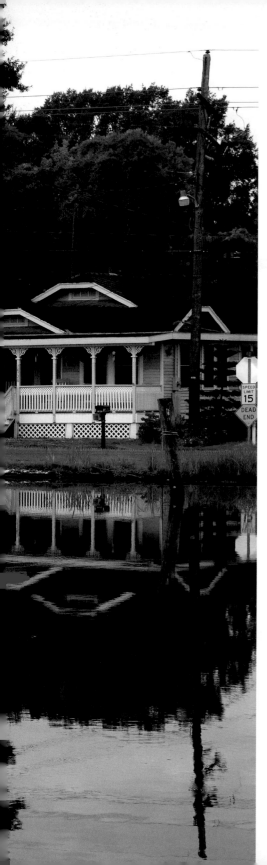

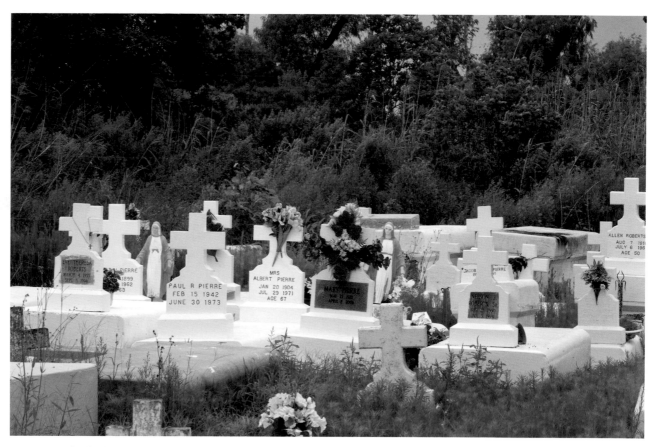

A cemetery built along the edge of the marsh in Grand Caillou remains in pristine condition.

Left: Yeoman farmers participating in the nineteenth-century migration into lower Lafourche Parish were forced to adapt to a new environment that was better suited to fishing than agriculture. Two shrimp boats along lower Bayou Lafourche in Galliano attest to the development of the Cajun community down the bayou.

Overleaf: Shrimp boats are docked along Bayou Lafourche at daybreak during the off-season. For decades, shrimping has been the economic lifeblood of lower Bayou La-fourche.

In 1829, the state of Louisiana issued a charter to the Barataria and Lafourche Canal Company, which the following year initiated work on an inland waterway (later popularly known simply as the Company Canal) to connect the lower Lafourche and Terrebonne parish areas to New Orleans. Extending from present-day Westwego to Houma by 1908, the canal was sustained by toll traffic. Subsequently supplanted by the Intracoastal Waterway, the Company Canal, photographed in Lockport, is now barely recognizable after decades of abandonment and neglect.

4 The Upper Prairie Area

During the colonial period (1699–1803), the area between the Atchafalaya River and the present Texas border, now commonly identified as Louisiana's prairie region, was divided into two political entities—the Opelousas and Attakapas districts, named for their respective indigenous peoples. The Opelousas District encompassed the present civil parishes of St. Landry (created 1807), Calcasieu (1840), Cameron (1870), Acadia (1886), Evangeline (1910), Allen (1912), Beauregard (1912), and Jefferson Davis (1912), while the Attakapas included modern-day St. Martin (1807), St. Mary (1811), Lafayette (1823), Vermilion (1844), and Iberia (1868) parishes. The traditional boundaries dividing the region, however, were rather arbitrary and do not accurately reflect the cultural and economic realities of the early twenty-first century. Two centuries of migrations and the attendant development of communications arteries mimicking those migration patterns have effectively divided the region into northern and southern zones, with an unofficial, but recognizable, line of demarcation running roughly from Cecilia to the Sabine River. The area north of the dividing line has experienced an evolutionary trajectory quite different from that of the southern prairie region, largely as a result of factors put into place in early historic times.

At the time of European colonization of the Gulf Coast region, the upper prairie was home to the Opelousas Indians. Little is known of the Opelousas. Modern anthropologists presume that they were related linguistically to the Attakapas nation of the southern prairie and that they functioned as middlemen in the flow of trade goods between tribes of the Red River and lower Mississippi River valleys. In the 1760s, their village was reportedly located at Ile Langlois, west-southwest of present-day Opelousas, but the land claims section of the *American State Papers* suggests that they may have resided near modern Lewisburg by the early nineteenth century. The tribe, which was consistently quite small throughout the historical era, consisted of only twenty members in 1814; by 1900, the tribe was extinct.

Although the indigenous people had little to barter with visiting Europeans, the local Native American population's trade contacts were evidently significant enough to lure French traders into their territory in the late 1730s. As related by Mathé Allain and Vincent Cassidy, Joseph Blanpain, a *coureur de bois,* and Jean-Joseph Le Kintrek *dit* Dupont, the janitor at the New Orleans jail, entered into a contract to trade "in pelts, horses, and merchandise" with the Attakapas and the Opelousas on December 11, 1738. The 1738 contract, notarized at New Orleans, indicates that the partnership was to endure for six years and that the partners were to contribute a total of three slaves to the venture and also to recruit four unidentified orphans as employees. The contract's signatories clarified their contractual obligations through a solidary agreement signed in the Opelousas country in April 1740. Circumstantial evidence suggests strongly that the focus of trade was not the local tribes, particularly the primitive Attakapas who were nomadic hunter-gatherers, but rather the indigenous peoples of Texas, who had access through local Spanish settlements to horses, cattle, pelts, and other goods that were in great demand in Louisiana. (The Louisiana government, for example, hired Blanpain, who was quite familiar with the neighboring Spanish territory, to rescue a French crew shipwrecked along the southeastern Texas coast in 1745.)

Louisiana land office records provide tenuous evidence that Le Kintrek subsequently established a trading post at the junction of Bayous Courtableau and Teche, in what is now Port Barre, although it is not clear if the post was established before or after dissolution of the Le Kintrek–Blanpain partnership in January 1744, following a dispute between the partners, probably over Blanpain's propensity for entering into additional contracts conflicting with the original agreement. It is also unclear if the trading post endured beyond Le Kintrek's death around 1753, when it appears to have come into the possession of his daughter, Marguerite. On May 4, 1765, Marguerite Le Kintrek, Jean-Joseph's daughter and the widow of Claude Desbordes, married Jacques Guillaume Courtableau, who had apparently established himself in the Opelousas country, perhaps at the trading post, by mid-May 1756.

The focus of local development shifted in the 1760s as the Opelousas region was formally opened to settlement in response to migrations resulting from ratification of the Treaty of Paris (1763), which partitioned Louisiana into Trans-Appalachian and Trans-Mississippi zones and transferred these territories respectively to Great Britain and Spain. British representatives were quick to occupy the Trans-Appalachian region, and the newly installed English colonial government soon invalidated the often-unsubstantiated land titles of the region's French inhabitants, triggering an exodus of Francophones to the Trans-Mississippi region. There, thanks to a dilatory Spanish response to the transfer, the caretaker French colonial government still held sway. Most

of the immigrants were from present-day Alabama, particularly Mobile and Fort Toulouse, a French military installation near modern Montgomery.

The Fort Toulouse garrison is particularly significant. Unlike their counterparts at other military posts throughout the sprawling colony, the Fort Toulouse soldiers did not participate in regular troop rotations through which individual soldiers were relocated periodically—evidently because many of them had intermarried with the local Alibamon (Alabama) tribe, staunch French allies who helped protect the colony's vital eastern flank from English, Spanish, and hostile Native American incursions. By the 1760s, two generations of Fort Toulouse soldiers—bearing such surnames as Fontenot, LaFleur, and Brignac—served side by side in the garrison. Following deactivation, the troops and their families migrated en masse to Trans-Mississippi Louisiana. Most of these migrants settled initially near present-day Washington, Louisiana, in 1764. They subsequently migrated to the portion of Prairie Mammouth (now usually rendered "Mamou") in modern Evangeline Parish, where many of the Fort Toulouse families received land grants in the mid-1780s.

Other immigrants from established Louisiana communities quickly occupied properties along the banks of Bayous Courtableau and Teche. By 1766, the region's population included 271 individuals—184 whites, 3 free persons of color, and 84 slaves. As in most North American frontier societies, men constituted a large majority (61.4 percent) of the white population, but as in other frontier societies of the Lower Mississippi Valley, the Opelousas post also boasted a large enslaved African American population. Yet only three individuals—Louis Pellerin, Jacques Courtableau, and Mobile immigrant Grégoire Guillory—collectively owned approximately two-thirds of the local bondsmen.

The migration created a local population base of sufficient magnitude to warrant the selection of a local commandant and the designation of the region as an administrative district. Louisiana's French governor named Louis Pellerin, a politically well connected former French colonial military officer, as the first commandant. On July 2, 1764, around the time of his appointment, Pellerin received a large land grant (three-fourths of a league frontage by one-and-one-half leagues in depth) extending roughly from present-day Notleyville on Bayou Teche to the outskirts of modern Opelousas.

Pellerin was soon joined by a number of Acadian exiles who had immigrated to Louisiana in early 1765. Subsequently established in what is now the St. Martinville area, the refugees dispersed following the outbreak of an unidentified epidemic. Some of the party migrated north into the Opelousas District, where Jacques Courtableau, the new district's largest landowner, settled them at Prairie des Coteaux, along the borders of the Pellerin grant.

The location of the Acadian settlement may not have been coincidental, for,

as the exiles later reported to colonial authorities, Pellerin commandeered for his own use many of the implements and other goods provided the refugees by the governor to facilitate their resettlement. He then evidently offered these appropriated goods for sale at his recently established Indian trading post at Ile Langlois.

The misappropriation of the Acadians' supplies was but one of many acts of malfeasance enumerated in complaints filed by local residents. Other Opelousas pioneers charged Pellerin with using his political position to drive rival traders out of business, and the local priest, Father Valentin, feuded with the commandant over the raucous tavern he operated next to the parish church. When Valentin eventually secured the tavern's closure, Pellerin retaliated by expropriating the church's sacred vessels for his own use. Other incidents ensued, and over the course of his tenure as commandant, Pellerin managed to alienate virtually every important local, and eventually provincial, constituency. Even Antonio de Ulloa, Louisiana's first Spanish governor, who arrived in Louisiana in March 1766 and subsequently visited the Opelousas District, recalled that Pellerin "sought to steal everything he could from the . . . [colonial] government, in order to acquire, in a few years, a large fortune and then retire with his family to France." Unable to ignore the increasingly shrill complaints of the Opelousas residents, who by 1767 were threatening to migrate en masse to British West Florida, colonial authorities summoned Pellerin before a court-martial, found him guilty, and forced him to retire from public life. He died a discredited but wealthy man, on May 12, 1785, along lower Bayou Teche.

Turmoil in the Opelousas District continued after Pellerin's court-martial and dismissal from office. In 1768, Courtableau acquired Pellerin's Opelousas land grant, and upon his death shortly thereafter, his widow, Marguerite Le Kintrek, pressed legal claims against her new Acadian neighbors, maintaining that they were squatting on Courtableau property. The ensuing acrimonious and long-running legal dispute between Mme. Courtableau and the Acadians was ultimately resolved in the exiles' favor. But, shaken by the experience, the Prairie des Coteaux Acadians sold their properties as soon as they acquired formal title to them, generally between 1776 and 1778, and migrated to Prairie Bellevue, between present-day Sunset and Opelousas. From Prairie Bellevue, second-generation Acadians moved to the Grand Coteau and Church Point areas.

The Acadian migration and the nearly concurrent exodus of Fort Toulouse immigrants to present Evangeline Parish signaled the onset of a gradual demographic movement into the open prairies west of Bayou Teche. By 1788, Bellevue, Plaquemine Brulée (the Roberts Cove, Wykoff, Branch, and Church Point areas), Plaisance, and Grand Prairie were the four most densely populated subregions in the sprawling Opelousas District. Significant settlements

had also sprung up at Bayou Chicot and Carencro (actually the present Sunset-Cankton area of St. Landry Parish). These six settlements accounted for approximately 73 percent of the region's free population. The district's center of population subsequently continued to shift westward toward Mermentau, which had only eight settlers in 1788, and other prairie settlements later emerged as viable communities. The movement of the district's population center away from the region's major waterways was significant enough in the mid-1790s to warrant the relocation of the parish's Catholic church from Bayou Courtableau Landing (present-day Washington) to a more centralized location near the site of the modern St. Landry Catholic Church.

Most of the participants in this migration were members of Opelousas's "first families." This is particularly true of the post's Fort Toulouse and Acadian immigrants. But the French families were accompanied by a surprising number of English-speakers, most of whom settled in the prairies of what is now northeastern Acadia Parish. Prairies Hayes, Roberts, and Wykoff all take their names from prominent members of this group.

Pioneers participating in this movement hopscotched from waterway to waterway. Early colonial settlers avoided the open prairie because the grasslands concealed a shallow clay pan that was impenetrable to the wooden agricultural implements of the day and because only the margins of streams, however modest, contained enough timber to meet frontier families' needs for building and fencing materials and firewood.

The vacuum created in the older settlement districts was filled by a continuous trickle of immigration. In 1779, approximately sixty Catholics arrived at the post after fleeing religious persecution at Fort Pitt (modern Pittsburgh). Although they eventually dispersed, many of these refugees, including the Ritter and Wyble families, remained in the district, carving out homes for themselves along Bayou Teche. The 1788 census of the Opelousas District also lists numerous individuals, including representatives of the Vidrine, Fleuriau, Meuillon, and Lemelle families, who had migrated from the colonial capital or the German Coast around the time of the American Revolution.

For the roughly one-third of the district's population who chose to remain in the area's original settlement areas, agriculture quickly took hold, supplanting the fur trade and smuggling as the backbone of the regional economy. Agriculture in the Opelousas District was originally diversified, as settlers struggled to find crops suited to the region's soil and climate. In the late 1760s, the Acadian exiles experimented briefly, and ultimately unsuccessfully, with wheat production; corn, a crop far better suited to the Gulf Coast's heat and humidity, became the staple of the local diet by the 1770s. By the 1780s, many local farmers had also turned to the cash crops being intensely promoted by the colony's Spanish government—tobacco and indigo. Production of these commodities, however, fared poorly, for the inferior quality of local tobacco and indigo made them uncompetitive with superior varieties from elsewhere in the Americas. Opelousas farmers would abandon this endeavor in the early nineteenth century, after the end of Spanish rule.

The introduction of commercial agriculture and the concurrent migration into the local prairies marked a watershed in the region's economic development. Within a generation of the district's establishment, two distinct agricultural communities had come to coexist. The larger of the two consisted of yeoman farmers, who tilled the soil themselves with the assistance of their family labor force. In 1788, 59 percent of local free households owned no slaves.

Slavery nevertheless was an institution of rapidly growing local importance. Land-clearing operations in the region's water bottoms was difficult, and indigo production was not only labor-intensive but also posed serious health risks to persons employed in its manufacture. Hence, it is hardly surprising that the post's commercial farmers became increasingly dependent upon slave labor. By the late 1780s, slaves had come to constitute nearly 39 percent of the local population. In the Spanish period, slaveholdings were generally small by antebellum standards. Approximately 25 percent of Opelousas slave owners possessed four or fewer bondsmen. Only nineteen local households owned ten or more slaves, but this emerging planter class played a disproportionately large role in shaping the development of the region's commercial agricultural development.

Following the American acquisition and occupation of the Opelousas District and the end of Spanish incentives for tobacco and indigo production, most local farmers turned to cotton production, an industry blossoming throughout the American South in the wake of Eli Whitney's invention of the cotton gin. The ravages of an army worm infestation, however, caused most of the larger, staple-crop producers along Bayou Teche to switch to commercial sugar production in the 1830s, and the region produced 5,424 hogsheads in 1849—and 7,388 hogsheads ten years later.

Sugar production required immense amounts of labor, as is clearly reflected in the explosive growth of the parish's slave population, which in 1850 numbered 10,871 persons—the state's third-largest parish total. Slavery, however, became progressively less prevalent as one moved away from the water bottoms along the parish's principal waterways, and in the open prairies, it was virtually nonexistent.

The areas immediately west of the major streams, the fringes of the eastern prairie region where a deeper clay pan permitted small-scale agriculture, constituted a transitional zone. Here, cotton was and remained the crop of choice. Not only was it better suited to the less fertile soils beyond the natural levees, but it was also far less labor-intensive, an important consideration for local

yeoman farmers and minor slave owners. The output of individual farms was typically small, but the region's high population density—St. Landry boasted Louisiana's largest rural white population in 1850—created an output whose volume more than offset the modest personal productivity.

Commercial agriculture was complemented by ranching, which dominated the prairie region, where row-crop farming was impracticable. Spanish colonial reports indicate that as early as 1769, the Opelousas District already boasted more than 2,000 cattle, and, by 1788, local livestock raisers collectively owned 17,351 head. In the 1780s, most local cattle production took place in the prairies south and southwest of present-day Opelousas. Indeed, the Bellevue and Plaquemine Brulée settlements together contributed 42 percent of the district total.

As staple-crop agriculture evolved and expanded to the east, so did ranching in the west. After the Louisiana Purchase (1803), the westward migration begun in the early days of Opelousas settlement continued, eventually culminating in the establishment of prairie region transplants in present Calcasieu Parish and southeastern Texas. Indeed, the demographic and economic development of the western prairie region was sufficient to warrant creation of Calcasieu Parish out of St. Landry in 1840.

These early westward migrants carried with them the area's early pastoral traditions. Cattle drives from Louisiana's prairie region to New Orleans began during the American Revolution, and they continued through the late nineteenth century. As early as 1811, prairie cattle fetched fifteen to twenty dollars per head in the Crescent City, and enterprising ranchers invested their profits in land acquisitions to accommodate ever-larger herds. By 1850, the western prairie region boasted more than fifty 500-acre *vacheries* (ranches), and fully one-fourth of the area's Acadian ranchers in the area owned more than five hundred head of cattle.

Ranching and commercial agriculture were sustained by external markets accessed via New Orleans. Sustained contact with the Crescent City, however, was always quite difficult in the colonial and antebellum eras, for Opelousas's agricultural exporters had to transport goods by means of a circuitous and frequently treacherous labyrinth of waterways beginning with Bayou Courtableau and extending across the Atchafalaya basin to Bayou Plaquemine and the Mississippi River. This journey was fraught with difficulties. Water levels in these unregulated streams experienced dramatic seasonal fluctuations, and, as a result, New Orleans was accessible only during "high-water" periods as a result of the route's two most enduring challenges: the Petit Diable and the seasonal navigability of the lower Plaquemine. The Petit Diable was an exceptionally shallow sandbar at the confluence of Bayou Courtableau and the Atchafalaya River. Because the river was riddled with logs that could eas-

ily rip a hull, boatmen had to exercise extreme caution when crossing the Petit Diable, even in high-water season, and, during exceptionally low-water periods, the bar was fully exposed, constituting an effective dam across the waterway.

Even when boats could negotiate the Petit Diable, pilots and crews faced the difficult task of crossing the Atchafalaya basin before confronting Bayou Plaquemine. Prior to construction of a lock at the confluence of the Plaquemine and the Mississippi at the turn of the twentieth century, the bayou was a raging torrent during the river's spring high-water season. Indeed, because of the steep gradient between the Mississippi River's floodwaters and the bed of Bayou Plaquemine, waters flowed through the Plaquemine with such velocity that heavily laden boats required the assistance of ox teams on levee-based cordelle roads to combat the current. By late June, the beginning of low-water season, Bayou Plaquemine was reduced to a trickle, and from midsummer to late fall, the stream bed was virtually dry for a distance of at least five miles. Boatmen thus had to suspend voyages to New Orleans or arrange for overland transportation of their cargoes from the junction of Bayous Plaquemine and Grosse Tête to the Mississippi River landings. Low-water navigational issues forced the suspension of shipments as early as 1780.

The primitive transportation technology available to shippers exacerbated these navigational hazards. During the earliest days of settlement, the pirogue, a traditional Louisiana cypress dugout, was the principal mode of transportation. Later during the colonial era, the pirogue gave way to the flatboat. Flatboats, however, often required up to three weeks to complete the journey from the Opelousas country to New Orleans—navigational conditions permitting.

Thus the region's farmers and shippers eagerly embraced steam navigation when it was introduced into Bayou Courtableau in March 1826. Washington, at the head of navigation on Bayou Courtableau, became the major regional entrepôt, shipping to New Orleans the bounties of regional agriculture as well as the output of local tanneries and leatherworking facilities. In 1855, for example, sixty-two Bayou Courtableau steamers deposited 8,868 hogsheads of sugar, 13,492 barrels of molasses, 16,345 bales of cotton, 1,082 hides, and 102 rolls of leather at New Orleans. These figures are significant, but, to put them in perspective, they pale in comparison to those of other Acadiana inland ports, particularly those along Bayous Lafourche and Teche, which together exported nearly five times as much sugar, nearly 4.5 times as much molasses, and approximately 2.5 times as much cotton. The striking disparity between the Courtableau region's exports and those of Acadiana waterways to the south and southeast bears compelling testimony to the detrimental economic impact of Washington's only seasonally viable transportation system.

STEAMBOATS

Acadiana's steamboat era began on February 16, 1818, when the Louisiana legislature granted Martin Duralde Jr. and François Duplessis the exclusive right to operate a steamboat across the Atchafalaya basin between Bayou Plaquemine and present-day Henderson (in St. Martin Parish). Within a year, the owners of the *Louisianais* faced local competition from boats operated by rival investors, and by the mid-1820s, the steamboat industry was well established on Acadiana's major navigable streams—Bayous Lafourche, Teche, Courtableau, and Vermilion. (The upper Atchafalaya River was unnavigable due to a 10-mile-long logjam for much of the antebellum era.) Acadiana's steamboat trade focused upon export of agricultural commodities to New Orleans, and traffic and tonnage peaked in the decade prior to the Civil War. In 1855, for example, boats from inland ports along the four navigable streams deposited 57,453 bales of cotton, 53,187.5 hogsheads of sugar, and 72,605 barrels of molasses at Crescent City docks. Much of the region's steamboat flotilla was confiscated for military use or destroyed in military action during the Civil War, and the local transportation industry never recovered. Completion of a major railroad through western Acadiana in 1880 signaled the beginning of the end of the steamboat era, and although steam-powered vessels continued to operate—primarily as cypress lumber pullboats—in Acadiana waters until World War II, the industry's role as a pillar of the regional economy ended with the dawn of the twentieth century.

Nevertheless, until the postbellum era, Washington remained the upper prairie's commercial hub, while Washington's sister village, Opelousas, established approximately six miles south of the inland port on property subdivided by the police jury circa 1806, became the parochial seat of government and justice. The concentration of power and wealth in the eastern part of the Opelousas country—which these communities serviced—accurately reflected the disparity in income, power, and worldviews that separated the prairie region from the plantation belt.

This fracture line cut across racial and ethnic boundaries, as is seen perhaps most clearly in the region's free black community. In 1850, St. Landry boasted 1,242 free people of color, the second-largest number in the state and easily the largest total among the state's rural parishes. Occupying the middle level in the state's three-tier socioeconomic system—whites, free persons of color, and slaves—the *gens de couleur libre* enjoyed most of the property rights, though none of the social privileges, of the white population. In the eastern portion of the Opelousas region, free persons of color possessed extensive property holdings and, in some cases, slaveholdings. In the late antebellum period, for example, free blacks owned approximately one-fourth of the real estate within Opelousas's corporation limits, and before his death in 1848, Martin Donato, one of the nation's wealthiest African Americans, possessed an estate appraised at $96,620 (approximately $2.4 million in early twenty-first century dollars), including eighty-eight slaves. Free blacks of more modest means—like their white counterparts—generally resided in the portion of the open prairies west of Opelousas dominated by the region's yeoman farmers and ranchers.

Not all of the eastern prairie dwellers, however, were prosperous landowners. A significant minority owned no property whatsoever. Their predicament resulted in part from the federal government's refusal to sell all of its vast prairie region holdings, thereby reducing many immigrants to squatter status, and in part to a lack of resources or personal initiative. Regardless of the cause, a significant and growing gulf existed in the twilight years of the antebellum era between the local haves and have-nots. Class tensions came to a head in 1859, when a wave of lawlessness, left unchecked by the region's civil authorities, engendered the nation's second-largest vigilante movement. Born in the Côte Gelée area of Lafayette Parish, the movement quickly spread northward into the Opelousas country.

During the subsequent vigilante reign of terror, night riders combed the prairies in search of reputed criminals who, when apprehended, were banished, flogged, or hanged. Although flogging was accompanied by an admonition to leave the state under penalty of death, many vigilante victims instead congregated in southwestern St. Landry Parish (now Acadia Parish), near the present community of Mire, and organized themselves into paramilitary units to combat their tormentors. The inevitable result was armed conflict, and, in early September 1859, vigilantes from throughout the prairie region met anti-vigilantes at Emilien Lagrange's fortified home near Bayou Queue de Tortue. In the ensuing route, vigilantes captured and lynched an undetermined number of captives.

The spreading web of terror forced Louisiana's governor, Robert C. Wickliffe, to confront the vigilante leaders in late September 1859 and order the immediate suspension of their groups' extralegal activities under penalty of the declaration of martial law and the mobilization of the state militia. In the wake of this conclave, the vigilantes officially suspended operations, but, in St. Landry Parish, the night riders openly continued their nocturnal activities, now concentrating on the expulsion of fugitives from the Attakapas vigilance committees. Reputed criminals, however, were not the sole targets of vigilante justice. Recent immigrants, free persons of color, and assorted other groups simply disliked by the night riders became victims of coordinated acts of terror. Following the fiery destruction of the free black school at Washington, large numbers of free persons of color sought temporary refuge at New Orleans before emigrating to Mexico or Haiti. Most would return to the area shortly after the end of the Civil War.

The vigilantes were evidently shielded from harsher, immediate conse-

quences by the involvement of former state governor and U.S. senator Alexandre Mouton, one of the acknowledged leaders of the southern prairie vigilantes. Mouton, who was responsible for Louisiana's adoption of the 1845 state constitution that enfranchised poor whites, enjoyed a large and devoted political following that constituted a crucial block vote for the state's then-dominant Democratic Party.

Mouton would use his vast influence the following year in influencing the course of voting in the pivotal 1860 election and in the ensuing secession controversy, which ultimately resulted in the dissolution of Louisiana's bonds to the Union. The onset of the Civil War in 1861 paradoxically brought a hiatus in the violence plaguing the upper prairie region, for large numbers of vigilantes volunteered for Confederate military service, enlisting in units quickly assigned to military theaters east of the Mississippi. Night riders would again become active on the prairies in 1863, but in this instance, they were antivigilantes who had turned the tables on their former tormentors.

These new night riders, known locally as Jayhawkers, were typically poor individuals who had been conscripted into Confederate military service following the Union capture of New Orleans in the spring of 1862. Deserting en masse from their Rebel units during the Union invasion of the Teche region in 1862, some of the fugitives went into hiding, while others organized themselves into paramilitary groups to protect themselves from Confederate cavalry detachments seeking to execute them or force them to return to the service. Rebel intelligence reports indicated the existence of three main Jayhawker bands: Two of the three were in the upper prairie region, and the largest was centered in Bois Mallet near present-day Eunice.

Under the leadership of Ozémé Carrière, a white man, the Bois Mallet Jayhawkers became a tightly knit, quasi-military force. Over time, the core group was joined by fugitive slaves and, after July 1864, by free men of color seeking to escape Confederate attempts to impress them into work crews in northern Louisiana. In the early days of its existence, Carrière's band enjoyed considerable popular support among non–slave owners, who viewed the group as champions of anti-Confederate resistance; this multicultural, multiracial group, however, quickly became the scourge of the upper prairie region. As his

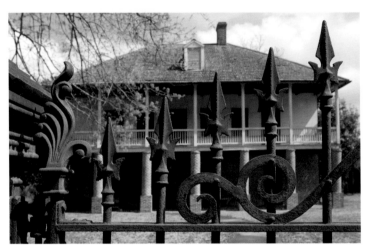

The Michel Prudhomme House (popularly known as Ringrose) in present-day Opelousas, widely considered to be one of the best examples of French colonial plantation architecture in western Acadiana.

force grew, Carrière faced major logistical problems, and, to feed and arm his men, he ordered raids on isolated prairie residences from Plaquemine Brulée to the southwestern outskirts of Opelousas. These raids were often carried out at night, and individuals or families who resisted were routinely killed.

A shrill public outcry elicited a quick response. In August 1863, combined Confederate and Home Guard forces raided the Jayhawkers' camp, but were themselves ambushed by Carrière's attentive men. The Rebel forces were routed, and the Jayhawkers became the undisputed masters of the upper prairie region.

The activities of Carrière's band attracted the attention of Northern military leaders in Union-occupied Louisiana. During the second Yankee invasion of the Teche region in the fall of 1863, Maj. Gen. William B. Franklin, field commander of the expedition, offered Carrière a commission in the Union army. Carrière evidently refused, perhaps because of the scorched-earth policy conducted by the Union invaders in the St. Landry Parish area. In an effort to deprive the Confederate army of the agricultural bounties of this potentially rich foraging area, the invading Union army, whose advance stalled between Vermilionville (present-day Lafayette) and Opelousas, destroyed immense quantities of livestock, ruined as much of the local economic infrastructure as possible, and seized all of the processed agricultural produce they could locate.

The Union depredations, coupled with the Jayhawker rampage, cost Carrière and his cohort most of their public support. Their position was further undermined by the end of Confederate conscription in southwestern Louisiana. Lacking a raison d'être and facing mounting public backlash, the Jayhawker band disintegrated through defections in the waning months of the war. Only fifty men reportedly remained under Carrière's command when he was ambushed and killed by Confederate soldiers in May 1865. Following Carrière's assassination, free man of color Martin Guillory, Carrière's former lieutenant and brother-in-law, accepted a Union army commission as captain and organized the remaining Jayhawkers into the Mallet Free Scouts. For St. Landry Parish, the American Civil War thus ended the way it had begun—with the local citizenry at war with itself.

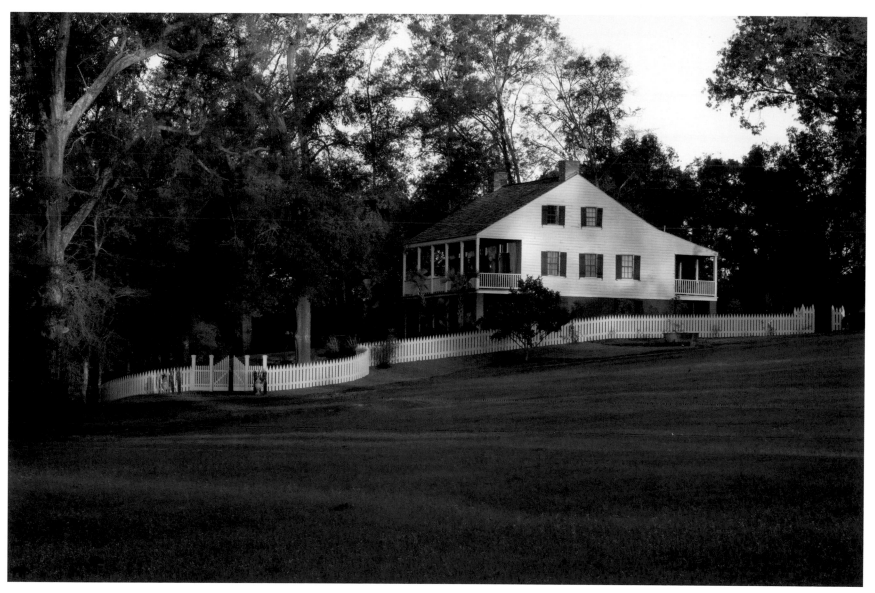

Serenity House, located in St. Landry Parish just outside Washington, was originally built in Thibodaux during the early part of the nineteenth century. The simple white-washed picket fence that confines parterre and flower gardens adjacent to the house is reminiscent of many of the fences depicted in the nineteenth-century drawings of Adrien Persac.

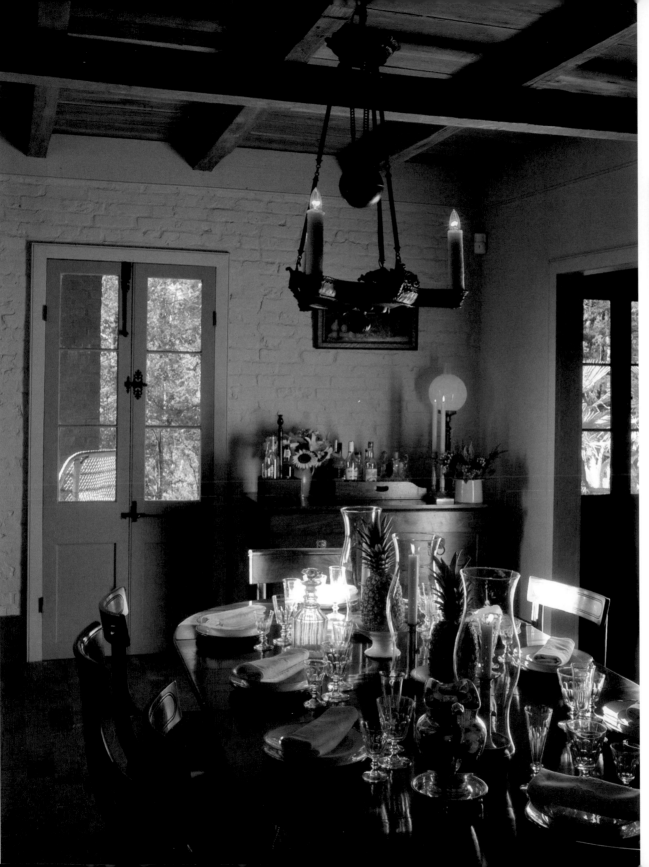

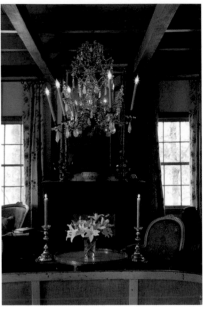

Serenity House's dining room is located on the ground floor. The table and chandelier date from the early 1800s; the table settings date from the late eighteenth century. *Above:* In the upstairs drawing room, a late eighteenth-century rock crystal chandelier serves as centerpiece.

Serenity originally had an exterior staircase typical of many Acadian-style houses. Later, simple interior staircases were installed. The present owner commissioned master stair-builder Raymond Reineche of Grand Coteau to re-create a mid-nineteenth-century interior staircase appropriate to the house. All parts were handcrafted from period materials and were fabricated on-site.

Overleaf: Bayou Teche (seen here near Arnaudville) was the communications artery that tied together the Attakapas District in the late eighteenth and early nineteenth centuries. The upper reaches of the stream, however, were not generally navigable, particularly during the low-water season, until the U.S. Corps of Engineers completed the Keystone Lock in June 1913.

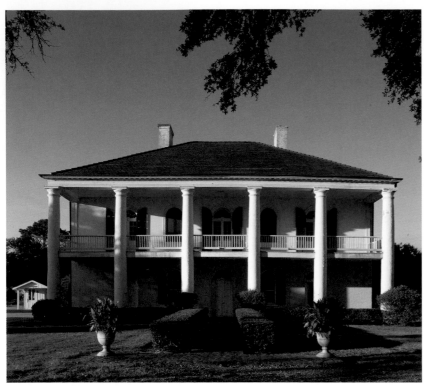

Above and right: In 1831, Hypolite Chretien II entered into a building contract to erect the two-story brick plantation home that has come to be known as Chretien Point.

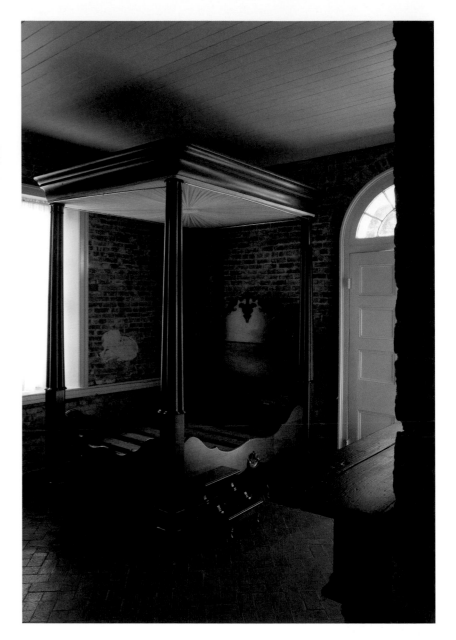

Right: During the steamboat era, Washington was the eastern gateway to the Opelousas Country. Substantial hotels and antebellum residences like the François Marchand House stand in silent testimony to the river port's former prosperity.

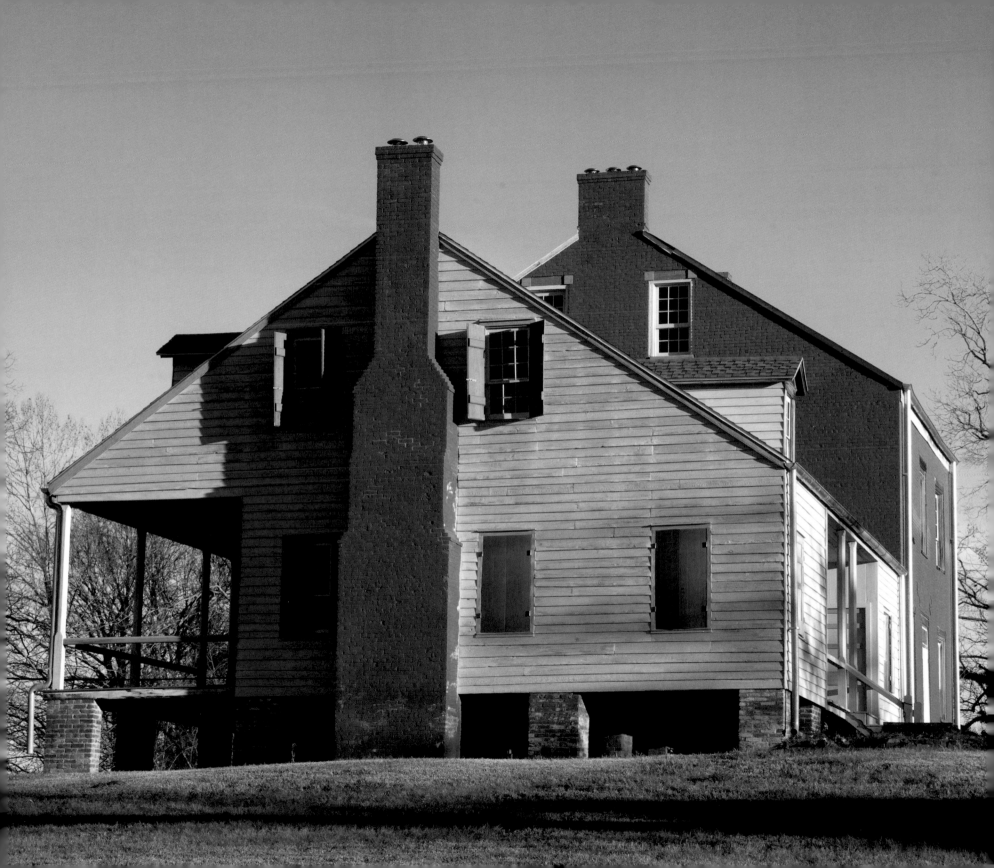

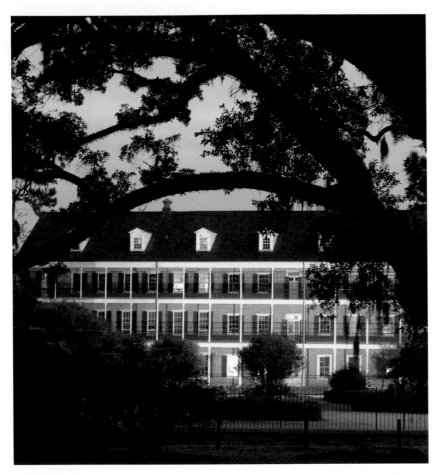

Established by Mother Eugenie Audé and Sister Mary Layton, the Academy of the Sacred Heart opened its doors to Acadiana's young women in 1821. The campus houses a chapel honoring St. John Berchmans, who is believed to have miraculously cured novice Mary Wilson of a fatal illness—a miracle that subsequently led to Berchmans's canonization.

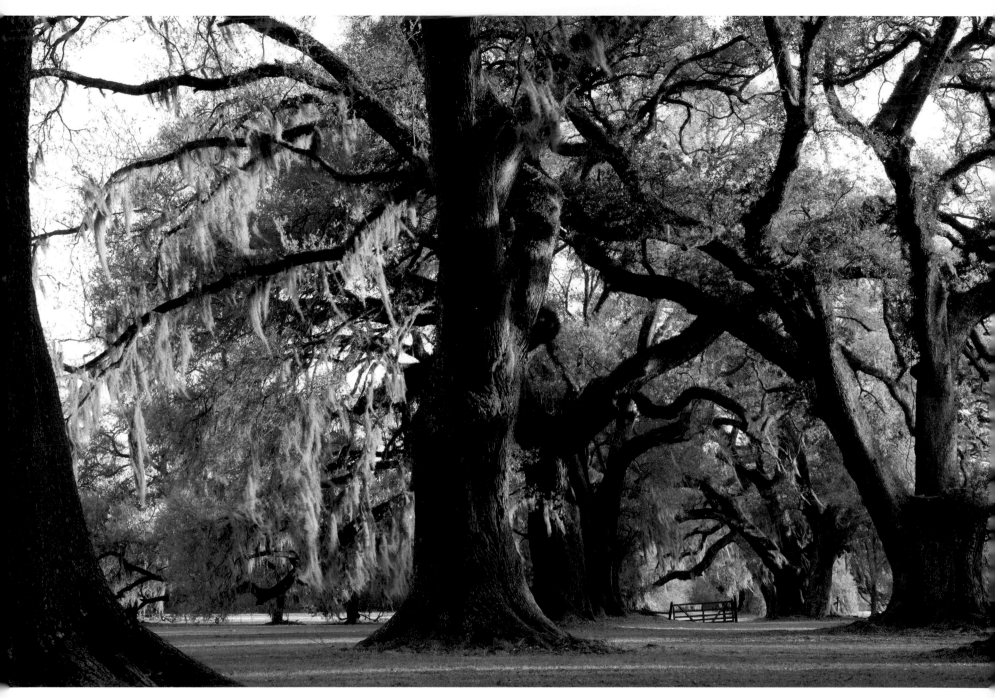

The school's oak alley is one of western Acadiana's most easily recognizable land-
marks.

St. Charles Borromeo Catholic Church in Grand Coteau was established in 1819. The current church building, one of the finest Catholic wooden churches in the Deep South, was built in 1879–80 and renamed Sacred Heart. The church parish reverted to its original name after the Second Vatican Council.

The church cemetery, located on a ridge overlooking the local countryside, is the final resting place for many of the area's pioneer families.

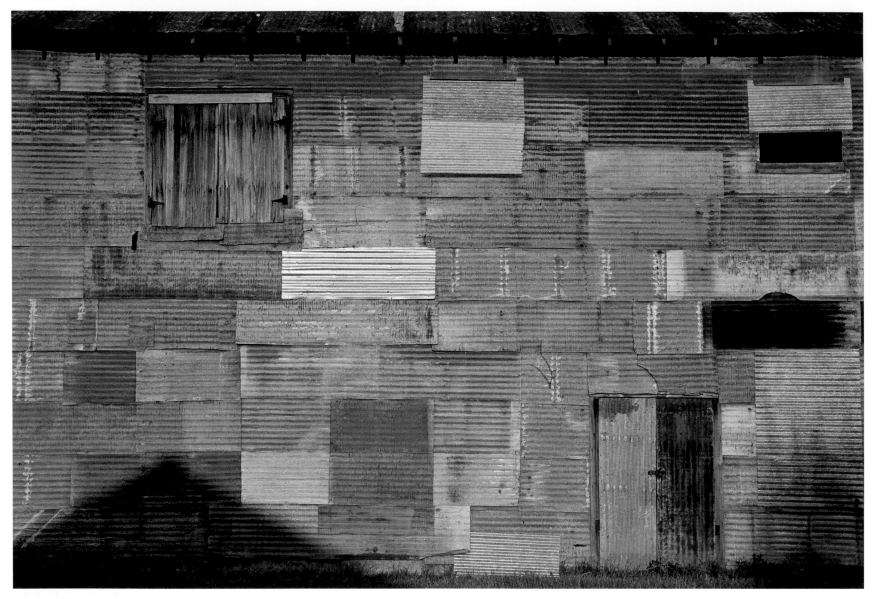

In the wake of the severe 1890s depression, Acadiana farmers embraced agricultural diversification. Sweet potatoes quickly proved to be successful thanks to distributors' ability to market this root crop to northern consumers, particularly during the lucrative holiday season. By the 1920s, the sweet potato industry had come to dominate the economic landscape in the upper prairie and Avoyelles Parish areas. St. Landry Parish boasted the self-styled Yam Capital of the World (Opelousas) and Sweet Potato Capital of the World (Sunset). Following the early 1960s, however, the labor-intensive industry entered a long period of decline. Above is a sweet potato shed in Sunset.

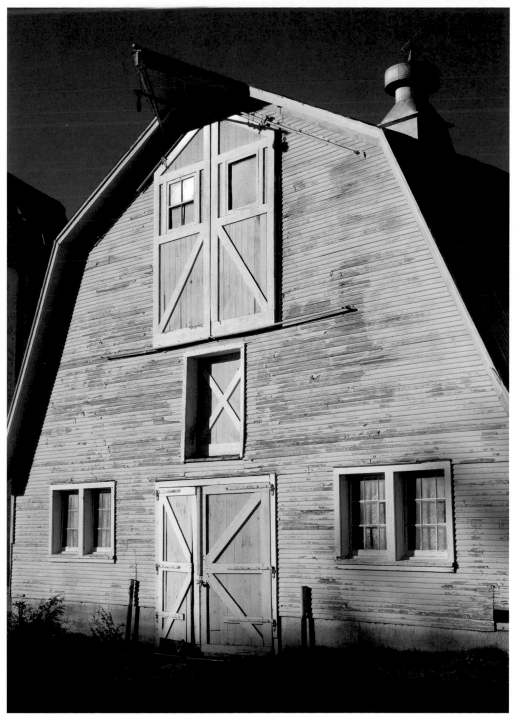

Dairy farming provided Acadiana farmers with one way to free themselves from King Cotton and the perpetual poverty that its cultivation engendered. Once a thriving component of the local economy, the dairy industry has more recently fallen on hard times. Shown here is the abandoned dairy barn at St. Charles College in Grand Coteau.

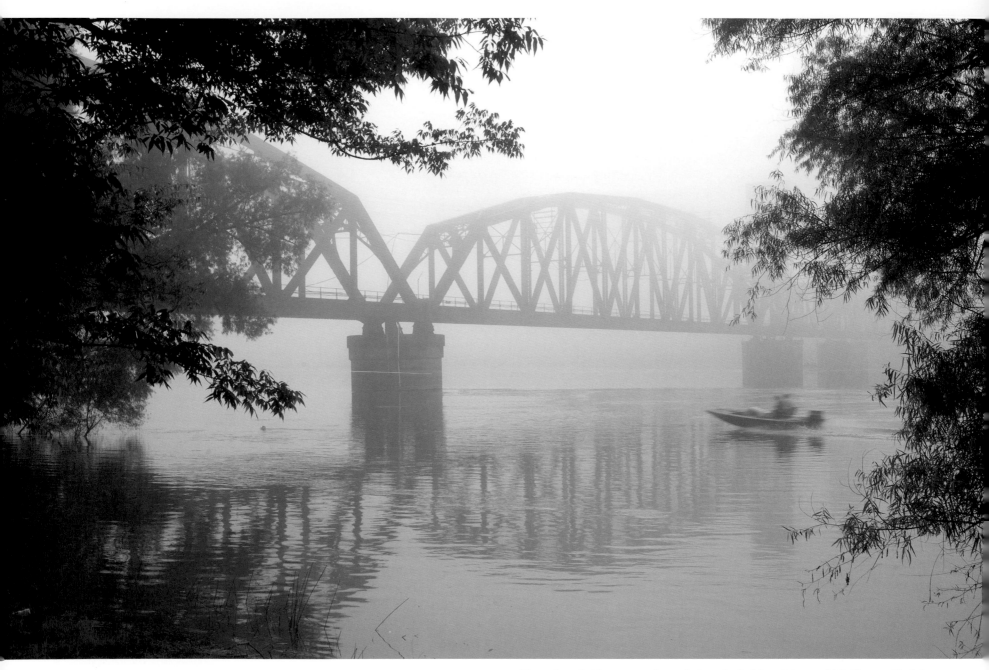

The railway bridge across the turbulent Atchafalaya River at Melville provided the upper prairie with one of its earliest direct links with Baton Rouge. During the 1927 flood, the elevated railway bed permitted evacuees to make their way to safety at Opelousas or the state capital.

5 The Lower Prairie Area

The lower prairie region, roughly the area west of the Atchafalaya River and south of an imaginary line running from Cecilia to the Sabine River, initially derived its name from the territory's indigenous people—the Attakapas. Reputedly cannibalistic, the Attakapas were a primitive, nomadic, pre-agricultural people who reportedly ranged from southeastern Texas to the edge of the Atchafalaya basin.

The Attakapas, however, were not the area's only indigenous people. In the early eighteenth century, the Chitimacha occupied lands along lower Bayou Teche and the lower Bayou Plaquemine area, with allied groups occupying lands along Bayou Lafourche. The Attakapas, however, dominate the historical narrative during the era of initial Native American–European contacts.

Southwestern Louisiana's Native Americans first encountered Europeans in the sixteenth century, when a 1528 hurricane cast upon a barrier island a flotilla of shallow-draft vessels bearing eight Spaniards, the survivors of Pánfilo de Narváez's ill-fated Spanish expedition to the eastern Gulf coast. Historians disagree over the location of the shipwreck site, variously described as Galveston Island, Timbalier Island, or Isles Dernières. In any case, the castaways were probably the initial Old World visitors to southwestern Louisiana's coastal plain. Many of the Narváez party's survivors quickly fell prey to disease, starvation, and the local Indians. Only four members of the party—Álvar Núñez Cabeza de Vaca, Alonso del Castillo Maldonado, Andrés Dorantes de Carranza, and Berber slave Estevanico—would survive and reach Mexico. The expedition's chronicler, Cabeza de Vaca, who eventually became a trader while living among the local Karankawa or Attakapas Indians, periodically traveled 120 to 150 miles from the island. The course of his peregrinations, however, remains a matter of speculation because of the rather sketchy geographical descriptions he penned following his fortuitous rescue by a party of Spaniards from New Spain in July 1536. It is nevertheless possible that he could have visited the southwestern corner of present-day Louisiana.

No other Old World travelers are known to have explored the lower prairie region before the early eighteenth century, and only a handful of Europeans and Africans visited this remote area, which remained largely uncharted on contemporary maps until the 1760s. The region was rarely visited by Old World immigrants in large part because of strongly negative, sporadic trav-

elers' accounts of the Attakapas. The most famous of these was the report of François Scimars de Bellisle, a French officer bound for New Orleans aboard the French transport vessel *Maréchal d'Estrées*, which ran aground along the Gulf coast near Galveston Bay in 1719. Shortly after the grounding, Bellisle and four companions put ashore and traveled inland to determine their location and seek help. Meanwhile, the ship, having floated free, continued its voyage, abandoning the four stranded Frenchmen to their fate. Subsequently captured and enslaved by the Attakapas, who spared his life only because a widow demanded that he become her servant and male concubine, Bellisle endured approximately a year of misery before his liberation and transportation to the French outpost at Natchitoches. Bellisle's official report of the incident, the lurid details of which enjoyed wide circulation, long discouraged European settlement in Attakapas territory, and, according to Frenchman C. C. Robin, many Louisianians still regarded the region "with horror" as late as the first decade of the nineteenth century.

The Attakapas' unsavory reputation and their lack of valuable trade goods made the French settlers and traders established along the Mississippi River after 1718 understandably reluctant to conduct trading missions to the lower prairies. According to local historian Winston Deville, the next known French incursion into the lower prairie region occurred in 1728, when one Mr. Massy, presumably Jean-Baptiste Massy, a Company of the Indies trustee, explored the area west of New Orleans. Having evidently crossed the Atchafalaya basin, where he found "a clump of trees five miles wide," Massy discovered a land of "immense and excellent" open prairies suitable for ranching.

When additional French missions failed to materialize, the peoples of the lower prairie region sent a formal delegation to New Orleans, the colonial capital, to meet with Governor Jean-Baptiste Le Moyne de Bienville and request the establishment of economic ties with the French colony. In return, the Native Americans promised to establish permanent villages and adopt a sedentary lifestyle. The Indians' mission to New Orleans produced no immediate results, but as discussed in chapter 4, on December 11, 1738, Jean Joseph Le Kintrek *dit* Dupont and Joseph Blanpain entered into a partnership to trade for "pelts, horses and merchandise" with the Attakapas and Opelousas tribes of the prairie region. The fact that horses were involved suggests that the focus

of the trading operation was actually Spanish Texas and that the Louisiana tribes possibly served as middlemen in the exchange. Much of the trading activity centered on the Attakapas region between Bayou Teche and the Mermentau River. The partners initially furnished three slaves and four orphan workers to the enterprise, but, on January 30, 1740, Le Kintrek entered into a personal services contract with Jerome Dupont and his wife, Marie Elizabeth, to engage in the fur trade at the "village of the Atacapas" and elsewhere for a six-year period. In 1741, while the Le Kintrek–Blanpain contract was still in effect, Joseph Blanpain evidently entered into an agreement with André Fabry de la Bruyère, a New Orleans bureaucrat who would later participate in an unsuccessful exploratory trading expedition to Santa Fe, to engage in the deerskin trade with the Attakapas. Their contract was rescinded on March 19, 1744, and, in the process, Fabry de la Bruyère obtained from his former partner the exclusive right to trade with the region's indigenous population. Fabry de la Bruyère appears to have remained active in the lower prairie fur trade until only around 1746, when mounting indebtedness and attendant legal problems evidently forced him to curtail his operation.

In the succeeding years, Louisiana colonists seem to have made periodic forays into the lower prairie region—at least tantalizing hints in obscure documentary sources suggest that this was the case. In 1755, André Masse, an Attakapas pioneer, unsuccessfully petitioned the Spanish government of Texas for permission to settle along the Trinity River, probably as a means of facilitating smuggling between southeastern Texas and the Attakapas region. On June 5 of the following year, several slaves owned by Masse were baptized in the Attakapas territory by an itinerant Catholic missionary. Masse freed these slaves by the 1760s, when the colonial government opened the region to more extensive settlement.

Gabriel Fuselier de la Claire, a New Orleans merchant representing a Lyon-based mercantile firm, was among the first of the new immigrants. In November 1760, he purchased from the local Indians a large tract of land just below present-day Arnaudville bounded on three sides by the southern bank of Bayou Fuselier and the western bank of Bayou Teche. This landholding, the title to which was confirmed ten years later by the colonial government, encompassed nearly 7,800 arpents. Word of Fuselier's success evidently spread throughout the colonial capital, fueling interest in the area, and by the mid-1760s, a handful of New Orleans–area settlers had also carved virtual fiefdoms for themselves along Bayou Teche. Among the most notable of these land barons were Masse and his new partner, Antoine Bernard Dauterive, a former French military officer who established a *vacherie* on the east bank of the bayou, opposite St. Martin de Tours Catholic Church, and the Grevemberg brothers, who claimed a 27-square-mile tract running from the great eastward bend of the Teche between present-day New Iberia and Keystone to the Vermilion River.

These pioneers were quickly overwhelmed demographically following the onset of the Acadian influx in 1765. In February 1765, 193 exiles, led by the legendary former Acadian resistance leader Joseph Broussard *dit* Beausoleil, arrived at New Orleans after a voyage from Halifax, Nova Scotia, via Saint-Domingue. By April 1765, the number of Acadian refugees had grown to 231. These destitute immigrants found themselves in a colony poorly prepared to receive them. Louisiana's French caretaker colonial government, desperately awaiting the arrival of its Spanish successor, was essentially bankrupt; hence, the exiles were faced with the prospect of having to support themselves with little governmental assistance. Acting governor Charles Philippe Aubry encouraged the Acadians to settle in the Attakapas territory, where the region's open grasslands would allow the immigrants to establish themselves quickly and where the Canadian transplants could begin to develop a local cattle industry. Establishment of a viable ranching industry there was essential, Aubry believed, because the colony had lost its traditional source of beef when Great Britain acquired Trans-Appalachian Louisiana in 1763. The Acadians' role as ranchers was assured on April 4, when eight refugee leaders agreed to raise cattle on shares for Dauterive. Under the terms of the contract, the Acadians agreed to tend Dauterive's livestock for six years; in return, they would receive not only half the herd's increase, but also the ranch Dauterive and Masse had acquired in the early 1760s. Louisiana's caretaker government readily ratified the agreement, and once provisioned by the head of the colonial bureaucracy with meager amounts of foodstuffs, tools, muskets, and building materials worth 15,500 *livres,* the Acadian exiles departed New Orleans for the Attakapas in late April under the direction of Louis Andry, a retired French military engineer and surveyor.

Traveling by way of Bayou Plaquemine and the Atchafalaya basin, the refugee band wended its way to the anticipated settlement site. Upon their arrival, however, the well-conceived settlement scheme began to unravel. The cause for the breakdown is uncertain, but within a month the exiles had abandoned the Masse-Dauterive *vacherie* for unclaimed lands directly above and below the ranch. Concurrent with the relocation, the exiles were stricken with a mysterious epidemic that claimed approximately one-fourth of them. Driven to desperation by their dire circumstances, the surviving Acadians dispersed: Some migrated to the Opelousas District, some to Côte Gelée (the area surrounding present-day Broussard), and some sought refuge at the Acadian Coast. Banding together into communities based upon extended families, the immigrants began the process of carving a new home from the wilderness as quickly as their health permitted, engaging in small farming and ranching with stock

THE CULT OF EVANGELINE

Since its publication in 1847, Henry Wadsworth Longfellow's epic poem *Evangeline* has shaped the international image of the Acadians and their modern-day Louisiana descendants, the Cajuns. Generations of American and Canadian schoolchildren were taught that *Evangeline* was a thinly veiled historical saga, a great North American tragedy, but one in which the principal characters were nevertheless fictional. Over the ensuing decades, however, Longfellow's heroine came to be accepted as a historical personage whose poignant story was accurately recounted by the poet. This evolution in the popular conception of Evangeline resulted from a series of historical developments in Acadiana prompted by the enduring popularity of Longfellow's literary creation.

The unprecedented success of Longfellow's epic produced cultural and economic consequences that continue to resonate throughout Acadiana. The fictional story Longfellow so carefully crafted was transformed beginning in the 1880s, when the St. Martinville local-color writer Sidonie de la Houssaye published *Pouponne et Balthazar*. This novel recast the *Evangeline* story as a French-language melodrama with a local focus. Because De la Houssaye depicted the Acadians, with the notable exception of her Acadian heroine and hero, as ignorant, vile, repulsive characters, *Pouponne et Balthazar* elicited a quiet but predictably negative reaction from the Acadian community. Felix Voorhies responded to the De la Houssaye story with an *Evangeline* derivative of his own—an English-language novelette entitled *Acadian Reminiscences: The True Story of Evangeline*. Like De la Houssaye's tale, his had a local focus, but unlike its predecessor, it conveyed an uplifting message centered on self-esteem and ethnic pride. Voorhies's work quickly supplanted that of De la Houssaye in the popular imagination.

Although the Voorhies novelette was fictional, its readers accepted its characters as historical personages, and the work served as a source of ethnic pride for Louisiana's impoverished French-speakers. They, by the dawn of the twentieth century, were lumped together by outsiders under the umbrella label "Cajun," and their culture was the object of almost universal denigration. *Acadian Reminiscences* was particularly important to persons who came of age after the onset of statewide compulsory education in 1916. Status- and image-conscious members of this generation, particularly upwardly mobile individuals, generally became "true believers" who embraced the emerging cult of Evangeline.

The cult of Evangeline was in no small part the product of the economic outgrowth of the literary-cum-cultural phenomenon that, over the course of several decades, had become so intimately linked with St. Martinville. In the 1890s, the St. Martinville area, bypassed a decade earlier by the major railroad linking Houston with New Orleans, turned to a then-revolutionary notion—tourism—to invigorate its stagnant economy. That incipient tourism industry was based upon links local community members intentionally forged with *Evangeline* through the creation of de facto shrines: the designation of the first Evangeline Oak in the 1890s, the subsequent opening of the Evangeline Enshrined Museum operated by André Olivier, and the establishment of an official Evangeline gravesite alongside St. Martin de Tours Catholic Church by the early 1920s. The effort to "enshrine" Evangeline culminated in the Roaring Twenties with the formation of an organization to lobby Congress for creation of a Longfellow-Evangeline National Park. That effort failed, largely because of the onset of the Great Depression, but it resulted instead in the creation of the Longfellow-Evangeline State Park in 1930, and, later, in the park service's designation of the antebellum Raised Creole Cottage on the park property as the residence of Louis Arceneaux, "Gabriel" in the Voorhies rendering of the tale. Meanwhile, in 1929, the Hollywood director Edwin Carewe brought his production crew to St. Martinville for on-location shots of his silent-movie version of *Evangeline*. The star of the move, Dolores del Río, was moved to tears by André Olivier's recounting of the tale of star-crossed lovers, and she dutifully provided funds to help the town underwrite the cost of erecting a statue (bearing her likeness) over Evangeline's supposed gravesite. Thus, by the mid-1930s, a remarkably robust and mature local Evangeline-based tourism infrastructure had been put into place.

Establishment of the shrines quickly engendered numerous variants of the original Longfellow-Voorhies story line, a full cataloging of which would require a separate publication. Most of these variants, however, are ultimately grounded on Voorhies's *Acadian Reminiscences*. Having acquired the mantle of age, the Voorhies saga has become sacrosanct, despite the efforts of young Acadian activists to depose Evangeline because, they maintain, the myth has distorted the image of their people. The enduring vigor of the Evangeline story stems largely from its romantic appeal to both Louisianians and outlanders, thousands of whom annually visit St. Martinville's shrines. For non-Acadians, the poignant tale of the long-separated but faithful lovers has a timeless literary quality whose universal theme was merely enhanced by the backdrop of the tragic Acadian dispersal. For many Acadians, on the other hand, *Evangeline* is literary testimonial to their ancestors' ordeal during the devastating diaspora of 1755. For these Acadians, the epic injects through its portrayal of the suffering endured by the exiles a human element sadly absent from the existing historical literature on the Grand Dérangement. The Evangeline legend will unquestionably endure, but one can only wonder what new wrinkles this old and ever-evolving story will exhibit in its future incarnations.

obtained on credit from the district's established ranchers. Working tirelessly, the Acadians achieved within a decade of their arrival a standard of living comparable to that of their pre-dispersal Canadian homeland.

Having adapted to their new surroundings, Acadian immigrants began a migration across the prairie region as the initial bayou-front settlement areas became congested, with a corresponding increase in property prices. By the mid-1770s, they occupied much of the land along Bayou Carencro and the Vermilion River.

In this first decade of settlement, the Acadians were easily the region's dominant demographic group. The 1766 census of the Attakapas District indicates that Acadians constituted 90 percent of the local households and approximately 89 percent of the total enumerated population. Although they were, and would remain, the region's dominant ethnic group, they were by no means the area's only notable colonists. The Chitimacha would continue to occupy lands near present-day Charenton, while the remaining Attakapas became ever more marginalized in the colonial era as they repeatedly sold village sites

to Acadians and then retreated to new areas beyond the western periphery of the advancing Attakapas District frontier. After 1803, they had withdrawn to prairie areas well beyond the Mermentau River.

The void created by the withdrawal of the Attakapas was filled by other groups. In 1779, two new immigrant groups would profoundly shape the local cultural landscape. The first group consisted of German and Irish refugees from religious persecution. Traveling to Louisiana from Fort Pitt (modern Pittsburgh), they arrived unannounced at the Opelousas post in 1779, after Spain's declaration of war against Great Britain as a de facto ally of the American Patriots. Although disarmed and initially held under suspicion as potential fifth columnists, the immigrants soon integrated themselves into local society. These refugees were quickly followed by other English-speaking immigrants, including the surveyor Thomas Berwick, who eventually established an Anglophone beachhead in present St. Mary Parish. This foothold would blossom into a major English-speaking enclave in French Louisiana in the early nineteenth century.

The other notable immigrant group consisted of Malagueños from southern Spain. These immigrants were recruited for Attakapas settlement by Col. Francisco Bouligny, an officer in the Louisiana garrison since August 1769, as part of an ultimately unsuccessful effort to Hispanicize the colony's overwhelmingly Francophone population. Sixteen families, numbering approximately eighty individuals, answered the call. After crossing the Atlantic and arriving at New Orleans, the Malagueños, under Bouligny's personal direction, traveled to lower Bayou Teche and began to establish a new settlement near present-day Charenton in February 1779. This nascent settlement was inundated by springtime flooding, and the hapless Spaniards were compelled to seek a new settlement site on higher ground upstream. They eventually established themselves upon a bluff near the base of the Teche's great eastern bend on property Bouligny purchased from François Prévost *dit* Colette. Although this new settlement, dubbed Nueva Iberia (New Iberia), initially showed promise, it quickly proved a failure because of several persistent problems. The Spanish farmers, for example, were unable to cultivate their traditional crops in the region's hot, humid climate, and, frustrated and increasingly disgruntled, they frequently feuded with colonial officials over government subsidies. These problems were compounded by the fact that the settlement site was overcrowded. Unfavorable gubernatorial restrictions on their movements prevented the unhappy Malagueños from leaving Nueva Iberia until 1795, when all but one of the Spanish immigrant families relocated to the banks of nearby Spanish Lake, where they subsequently engaged in ranching.

Unlike the English-speaking settlers in modern-day St. Mary Parish, the Malagueños were quickly absorbed through intermarriage into the re-

gion's French-speaking majority. In the process, many Hispanic names were Gallicized. For example, Villatoro became Viator, and Domingues became Domingue. Today, many of Acadiana's Malagueño descendants have no idea whatsoever of their Spanish heritage. The Spanish immigrant community, however, left an indelible mark on the regional cultural landscape through the introduction of the guitar, melodies incorporated into the local musical repertoire, spices, smoked meats, and, evidently, paella, which eventually evolved into jambalaya.

As the Malagueños moved into the local French cultural mainstream, other immigrant groups entered the region, leavening the region's ethnic and racial mix. In the late eighteenth and early nineteenth centuries, refugees from revolutionary France and the slave revolution in Saint-Domingue made their way into the Attakapas region. These were emphatically not members of the French aristocracy, as maintained by local lore in the St. Martinville area, but rather destitute refugees generally of modest socioeconomic backgrounds driven by desperation to a part of the globe regarded by their contemporaries in much the same way that twenty-first-century Americans view the backwaters of the Amazon basin. These refugees were followed in the nineteenth century by a steady stream of European immigrants fleeing economic and political upheavals in their respective homelands, Anglo-Americans seeking economic opportunity, and, increasingly, black slaves destined to function as the engine driving the area's economic development.

The regional economic development, like the cultural landscape, was a work in progress in the eighteenth and early nineteenth centuries. The region's earliest European visitors had successfully engaged in smuggling and the fur trade, and the Acadian immigrants revived this increasingly entrenched economic tradition following their installation along Bayou Teche. Indeed, by the early 1770s, the Teche Valley Acadians were bartering liquor for furs and horses stolen in New Spain. But the 1770s also witnessed the establishment of a viable local economy based upon agricultural production and ranching. Although much of the Attakapas' early agrarian activity centered upon subsistence agriculture, some major landowners, like former military officer Etienne de Vaugine, who owned a plantation near present-day Loreauville, began experimenting with indigo production at the behest of the Spanish colonial government. Indigo production, however, was poorly suited to southern Louisiana's climate, and it and tobacco cultivation, also strongly encouraged by the Spanish administration, both ultimately failed to take root. Local farmers turned instead to cotton, cultivating this staple in increasing quantities in the late eighteenth and early nineteenth centuries.

The burgeoning staple-crop production along Bayou Teche served as an impetus for slave acquisition and the maturation of a regional plantation econ-

omy. The 1774 census of the Attakapas District identifies 155 slaves, and the number of local bondsmen grew nearly tenfold—to 1,532 persons—by the first decade of the nineteenth century, according to the 1810 federal census.

The number of slaves and the significance of the local plantation economy increased exponentially after the War of 1812, when an army worm infestation destroyed the local cotton industry along the lower Teche. In the wake of this disaster, local farmers turned to sugar cultivation, which had slowly supplanted cotton in southern Louisiana's other riparian settlements. P. A. Champomier's directory of antebellum Louisiana sugar producers indicates that as early as the 1844 growing season St. Martin and St. Mary parishes boasted 183 notable "sugar establishments" producing collectively 23,214 hogsheads of sugar. St. Mary's output ranked third in the state.

The widespread adoption of sugar production by the antebellum Attakapas area's staple-crop producers accelerated the region's socioeconomic metamorphosis, for it brought the region's budding plantation system to full flower. Nineteenth-century sugarcane cultivation, harvesting, and processing were particularly labor-intensive, and sugar planters consequently invested heavily in slave acquisitions. In flush times, like those of the 1850s, an expanding slave force generated an exponential increase in net income, and wealth became increasingly concentrated in the hands of the planter class. By the 1820s, this class dominated the region socially, economically, and politically. The historian Karl Menn identified in the parishes carved from the old Attakapas District during the antebellum period (St. Martin, St. Mary, Lafayette, and Vermilion) 121 slave owners who possessed at least 50 slaves; 89 percent of these leading planters operated plantations along Bayou Teche.

As personal wealth became increasingly concentrated within the slave-owning elite, local society became more highly stratified. In the plantation areas, a small bourgeoisie—consisting primarily of professionals, merchants, and craftsmen catering to the planter class—emerged in the antebellum period. Members of the dwindling yeoman class and the burgeoning day-laborer caste occupied the bottom rungs of white society. Prosperous free persons of color, who owned large portions of the area's emerging towns and villages, constituted an intermediate class, whose legal rights and elevated social status separated them from the ever-growing slave masses.

The socioeconomic profile of the Attakapas plantation belt contrasted sharply with that of the prairie region to the west of Bayou Teche and the Vermilion River. Occupied primarily by individuals who had been driven from the densely populated stream banks by the impact of forced heirship, the open prairies were home to ranchers and subsistence farmers who, despite sometimes marked differences in wealth, maintained a largely egalitarian society, in which slavery was virtually unknown.

SHADOWS-ON-THE-TECHE

This historic home was built by David and Mary Clara Weeks at New Iberia between 1831 and 1834. The home features a Greek revival façade superimposed on a Creole-style, asymmetrical floor plan. David Weeks had little time to enjoy his stately mansion, for he died at New Haven, Connecticut, in August 1834.

Weeks's widow maintained control of the Shadows until her death. Ownership of the house eventually passed to her granddaughter Mary Lily Weeks, the wife of Gilbert Lewis Hall and the mother of William Weeks Hall, the last "Master of the Shadows."

William Weeks Hall, who was born in New Orleans on October 31, 1894, attended the Pennsylvania Academy of Arts in Philadelphia. A year after his mother's death in 1918, Hall purchased his aunt's share of the Shadows, and this eccentric lifelong bachelor spent much of his lifetime restoring the house and its gardens. In his declining years, Hall became increasingly concerned about the fate of the home; he even appeared on a popular nationally televised program in the 1950s to mount a public appeal for a government agency to assume responsibility for preserving and maintaining the plantation house. His efforts eventually bore fruit, and as Hall lay upon his deathbed in June 1958, he learned that the National Trust for Historic Preservation had acceded to his request. On May 30, 1974, the United States Department of the Interior named the Shadows-on-the-Teche a national historic landmark.

The juxtaposition of these largely incompatible social and economic systems was the catalyst for class warfare. Although many nouveau riche planters, particularly those of Acadian ancestry, had assumed the role of advocates for the region's yeomen, who generally remained disenfranchised until 1845, they also played a pivotal role in suppressing and terrorizing the masses in the 1850s. In the years immediately preceding the Civil War, prosperous farmers and planters railed against the inadequacies of the local criminal justice system, which allegedly failed to convict and incarcerate known criminals, who brazenly perpetrated crimes without fear of retribution. Like their contemporary counterparts in the West and Midwest, Attakapas-area property owners responded by organizing extralegal vigilante committees. The first Attakapas vigilante committee was established by Aurelien St. Julien at Côte Gelée in January 1859. Neighboring communities soon followed suit, and at its height in August 1859, this movement—the second largest in pre–Civil War America—boasted at least sixteen committees in the prairie region. These quasi-military and judicial units combed the prairies at night in search of reputed criminals—particularly individuals recently acquitted of violent crimes—who, when apprehended, were banished, flogged, or hanged. Sentences, determined in advance by fifteen-member vigilante judicial councils, were initially administered indiscriminately, and members of each major local ethnic group felt the vigilante lash.

The alleged criminals identified by the vigilantes were soon driven into exile, and spurred on by their initial success, the night riders subsequently pursued unpopular individuals and groups whose members constituted—or at least were perceived to constitute—a social, economic, or political threat to the local planter aristocracy. Immigrants, persons of low economic status involved in interracial relationships, and free persons of color were targeted and openly persecuted. Such activities cost the vigilantes public support and quickly engendered a backlash.

Although flogging was accompanied by an admonition to leave the state under penalty of death, many vigilante victims instead congregated in southwestern St. Landry Parish, near present-day Mire, and organized themselves into antivigilante groups, in emulation of their tormentors. The inevitable result was armed conflict. In early September 1859, south-central Louisiana's vigilante groups assembled to crush the perceived antivigilante threat. Led by West Point graduate Jean-Jacques Alexandre Alfred Mouton and supported by a brass cannon previously used only for ceremonial firings, several hundred vigilantes formed a battle line in front of Emilien Lagrange's fortified home, where many antivigilantes and numerous antivigilante conscripts—reportedly totaling approximately two hundred people—had gathered. Although many antivigilantes dispersed immediately after the attackers' opening shots and many others surrendered peacefully, the victors dealt harshly with their captives, beating several to death and shooting an undetermined number of others who either resisted flogging or attempted to escape into the nearby open prairie. The pro-vigilante *Opelousas Courier* suggested that an additional eighty captives were transported to Lafayette Parish, near present-day Scott, Louisiana, where they were "tried by Judge Lynch" (that is, lynched).

Though sympathetic local newspapers attempted to minimize the death toll at the so-called Battle of Bayou Queue de Tortue, this apparent bloodbath did not escape the notice of the state government. Antivigilante forces called for immediate and forceful action, but state authorities were slow to react. The government's reluctance to intervene was mistakenly interpreted by the vigilantes as tacit support. Their unabated activities eventually forced Governor Robert C. Wickliffe's hand, and the Attakapas-area vigilance committees reluctantly disbanded when Wickliffe threatened to mobilize the state militia against them in late September 1859.

With the suspension of vigilante activities in the Attakapas region, the public turned its attention to the increasingly volatile 1860 presidential election and the chain of political events that would ultimately lead to the Civil War. Alexandre Mouton, a former United States senator and Louisiana's first Democratic Party governor, had been instrumental in securing approval of the 1845 state constitution that established universal white male suffrage. Despite his controversial role as a leader of the 1859 vigilante movement, he maintained an unassailable leadership position within the Attakapas region during the 1860 election, and his fiery states' rights oratory did much to sway the local electorate—including large numbers of the nonslaveholders whom he had helped to enfranchise—to support proslavery candidate John C. Breckinridge. Following Breckinridge's defeat at the hands of Abraham Lincoln, Mouton became a leading Louisiana advocate for immediate secession, and he secured election to the state secession convention, which convened at Baton Rouge in January 1861. The assembled delegates elected Mouton as the convention's president, and under the former governor's leadership, the assembly dissolved "the union between the State of Louisiana and other States by a vote of 113 to 17."

Following Louisiana's subsequent admission into the Confederacy, the Confederate bombardment of Fort Sumter, and the start of the Civil War, scions of the local planter class volunteered for Confederate military service in large numbers. These volunteers were quickly dispatched to the eastern theater, where most served in Tennessee and Virginia. Noticeably absent in the rush to military service were the local nonslaveholders, particularly those of the prairie region who recently had been victimized by the slave-owning vigilantes who had just entered the Confederate army. The prairie dwellers' apathy toward the Confederate cause turned to open hostility following enactment of the Confederate Conscription Act in April 1862. Opposition to the measure was centered in the lower prairie parishes, where the highly individualistic farmers and ranchers viewed forced recruitment as an intolerable intrusion into their formerly peaceful lives.

Conscription was first brought home to the prairie denizens after the fall of New Orleans to Union forces in April 1862 and the ensuing transfer of the Confederate state capital from Baton Rouge to Opelousas. Fearing a Union invasion via the bayou approaches to the temporary state capital, Louisiana's government directed Brig. Gen. John G. Pratt, commander of the local state militia, to establish a training camp to process conscripts badly needed for the state's defense. Camp Pratt, an enrolling, processing, and training facility established by the facility's namesake on the northern shore of Spanish Lake near New Iberia in May 1862, became a living "purgatory" for the men forcibly compelled to train there.

These reluctant Rebels patiently awaited an opportunity to prove themselves a liability to the Confederate military as just recompense for their de facto incarceration. In their baptism of fire at the Battle of Labadieville on October 27, 1862, the Camp Pratt conscripts, now assigned to the Eighteenth Louisiana Infantry Regiment, reportedly "threw away everything they had about them, except their guns, and made back tracks, boasting as they ran, that they had not fired a gun." The conscripts' poor performance at Labadieville marked an

ominous beginning for the Confederate defense of the Lafourche and Teche regions. As the Confederates withdrew along these streams in the face of an overwhelming Union force, which initiated an invasion in mid-January 1863, the conscripts performed admirably in desperate, unsuccessful attempts to check the invaders' advance into their native parishes. As the Confederate army scrambled to the safety of northern Louisiana following its defeats at Bisland (April 12–13, 1863) and Irish Bend (April 14, 1863), the conscripts took advantage of the chaotic retreat to return to their homes.

The resulting reprieve from compulsory military service was short-lived, for the invading Union army turned southeastward after chasing their Confederate quarry as far as Alexandria and subsequently laid siege to the Rebel stronghold at Port Hudson. In an effort to lift the siege, the Confederates returned to the Teche region in force and occupied Brashear City (now Morgan City), the strategic gateway to the lower prairie area. With the returning Rebels came John Pratt and his Texan conscription enforcers, who launched a ruthless campaign to return the deserters to the Confederate army by "hunting them down with dogs, like slaves." Most of the conscript evaders consequently went into hiding, but the open prairies afforded them few sanctuaries. Some found refuge in the Atchafalaya basin, while others sought a safe haven in the coastal marshes and sparsely populated prairies west of the Mermentau River, where, according to Confederate intelligence reports, more than eight thousand deserters had congregated. Still others organized themselves into paramilitary units, called Jayhawkers by Confederate sympathizers (see chap. 4). Jayhawker bands were such superb fighting units that they effectively banished Rebel conscription units from the area between the Mermentau and the Calcasieu rivers. Popular support for Jayhawkers, initially strong, quickly evaporated, turning into open hostility as the armed conscript evaders began to support themselves through a sustained foraging campaign targeted against the local civilian population. This led to armed clashes, such as one in Vermilion Parish that resulted in the deaths of numerous alleged Jayhawkers.

In the midst of this local internecine clash, residents of the region's plantation area soon found themselves confronted by yet another threat. In August 1863, Louisiana's Union military commanders, flush from their victory at Port Hudson, mounted another invasion of the western bayou country. Dubbed the Great Texas Overland Expedition by its many detractors, this incursion actually targeted the eastern portion of the Lone Star State, but the forty-thousand-man expeditionary force advanced only as far as the Vermilionville area before grinding to a halt. Lower prairie residents initially greeted the invading

Yankees as liberators, and large numbers of Confederate deserters voluntarily surrendered to Federal authorities in the hope of receiving Union paroles and the opportunity to return home. The Union officers were only too happy to oblige.

The resulting goodwill and the euphoria it generated quickly changed to horror as the invaders proved themselves to be less palatable than Confederate conscription enforcers. As the Northern occupation of the region extended into weeks, the invaders mounted a concerted effort to destroy the area's enormous agricultural and pastoral productivity. Fields, fences, bridges, storage sheds, and barns were severely damaged or razed, while standing crops and herds were destroyed. In addition to the property damage, Union deserters and camp followers assaulted numerous women and plundered the homes of numerous elderly local residents. It was thus with great relief that the locals watched the Union invaders withdraw in the late fall of 1863.

Confederate forces followed hard on the heels of the retreating Yankees, and amidst the public backlash against the Union depredations, Rebel conscription and impressment details enjoyed remarkable success. Once restored to the Confederate service, former lower prairie deserters and new conscripts were induced to remain in the ranks by ever-tightening disciplinary measures. Because of the heightened surveillance as well as the increasing immobility of Confederate units in south Louisiana after May 1864, desertion carried unacceptable risks. However, by early 1865, the living conditions of the conscripts' families had deteriorated to such an alarming extent that the reluctant Rebels were willing to face probable execution for desertion. In January 1865, Union intelligence reports indicated that "desertions occur[ed] daily"—in large numbers. Die-hard Confederate officers hunted the deserters, whom they usually executed upon capture, with increasing tenacity until mid-May 1865, when the manhunts were suspended.

With the end of the Civil War in Louisiana in May 1865, residents of the lower prairie region—civilians and former combatants alike—faced monumental challenges. The destruction of their farmsteads and the collapse of both the economic system and the social order undergirding their world were only the most tangible manifestations of the new and difficult circumstances in which they found themselves. The enduring nature of seemingly insoluble problems, which kept the region in turmoil for decades, held profound social, economic, and political ramifications for the lower prairie region—as well as Francophone Louisiana's other major subregions.

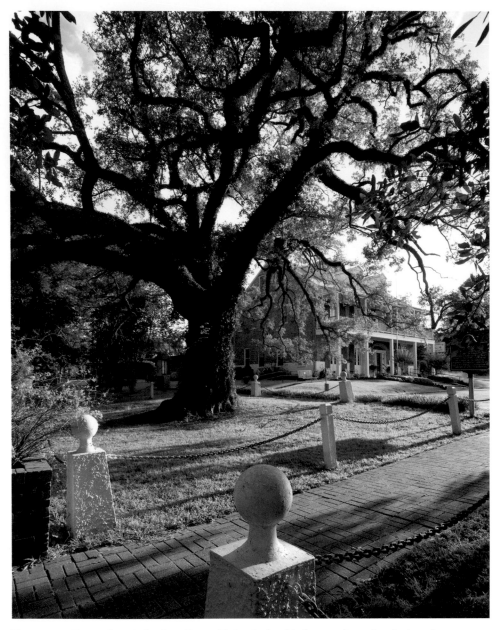

The current Evangeline Oak, along Bayou Teche, is the third tree to bear that designation.

The Evangeline statue behind St. Martin de Tours Catholic Church in St. Martinville was largely underwritten by Dolores del Río, who played the title role in the 1929 silent-movie version of Longfellow's epic poem.

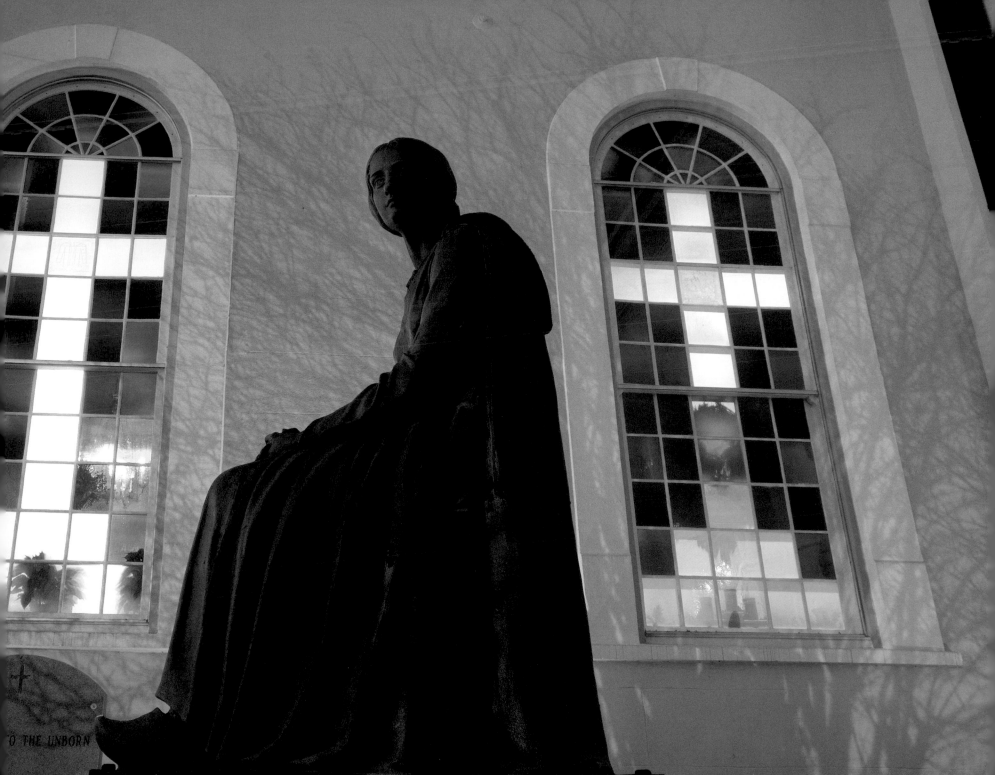

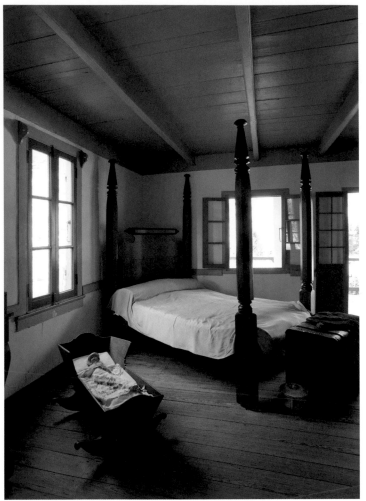

The Olivier House, a raised Creole cottage Longfellow-Evangeline State Park in St. Martinville, Louisiana's oldest state park, was originally built by the Olivier du Clozel family circa 1836.

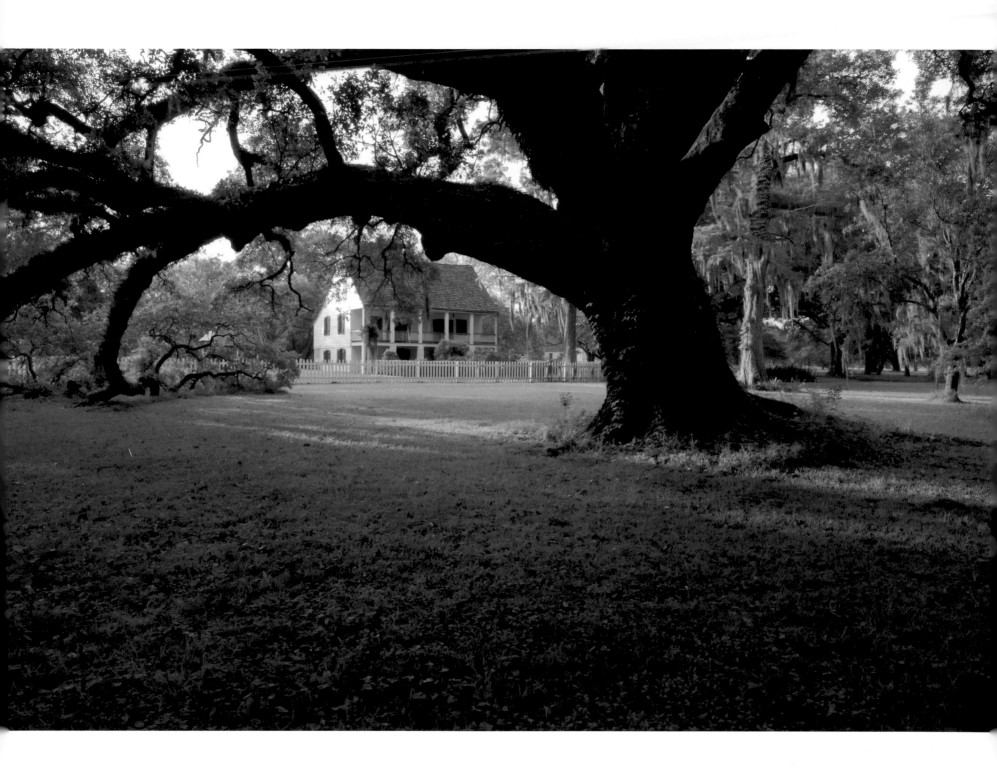

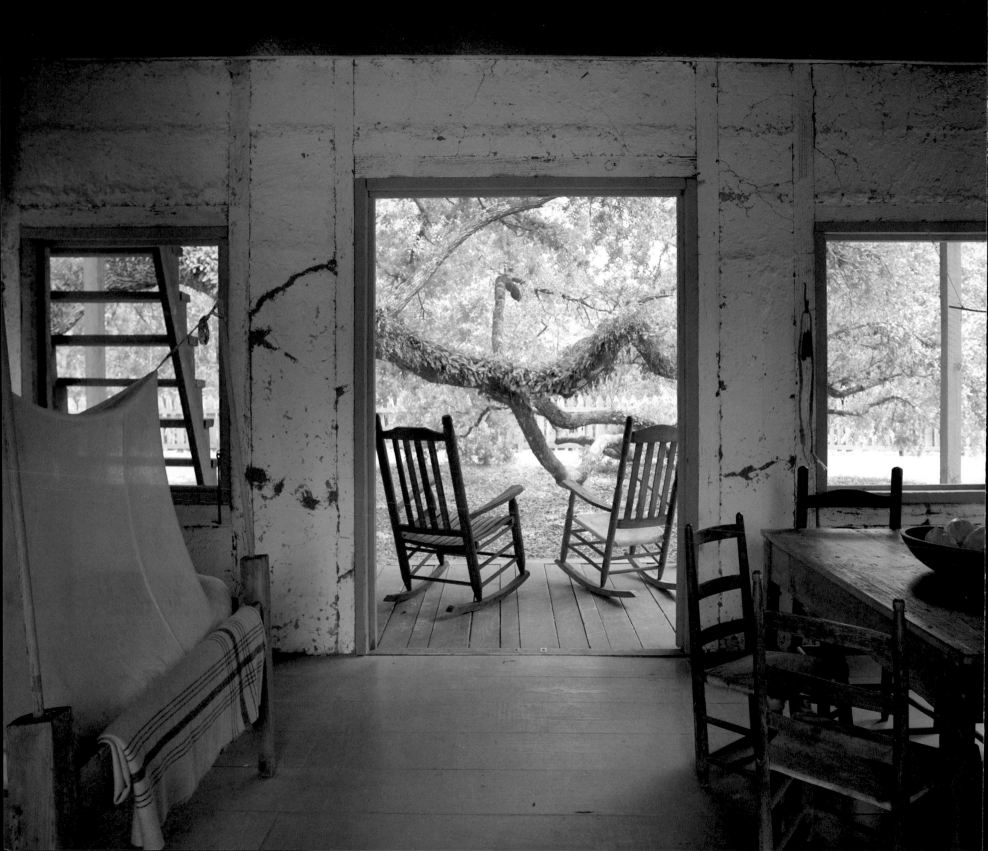

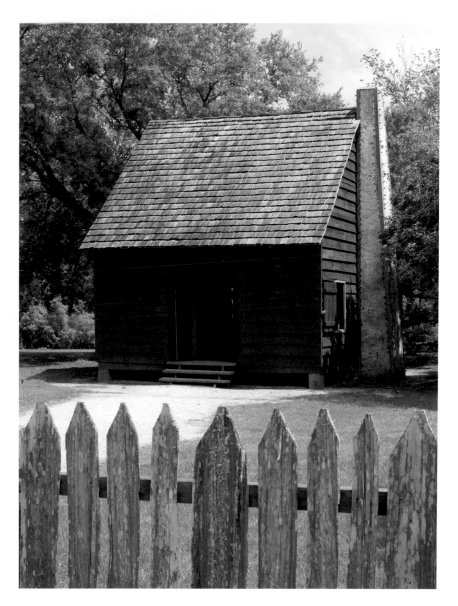

Acadian immigrants faced numerous challenges in adapting to their new homeland, the most immediate of which was securing a stable perennial food source. After experimenting unsuccessfully with cereal grains—particularly wheat—which they were accustomed to cultivating in pre-dispersal Canada, the exiles settled upon maize (corn), which had been given to them in modest quantities as seed grain by the colonial government.

Left and above right: This modern re-creation of an Acadian cabin at Longfellow-Evangeline State Park illustrates the exiles' initial attempt to adapt their original Canadian house-type, designed to maximize heat retention, to the climatic conditions of their adopted homeland.

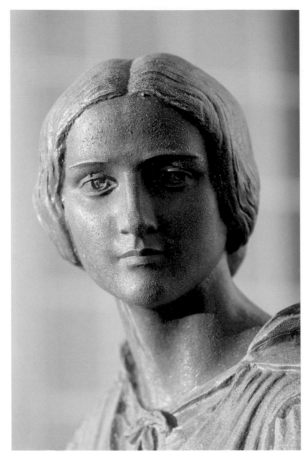

The Evangeline statue behind St. Martin de Tours Catholic Church in St. Martinville bears a pensive expression.

This large mural by famed muralist Robert Dafford at the Acadian Memorial in St. Martinville depicts the arrival of the Acadians in Louisiana's Bayou Country. Most of Dafford's models were the immigrants' living descendants.

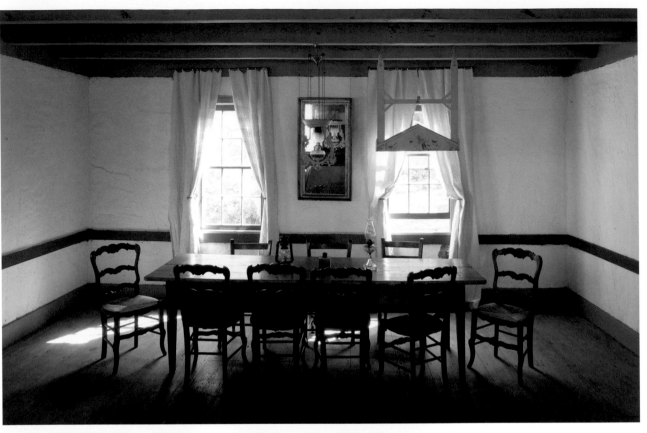

According to the architectural historian Fred Daspit, this Acadian-style home near Baldwin was built by Theodore Dumesnil circa 1830 and has remained in the family since then.

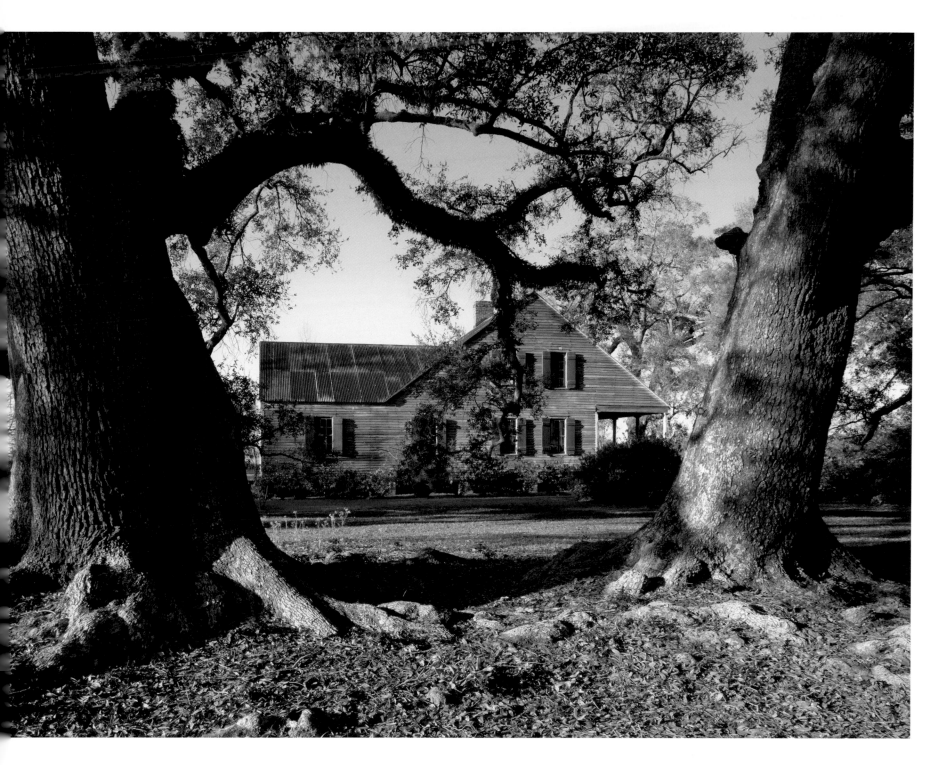

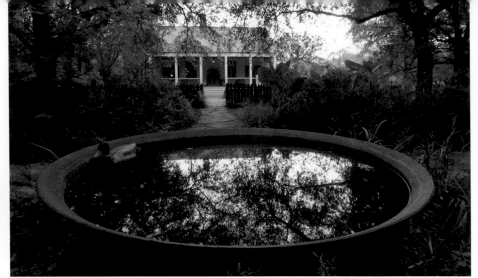

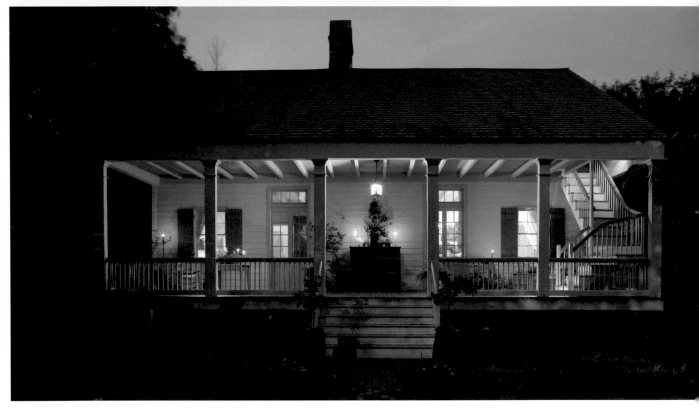

The Cenac House on Lake Martin, presently called Maison Madeleine, originally stood in a sugarcane field near Perry in Vermilion Parish, where in the late twentieth century it was converted to a storage shed. Acquired by Madeleine Cenac and moved to the Lake Martin area, the structure was lovingly restored over five years by Cenac and Mark "de Basile" Meier. Cenac now operates the building as a bed-and-breakfast inn.

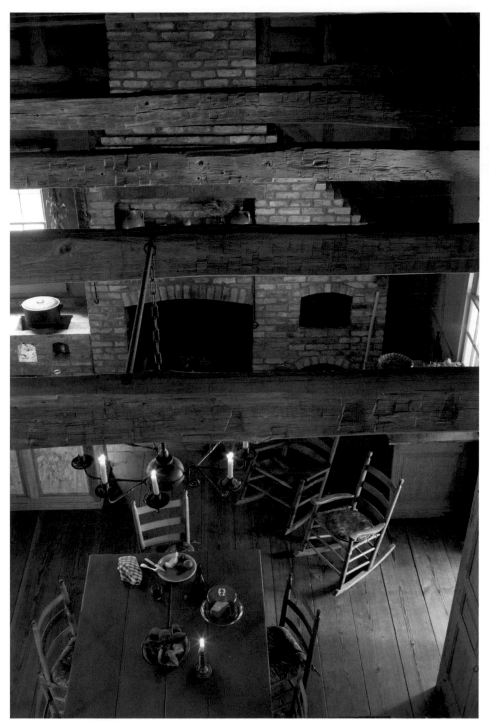

Old empty bottles are used to define the edges of a traditional bottle garden.

The area's rural population remains overwhelmingly Roman Catholic, as evidenced by the existence of the Stations of the Cross affixed to prominent trees along the St. Martinville–Catahoula highway. These stations, crèches containing tableaux depicting scenes of Christ's last hours, constitute designated venues for prayer and reflection for the local faithful, particularly on Good Friday, when dozens of individuals undertake a ten-mile pilgrimage on foot from Catahoula to St. Martinville.

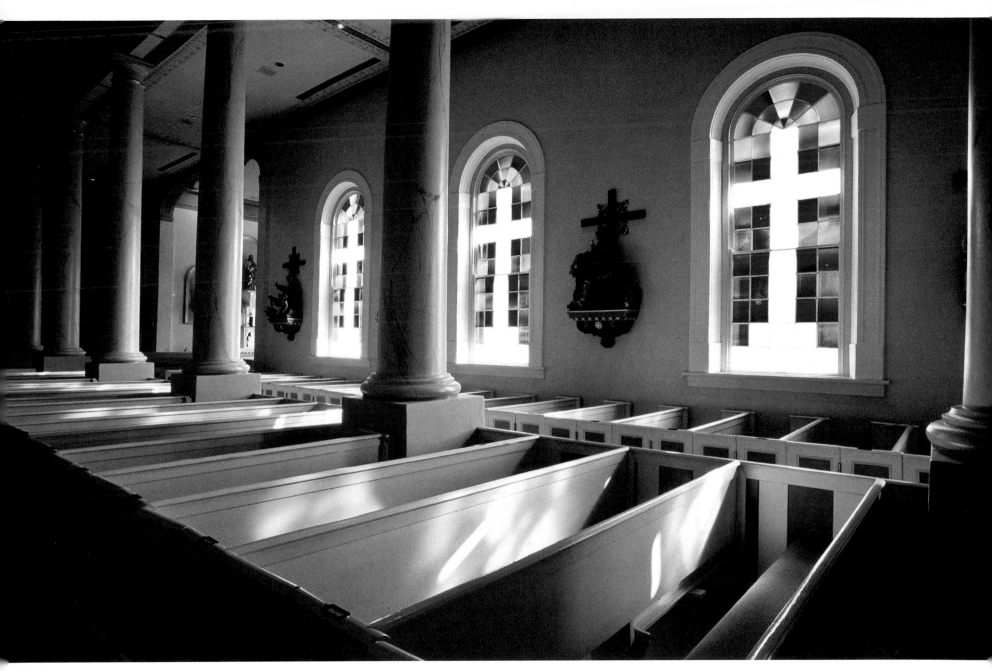

Left and above: St. Martin de Tours Catholic Church, the "mother church of the Acadians," was established by Fr. Jean-François, who was assigned to accompany a large party of Acadian exiles traveling from New Orleans to St. Martinville in 1765. The current church building was completed around 1844.

The famous Shadows-on-the-Teche, built at New Iberia in the early 1830s, is presently operated by the National Trust for Historic Preservation. In the 1920s, William Weeks Hall, a descendant of the original builders, designed an entrance path from the corner of the lot to instill visitors with a sense of awe when arriving at the Shadows.

A cast stone statue depicting spring graces a corner of the big house.

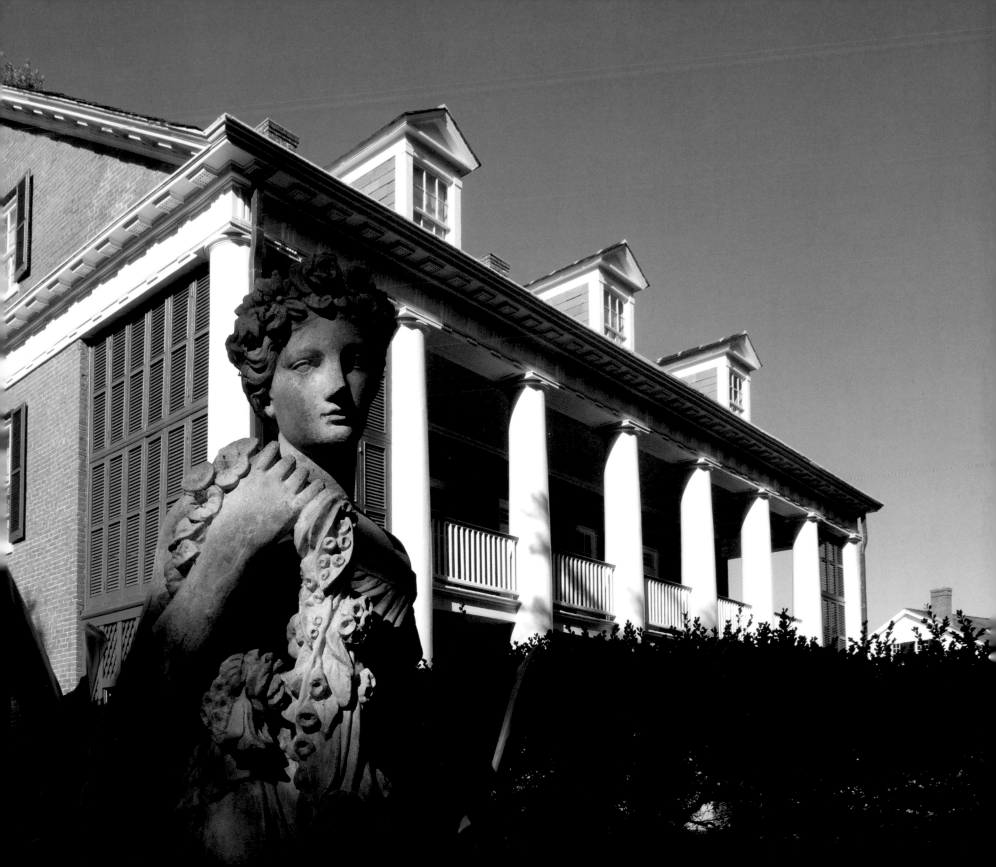

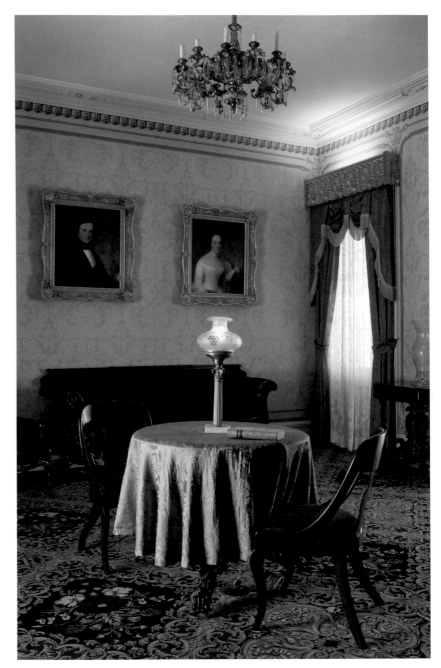

Weeks Hall's painting studio, above, is on the home's first floor. The second-floor parlor depicts the opulent lifestyle of nineteenth-century planters. Paintings on the wall show William F. Weeks and his sister Frances Weeks, both of whom lived at Shadows at various times in the nineteenth century.

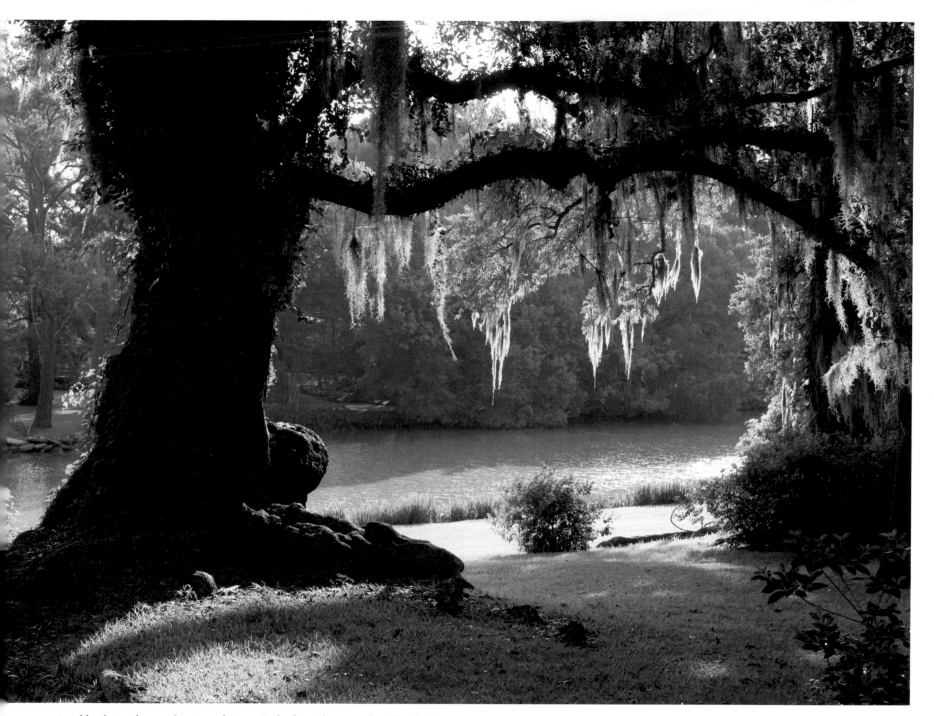

An old oak tree frames the view of Bayou Teche from the grounds at the Shadows.

Workers still pick peppers by hand each year in the surrounding fields.

Avery Island, one of five major salt domes along Acadiana's coastline, is home of the McIlhenny Company (manufacturers of world-famous Tabasco sauce), a major salt mine, and Jungle Gardens, encompassing the famous Bird City rookery. The older bottle of Tabasco Sauce at right dates back to as early as 1872.

Pepper mash is stored and aged in warehouses on Avery Island.

With a firm grip on a wood twig, an egret lands on the rookery at Avery Island to build a nest. The island is a major habitat for migratory birds.

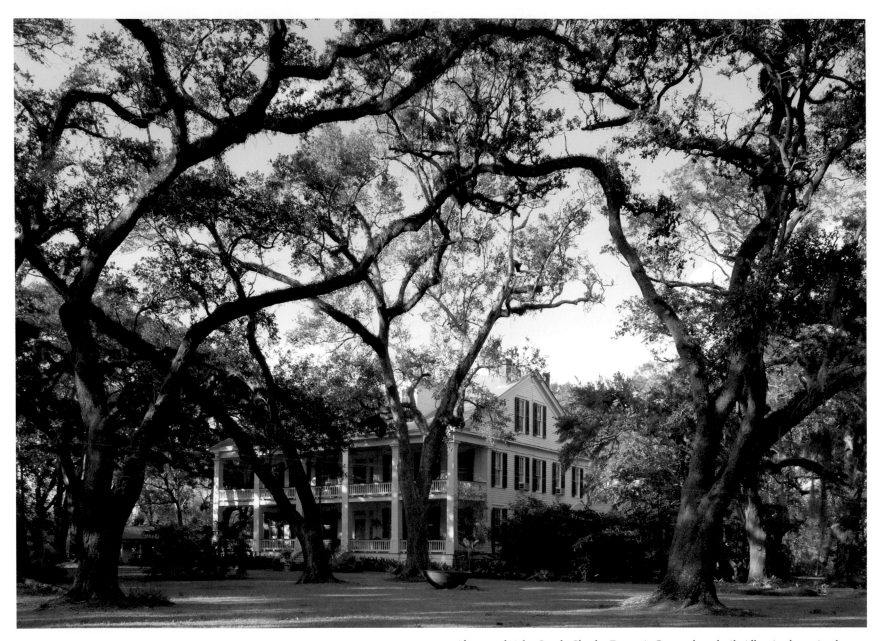

Above and right: Creole Charles François Grevemberg built Albania plantation house, a two-and-a-half-story Greek revival frame structure, along Bayou Teche sometime before 1855. In 1957, Emily Cyr Bridges purchased Albania Plantation and subsequently opened the home for tours. The home is currently under the stewardship of the renowned artist Hunt Slonem, who has faithfully restored it while maintaining its architectural legacy.

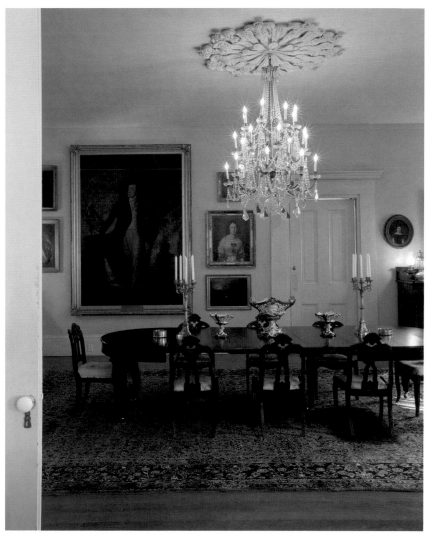

A large painting in the dining room depicts the Marquis de Lafayette in 1826. It is a copy of the original, which hangs in New York's City Hall.

Sugar is the mainstay of the agricultural economy in Acadiana's principal natural levees communities. According to the historian David O. Witten, Louisiana boasted 1,536 sugar mills in 1850. The Civil War and its aftermath ushered in a long period of consolidation and retrenchment that continued in the twentieth century. St. Mary Sugar Coop, pictured here, is one of only a dozen surviving Acadiana mills.

A barge passes downtown Morgan City on the Atchafalaya River. Originally a fishing village, the town served as the western terminus of Acadiana's earliest railroad. With the advent of offshore drilling, the town became more identified with the oil industry.

The Moresi Foundry in Jeanerette still manufactures metal parts for sugar mills.

A former bank in St. Martinville is now the aptly named Petit Paris Café.

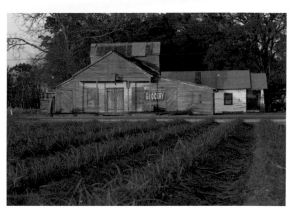

The Cedric Martin Country Store is situated on Irish Bend Road near Franklin.

Streetlights in Franklin illuminate numerous historic homes along the town's main street.

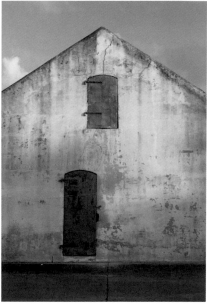

An old New Iberia warehouse

6 A Different Evolutionary Trajectory, 1865–1941

The end of the Civil War in 1865 ushered in a new and tragic chapter in the history of the disparate Acadiana subregions whose shared experience put them on a common evolutionary trajectory leading, in the late twentieth century, to governmental recognition as Louisiana's most distinctive cultural region. Like other vanquished southerners, Louisianians were bound together by defeat and despair. They faced the same overwhelming challenges and bleak prospects for economic improvement. And as they moved forward together, these shared experiences helped the region build on cultural, social, and linguistic commonalities that effectively transcended the differences that initially set these subregions apart.

Although the process of adapting to a grim new world actually began before the fighting ended, the cessation of hostilities brought a heightened sense of urgency born of extreme economic desperation. The end of slavery and its attendant labor crisis, the continuing Union military occupation of the region, and the virtual collapse of the south Louisiana economy collectively engendered an enduring regional crisis that persisted for decades.

The survivors' most immediate concern, however, was the region's extensive wartime devastation and the very real prospect of starvation. Many fields had not been cultivated since 1861. Clearing the land, however, proved exceedingly difficult because of manpower shortages. The only locally available white men in Acadiana were old, infirm, or disabled by battlefield wounds. Able-bodied veterans were still scattered across the United States, engaged in a long and arduous trek home, usually on foot. Their eventual return placed an even greater strain on their families' already almost depleted food stocks. Former slaves faced even more desperate circumstances. Lacking the property necessary to grow their own food and facing the prospect of long-term unemployment because of the almost universal bankruptcy of the landowners, the freedmen found themselves in dire straits indeed.

Such desperate circumstances demanded swift remedies, but clearing the fields and resuming normal agricultural operations proved a thorny problem. Foraging Union and Confederate armies had confiscated virtually all of the region's draft animals, and most of the fences, sheds, and tools were no longer serviceable as a result of protracted neglect or destruction at the hands of Union invaders. In fact, local demand for draft animals was so great that, by 1867, the cost of a mule had skyrocketed to $250 ($3,800 in 2010 currency)

per head. Few farmers could pay such exorbitant prices, despite the fact that a farming operation's survival usually hinged upon such purchases.

On October 15, 1881, the editor of the *Pointe Coupée Banner* recalled the situation: "when peace came it found this a desolate place and an impoverished people. . . . At this time there was not a house in decent repair. . . . [T]here was not a good fence, not a single stream, gin, no supply of work stock, and only a few broken down old mules and Creole ponies." Extant local histories make it painfully clear that similarly dire conditions existed throughout Acadiana.

The wartime destruction precipitated a lingering economic crisis compounded by the scarcity of credit. Farmers, then as now, relied heavily upon credit to fund their normal operations. Many farmers were already heavily indebted to Louisiana's few antebellum banks when the Civil War erupted. While they generally found bankers willing to extend credit in the conflict's immediate aftermath, when commodity prices—especially cotton prices—were at unprecedented highs, the availability of credit became increasingly problematic as the postwar era progressed and natural and man-made disasters stymied the anticipated agrarian recovery.

Acadiana residents of all backgrounds fully experienced the ravages of postwar apocalypse. The 1867 yellow fever epidemic, the state's second-worst nineteenth-century contagion, struck with particular severity in Acadiana's towns and villages, decimating the region's agricultural labor force. Despite these myriad problems, Acadiana's residents made a courageous effort to start life anew. But even "successful" years failed to provide much financial relief. In late 1865 and early 1866, for example, Pointe Coupée–area farmers had to recruit laborers to clear and cultivate long-idle fields, and the disappointing proceeds were used exclusively, according to one source, to buy "mules and plows and . . . fencing." The modest gains of 1866 were erased by the severe yellow fever epidemic, which greatly restricted available manpower, and the devastating flood of the following year. Man-made levees failed again in 1868, causing extensive flooding and devastation. As a consequence, many Acadiana farmers were land poor and indebted beyond all hope of financial redemption by 1873, when a national depression forced Louisiana creditors to call in their debts. In the wake of the resulting foreclosures, the surviving landowners, exploiting the distress of the region's large landless population, turned to sharecropping to ensure their own economic fortunes.

Although life was particularly bleak for individuals at the bottom of the regional socioeconomic ladder, mere existence was difficult for most of the local population in the postbellum era. Shortly after the Civil War's conclusion, Dr. Clarence Ward, editor of the *Iberville South* (Plaquemine), lamented that "the fortunes of war have brought well nigh all of us to the same estate, and that condition is one of startling, and in many instances, distressing poverty. The rich of yesterday are poor today, and the ever poor are poor indeed." The 1870 census of the Acadiana area bears grim testimony to Ward's observations. The decade following the war's conclusion witnessed the transformation of the region's highly stratified society into one that closely resembled the modern "third-world" model. By the 1890s, a small elite owned most of the local wealth. Beneath them in the local hierarchy existed a small middle class consisting of urban professionals and surviving yeomen, and a huge underclass made up of freedmen (former slaves) and former yeomen all reduced to tenancy. Crop liens, the high cost of credit, and the capricious local weather made the plight of tenant farmers increasingly desperate over the course of the ensuing decades, and a sense of desperation resulted, even as the region's economy became increasingly industrialized.

Acadiana's continuing economic woes were compounded still further by social and political upheavals as the local population adjusted to a new social order. The area's large African American community made great strides during the Reconstruction era (1862–77), particularly after the 1868 state constitution accorded people of color social privileges and political rights undreamed of a decade before. Thirty-five African Americans served in the lower house of the state legislature during the 1868–70 term; fifteen of them represented Acadiana districts. Acadiana delegates of African ancestry also constituted roughly one-third of the black delegation at the 1868 state constitutional convention. Freedmen and former free persons of color were equally prominent on the local political stage. For example, during the 1870s, two men of African ancestry—former free persons of color—served as sheriff of Pointe Coupée Parish, while two other African Americans functioned as Pointe Coupée Parish police jurors—one as police jury president. Five Creoles of color also represented the parish in the state legislature. In Ascension Parish, Pierre Landry became the nation's first African American mayor. The sudden flowering of black political power was made possible by the enfranchisement of the huge body of freedmen, who openly voted for the candidates of their choice before the end of Reconstruction. Following Reconstruction, however, that window of opportunity quickly closed, for terrorism by white vigilante groups and the race-based voting requirements of the 1898 state constitution effectively disenfranchised the vast majority of the region's black electorate.

The resulting black backlash against white supremacy brought about the development of African American religious congregations, particularly among Protestant denominations, in rural areas throughout Acadiana. The separation of the races, which development of the black churches symbolically represented and which permeated most aspects of local daily life by the turn of the twentieth century, was institutionalized by the U.S. Supreme Court's *Plessy v. Ferguson* ruling in 1896.

"Jim Crow" segregation would remain a fixture of daily life for two generations. The resulting lack of economic and educational opportunity drove many blacks—including the famed writer Ernest J. Gaines—to seek a better life elsewhere. For those who stayed behind, everyday life was almost universally difficult and socially, educationally, politically, and economically constrained.

Amidst the postbellum tumult, Acadiana experienced a communications revolution that transformed the area. Prior to the Civil War, Acadiana was linked to the outside world primarily by the traffic on its many waterways. Waterborne connections, however, were problematic because communication with the rest of the Mississippi Valley was seasonal, dangerous, and expensive (see chap. 4). The development of rail transportation in the area, begun in the 1850s with the construction of a line extending from Algiers to Brashear City (now Morgan City), was interrupted by the Civil War and the ensuing economic crisis. Not until the late 1870s would the economy and the reconstitution of the railroad company permit construction work to resume. In 1880, iron rails extended from Brashear City to Vermilionville. The following year, rails connected Vermilionville with Opelousas to the north, transforming the sleepy backwater community into a major regional transportation and communications hub.

The rail network radiating from such nascent transportation hubs became increasingly extensive and intricate in the ensuing years, and railroads traversing the prairies and following the natural levees bound the region ever closer together while at the same time tying it ever more securely to the rest of the nation. Indeed, by the 1890s, Acadiana's major railroad towns were connected not only to New Orleans and Los Angeles, but also to virtually every other major American metropolitan center.

These new transportation ties brought about a regional economic, cultural, and demographic revolution. The ready availability of rail service to major national markets, the availability of cheap land, and the region's temperate winters proved irresistibly attractive to thousands of Midwest farmers, who carved a new prairie home for themselves in the area between present Louisiana Hwy 13 and the Calcasieu River. After failed attempts to introduce wheat cultivation to the southwestern Louisiana prairies, these midwestern transplants turned their considerable agricultural skills, ingenuity, and state-of-the-art, steam-powered equipment to the establishment of a major regional

rice industry. In the process, they spawned a local culinary revolution and a shift away from the locals' traditional corn-based diet.

The rice field operations led to the establishment of a rice milling, processing, and transportation infrastructure in the prairie rail centers. Additional industrial development occurred in virtually every corner of Acadiana served

ACADIANA'S HIGHWAY SYSTEM

As in other frontier areas, Acadiana's early roadway system developed haphazardly. Because of the dense hardwood forests on the natural levees and the swampy backlands, the region's Native American, European, and African settlers relied instead upon Acadiana's numerous navigable waterways for transportation and communication. For most of Acadiana, the development of a land-based system effectively began with a land ordinance promulgated by Governor Alejandro O'Reilly in February 1770. O'Reilly's land regulations required all persons seeking Spanish land grants to meet specified criteria, including the construction and maintenance of a crude roadway across their respective properties and the connection of these lanes with those of their neighbors. In the late eighteenth and early nineteenth centuries, local government entities enhanced, then expanded the regional roadway system by building bridges across bayous and, later, by constructing farm-to-market roads from interior settlements to inland ports. But because these roads would be maintained by local property owners from colonial times until the twentieth century, the roads were universally poorly marked and even more poorly maintained. The following observation, from Emily Caroline Douglas in Acadiana in 1860, is representative: "[T]here is really nothing to mark the road save a few fences and trodden paths." In July 1898, the *Opelousas Courier* lamented, "We have heard complaints about an ugly mud-hole in the public road between Callahan bridge and town, making it dangerous to travel that route even in daylight." In 1911, Louisiana's government listed 25,000 miles of roadways within the state—virtually all of which were unimproved dirt roads. By the end of World War I, 671 miles of roadways had been upgraded with gravel or shell surfaces, but as late as 1919, the state's total highway budget was nevertheless a mere $140,000.

Significant improvements to Acadiana's roadway system began only after 1920, when an infusion of sorely needed federal highway funds, supplemented by the ambitious state highway initiatives of Governors John M. Parker and Huey P. Long, allowed Louisiana to join the rest of the country in a headlong rush to accommodate the automobile age. Such a move was necessary because, by early 1928, state residents had registered more than 255,000 vehicles with Louisiana authorities. By 1930, nearly 700 miles of Louisiana roads had been hard-surfaced—with approximately half of this construction activity taking place during Huey Long's brief gubernatorial term.

As a result of this frenzy of road development, most of Acadiana's core highway infrastructure was completed by World War II. The post–World War II era, however, witnessed an exponential increase in improved roadways thanks to the development of interstate highway systems (I-10 and I-49) through the region, the improvement and expansion of existing federal highways, and the hard-surfacing of numerous parish farm-to-market roads during the oil boom of the 1960s and 1970s.

by the rail system. Industrial development—based primarily upon the processing of the region's great natural bounty—continued apace throughout the region, even the coastal plain. The late nineteenth and early twentieth centuries, for example, saw the establishment of significant canning and bottling operations, including the now internationally famous Tabasco operation at Avery Island, vegetable canneries, commercial syrup mills and sugar refineries, and the world's largest oyster and shrimp canneries.

Persons not migrating into industrial facilities often found a way to tap into outside markets by means of the region's new rail system. Commercial hunters, for example, shipped enormous quantities of wild ducks packed in barrels to New Orleans via rail from coastal wetlands—reportedly 500,000 in 1886 alone. Commercial fishermen in the Atchafalaya and oystermen in the marshes also found a ready market for their catch in the Crescent City. In the prairie region, locals increasingly geared their exports to urban markets. In the early twentieth century, for example, Rayne shipped not only thousands of frog legs to upscale restaurants in the upper Midwest and Northeast, but also hundreds of thousands of eggs to metropolitan groceries in Los Angeles, New Orleans, Pittsburgh, New York, and other urban centers.

These manifold developments were initially complemented and eventually eclipsed by the emergence of the south Louisiana petroleum industry. After the discovery of oil in Texas's Spindletop field in 1901, thousands of Acadiana residents migrated into the Lone Star State's so-called Golden Triangle area in search of a new life. Most of these emigrants were from the lower and upper prairie regions. Economic hardship also drove many poor whites east of the Atchafalaya basin to seek employment in Baton Rouge, where the Standard Oil Refinery provided steady, high-paying work and a chance for advancement, both of which were in exceedingly short supply in their home parishes, where tenantry had been the norm since the end of Reconstruction.

Limited prosperity also came through local petroleum exploration and development. Only months after Spindletop, wildcatters discovered oil in the Evangeline field (Acadia Parish), and oil fever gripped southern Louisiana. Scott and Alba Heywood, geologists instrumental in the discovery and development of the Evangeline field, became immediate celebrities sought out by every Acadiana community desiring to become the next Louisiana boomtown. Between January 1901 and late December 1919, 107 oil wells were completed in Acadiana parishes, but over the next twenty years, oilfield crews, at first composed primarily of transplanted Texans and Oklahomans, brought in an additional 3,648 wells.

Transplanted oil workers were not the only outsiders radically transforming the cultural and economic landscape of Acadiana. Whistle-stops along the major rail trunk lines in communities such as Franklin, New Iberia, Lafay-

ette, and Crowley usually boasted "opera houses"—actually community performance centers. These theaters rarely presented actual operatic productions; instead, they typically hosted "one-night stands" by traveling troupes of minstrels, vaudevillians, musicians, and journeyman actors. These performances were complemented by periodic visits by touring circuses and other tent shows and well-attended annual local Chautauquas, which made available to local audiences presentations by nationally noted motivational speakers, academics, and musicians.

Local contacts with the outside world were sustained and expanded through the introduction of the wildly popular silent movies and, later, "talkies"; Progressive-era health reforms and the establishment of strict food-processing and restaurant regulations enforced by government inspectors; national and state conservation measures and the appearance of game wardens; and compulsory education (1916) and the attendant importation of hundreds of Anglo-American teachers. The burgeoning Americanization juggernaut, however, reached its zenith during the First World War (1917–18), when 19,003 Acadiana men and women—black and white—were inducted into military service and dispatched to training facilities throughout the United States. On the home front, Acadiana residents were subjected to wartime rationing, price controls, and "patriotic" educational programs, as well as national health regulations and quarantines during the terrible 1918 Spanish influenza epidemic.

Nor did the forces of Americanization abate in the post–World War I era. In the 1920s, local civic leaders launched lobbying efforts to secure development of national roadways through their towns. Particularly successful were the efforts of the region's Progressives to participate in development of the Pershing Highway (from Winnipeg to New Orleans, along the general route of U.S. 167) and the Old Spanish Trail (now U.S. 90).

Large numbers of "plain folk" increased their own connectedness with the rest of the country through the introduction of affordable home radios capable of receiving clear-channel radio broadcasts from throughout the eastern half of the country. Anecdotal information indicates that, by 1940, even trappers in coastal Vermilion Parish and fishermen in lower Lafourche used radios at their remote worksites.

Other postwar federal incursions were far less welcome. This was particularly true of Prohibition (1920–33), which engendered an almost universal grassroots backlash in Acadiana and a decade-long local struggle against federal "revenuers." The sometimes acrimonious cultural/political dialogue between "locals" and "outsiders" became more pervasive and intense as the entre-deux-guerres era continued to unfold. The 1927 flood—America's worst peacetime disaster to that date—displaced approximately one hundred thousand people from the western periphery of the Atchafalaya basin. Perhaps half of these evacuees were admitted to Red Cross camps at Lafayette, Opelousas, and New Iberia. Thousands of other evacuees from the basin's northeastern edge sought refuge in Baton Rouge's Red Cross camps. These camps became the foci of a very active culture war between the facilities' Anglo-Protestant administrators and the Franco-Catholic "inmates," who were virtual prisoners in the Red Cross facilities. For example, heated disputes resulted from administrators' refusals to allow the camp residents to eat their traditional foods, and family-planning classes were presented over the objections of local Catholic prelates. When not embroiled in the cultural skirmishing, many evacuees had their first encounters with the technological wonders of the age—electric lights, movies, running water, and indoor plumbing—amenities that many of Acadiana's town dwellers had taken for granted for nearly a generation. This exposure created an insatiable demand for these tangible fruits of Americanization.

After the floodwaters receded and the Red Cross closed its refugee camps, Congress took up the issue of establishing effective flood protection for the entire Mississippi River valley. The resulting massive levee-construction project in the Atchafalaya basin forever altered the hydrology of the entire Acadiana area, and in the process, the Corps became (and remained) the area's environmental arbiter.

The federal government's presence became increasingly stronger during the Great Depression as desperate Acadiana residents became ever more reliant upon governmental services and support. The region—like the remainder of the Gulf South—had been gripped by a persistent and deep economic depression resulting from the overproduction of staple crops during the First World War and its aftermath. Local newspaper reports suggest that the typical Acadiana farmer failed to turn a profit between 1920 and the 1927 flood, which literally washed away most of the modest economic progress made in the local agricultural sector over the previous four decades. Increasingly dire local economic circumstances emerged in the wake of the 1929 stock market crash and the onset of the Great Depression. The situation in Lafayette Parish provides a representative example of the resulting regional economic crisis. Between 1930 and 1935, 29 percent of the local work force was laid off, and twelve of the thirty local manufacturing establishments were forced to close their doors permanently. Farm income declined by 65 percent, and local property values fell at least 35 percent. Farm wages fell to one dollar per day, and a soup kitchen, operated with private funds, was established in the basement of the parish courthouse to feed the malnourished urban poor. Reeling under the effect of this economic dislocation, Lafayette's second-largest bank ceased operations.

Such severe economic woes forced thousands of Acadiana residents to seek

alternative employment opportunities. Many gratefully accepted jobs in New Deal public works and conservation programs, or in the increasingly active south Louisiana oil patch. Those who could not find oil industry jobs, government employment, or public relief adapted to the seemingly endless hard times in other ways. In the prairies and water-bottom areas, for example, some small farmers experimented with new crops, particularly sweet potatoes. Crop diversification, however, brought meaningful relief to few Acadiana residents. Thousands of sharecroppers and economically stricken small farmers consequently abandoned Acadiana altogether for high-paying, dependable jobs in the refineries, shipyards, and oilfields of southeastern Texas's Golden Triangle area. Those who could—or would—not leave sometimes resorted to extreme survival measures that they would never have considered appropriate a decade earlier. For instance, trappers and fishermen in Acadiana's coastal plain attempted to unionize in the 1930s to combat increasingly unfavorable market prices as well as increasingly ruthless exploitation by individuals who had acquired titles to the formerly public marshlands after World War I.

In the depths of the Great Depression, Acadiana found itself at a second postbellum watershed. The area's physical isolation had ended with the transportation revolution of the 1880s; now, in the economic turmoil of the 1930s, the story of the region's social isolation had drawn to a close. How, then, did Acadiana maintain its social distinctiveness to the present? The answer lies in the uneven pace of the region's sometimes creeping, sometimes galloping Americanization. A dichotomy existed: Americanization was most pronounced, as one would expect, in urban spaces, while regionally rooted ethnic traditions persisted longer in rural Francophone communities. For example, in Napoleonville, the seat of justice in Assumption Parish, monolingual English-speaking households accounted

Lafayette native Jean-Jacques Alfred Mouton, a West Point graduate, served with distinction as a Confederate general until his death at the Battle of Mansfield in 1864.

for fully 92 percent of all households within the corporation limits, whereas in the nearby rural community of Chackbay, where a majority of the men worked in the swamps as day laborers for timber companies, 87 percent of the population did not speak English at home.

Rural Francophone communities were almost universally denigrated and even lampooned in the local print and electronic media. Indeed, New Orleanian Walter Coquille, an ethnic humorist in the mold of the era's "ethnic" comedians and the host of the immensely popular *Mayor of Bayou Pom-Pom* radio program, was unquestionably south Louisiana's most popular Depression-era entertainer. Such open disparagement of the region's rural French-speaking population speaks volumes about the Francophones' social and cultural isolation from the mainstream. Yet, although such isolation impeded Americanization, it by no means neutralized the encroachment of national mainstream culture in the rural areas.

Even in the domestic sphere, times were unquestionably changing. Between 1910 and 1930, the house dance had given way to the dance hall; the fiddle had succumbed to the accordion; and the *veillée* had made way for a family gathering around a battery-powered radio. The French language and "traditional" culture would nevertheless remain dominant in many rural enclaves until the mid-1930s, when, as the historian Shane Bernard has demonstrated through census data, French language usage declined precipitously among Acadiana's rural youths. It is precisely this metamorphosis that permitted the development of the cultural institutions for which the region is now internationally known—Cajun music, Cajun cuisine, and zydeco, all of which are products of the twentieth century and all of which reached the pinnacle of their development after Japanese bombs fell on Pearl Harbor on December 7, 1941.

Right: A Robert Dafford mural, painted in 2000, depicts downtown Lafayette in 1900. The Gordon Hotel, Lafayette's great landmark of that era, looms in the background. The mural was removed in 2003 to build the Acadiana Center for the Arts and eventually the James Devin Moncus Performing Arts Theater in 2010.

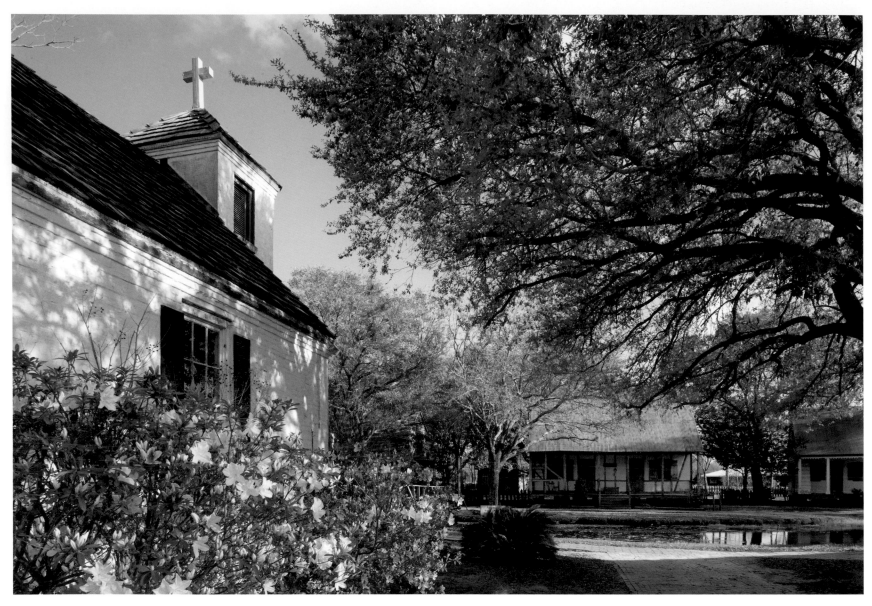

Traditional Acadian houses and a chapel line a small pond running through Acadian Village in Lafayette. In 1976, Lafayette-area preservationists collaborated with officials of the Lafayette Association for Retarded Citizens to establish Acadian Village, a collection of historic Acadian-style homes threatened with imminent destruction. The resulting museum was intended to promote historic preservation by fostering an appreciation for indigenous architectural styles and to generate revenues through ticket sales that, in turn, were to provide employment opportunities for mentally handicapped persons.

A wooden cistern located behind the Castille House collects rainwater. Such cisterns were vital for a homestead in the early years.

A cypress cabinet holds dishes and some dry goods at the Billeaud House.

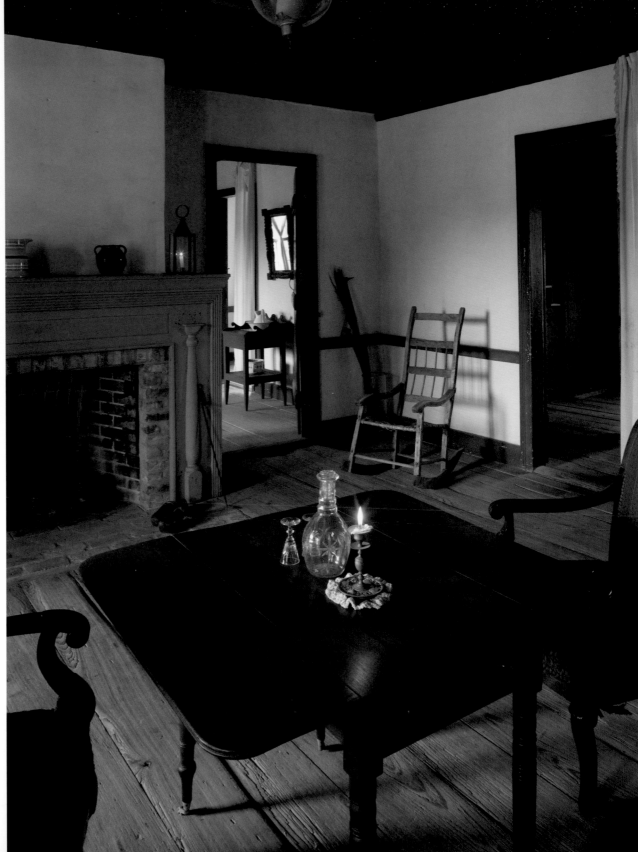

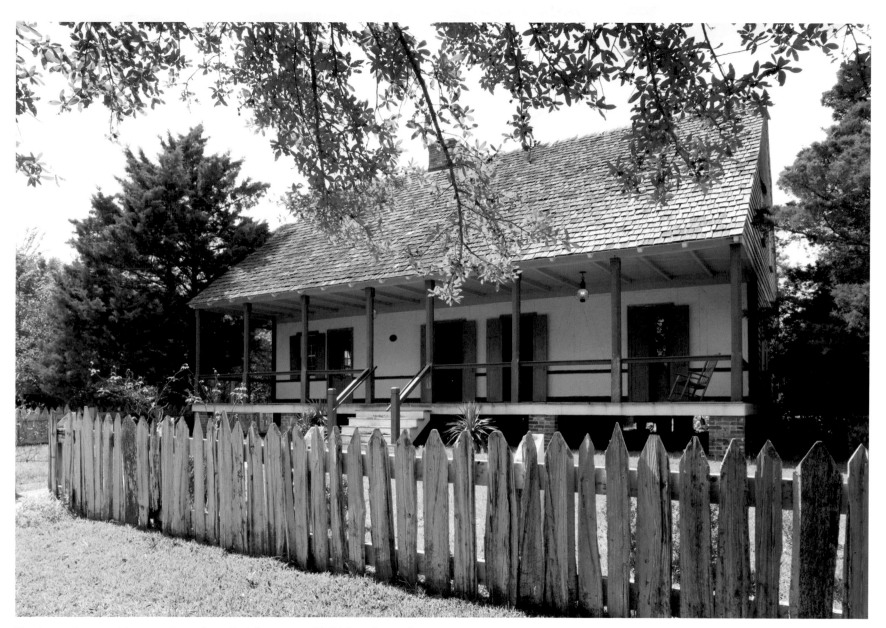

The Amant Broussard House at Vermilionville (a heritage and folklife park in Lafayette) was originally built near present-day Loreauville in Iberia Parish circa 1790. Amant Broussard was the son of Beausoleil, leader of the Acadians during the Grand Dérangement in the eighteenth century.

The Lafayette Museum is a three-building complex consisting of a two-story town-house with a distinctive cupola (shown here), an Acadian-style house (the original residence, later used as a detached kitchen), and a brick smokehouse. The original house was the temporary residence of Alexandre Mouton, a U.S. senator, governor, and president of the state secession convention. *Above:* A book on the French Revolution is illuminated by candlelight at the museum.

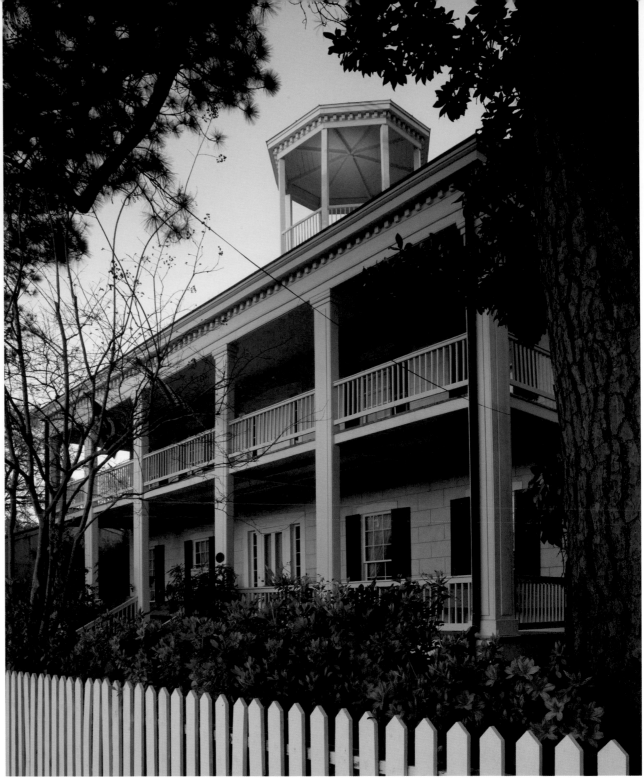

Designed by the architect George Knapp, Lafayette's Old City Hall first opened its doors as the Bank of Lafayette on June 21, 1898. It subsequently became the city hall; in recent decades, this building has served as the headquarters for the Council for the Development of French in Louisiana (CODOFIL).

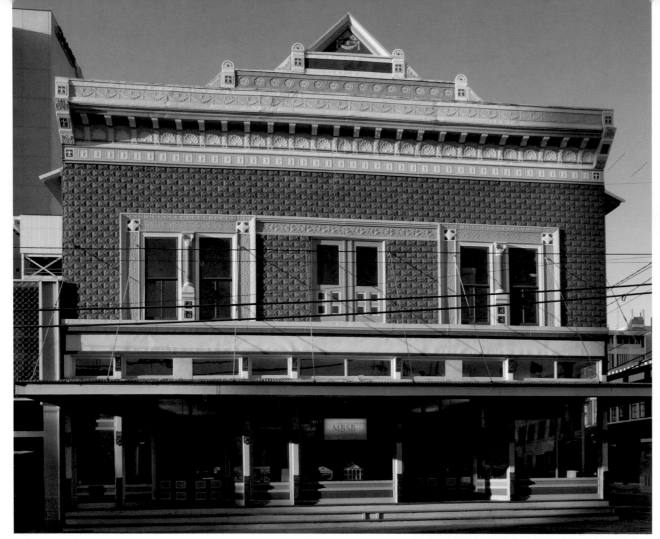

The Bank of Lafayette, better known as the Old Guaranty Bank Building, was built in 1905. Guaranty Bank acquired the building during the Depression.

The old Lafayette Hardware Store is typical of the frame structures that dominated the architectural landscape of Acadiana's small towns at the turn of the twentieth century. The building now serves as offices for MBSB Group Architects.

Original signage on Lafayette Hardware's exterior is revealed during demolition of an adjacent building's wall. Structures from the nineteenth century were quite susceptible to fire, and after blazes ravaged many downtown areas between 1890 and 1910, local municipalities passed ordinances requiring brick-and-mortar construction and firewalls. The resulting quaint streetscapes have characterized the region's small-town business districts for approximately a century.

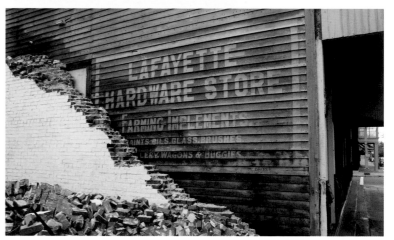

Borden's, one of Louisiana's last remaining authentic malt shops, represents the next generation of business structures, designed to accommodate automobiles rather than pedestrians. In 2009, it was restored by its new owner, Red Lerille.

The original Lafayette train station has been modernized, but it maintains its late nineteenth-century feel.

The iron horse first made its appearance in Acadiana in the late 1850s. In the 1880s, Lafayette became an important rail hub, located at the intersection of the region's most important east-west and north-south rail lines. Railroad traffic reached its apex around World War I before entering a period of protracted decline. By the early 1970s, only the major trunk lines remained.

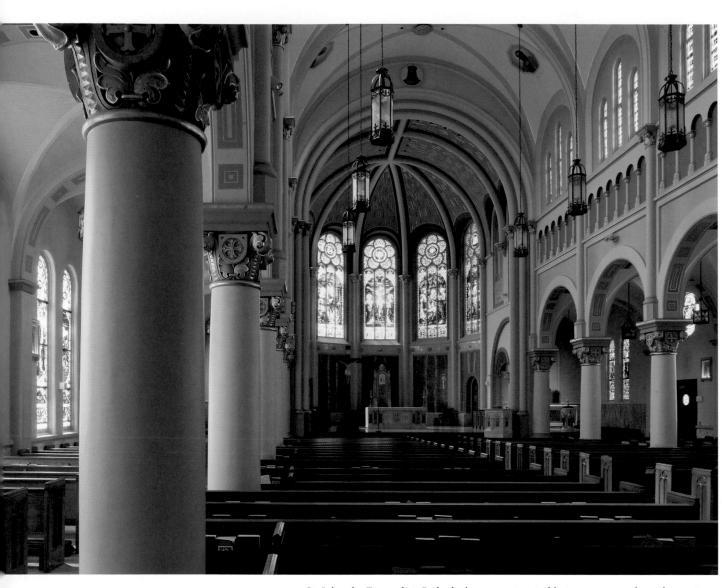

St. John the Evangelist Cathedral was constructed between 1913 and 1916 by contractor Eugene Guillot at a cost of approximately fifty thousand dollars. In 1918, when the Catholic Church established the Diocese of Lafayette, St. John's was designated as the diocesan cathedral.

The cathedral square is locally famous not only for the church's imposing architecture, but also for the equally impressive St. John's Oak, a monstrous live oak believed by some to be four centuries old.

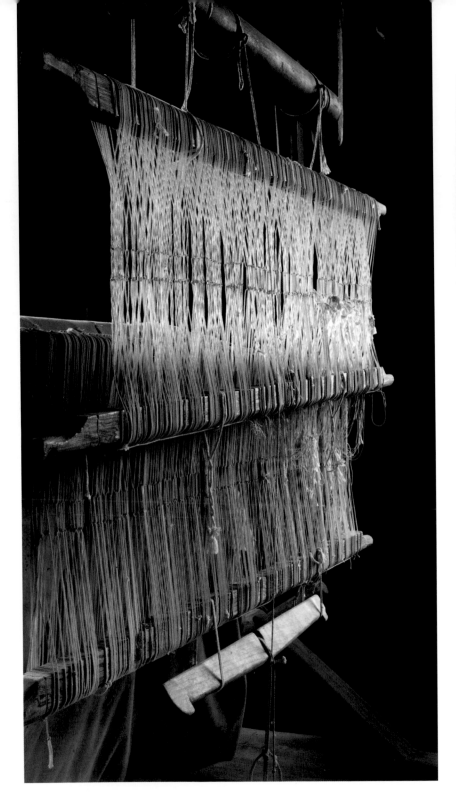

Although traditional indigo-dyed Attakapas *cotonnade* is no longer commonplace in local weaving circles, western Acadiana weavers continue to produce beautiful "yellow cotton" fabrics such as the one used for the blankets pictured here. The blankets are part of a collection of artifacts owned by Andy Reaux of New Iberia.

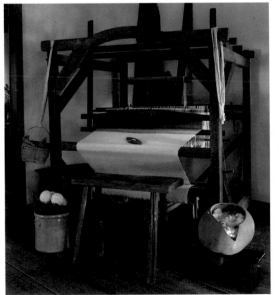

The Attakapas and Opelousas areas have been widely recognized for fine handmade textiles since colonial times. Looms at Acadian Village (*left*) and Vermilionville (*above*) attest to this legacy.

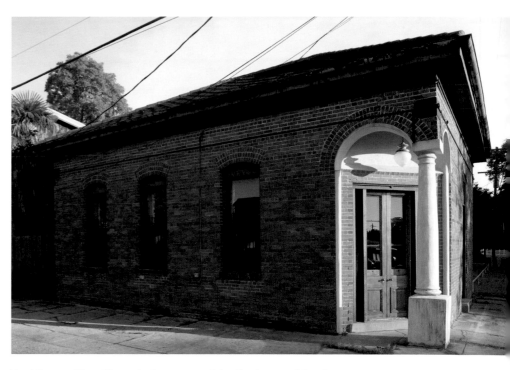

Paul Begnaud's residence in Scott was originally the town's bank.

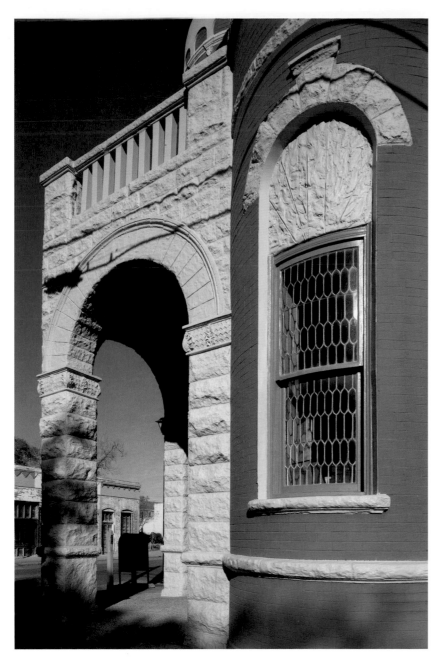

The former Bank of Abbeville building is one of the region's most beautiful architectural landmarks.

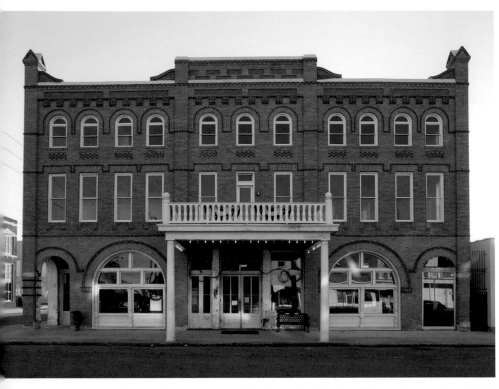

Crowley's Grand Opera House of the South, built by David Lyons in 1901, is typical of the so-called opera houses found in virtually all of Acadiana's bigger towns at the turn of the twentieth century. In recent years, the Crowley Opera House building and performance space were completely renovated by owner L. J. Geilen. As in its early life, the facility presents a wide variety of performances.

The town of Broussard (formerly Côte Gelée) in southeastern Lafayette Parish is home to some of Acadiana's finest Edwardian-era homes. One of the best examples is the magnificent residence above, long called the Paul Billeaud House but now more commonly known as La Grande Maison. It was erected in 1911 by the Billeaud family, which owned the parish's largest sugar mill. Family members occupied the home until the 1930s.

Nestled under an arbor of live oaks, the Blanchet House in Meaux was built in the 1840s by the Harrington family and doubled in size by C. H. Brookshire, a direct descendant, a century later. The house is currently occupied by Ben and Anne Blanchet, who like their ancestors raise and sell cattle, now using organic methods.

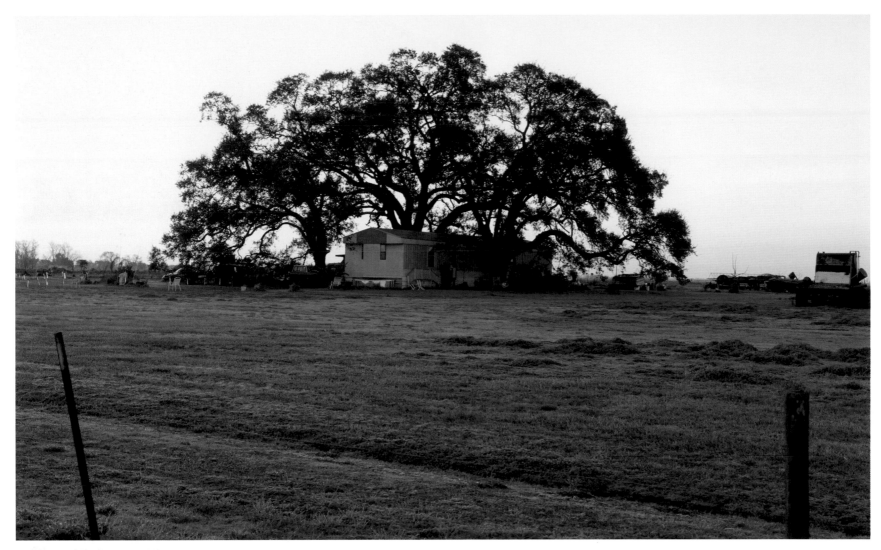

Mobile homes parked beneath live oak canopies are common sights in Acadiana. The oaks mark the sites of historic—usually nineteenth-century—homes that used shade from the spreading branches to mitigate the oppressive heat of the region's long summers. These historic structures were so universally associated with decades of grinding poverty that Acadiana residents rushed to destroy them as soon as disposable income became available during the regional post–World War II oil boom. In many cases, sturdy homes of cypress and *bousillage* construction were replaced with far less substantial mobile homes ill equipped to withstand the rigors of the local climate and hurricanes.

Overleaf: A house on the open prairie near Kaplan. These treeless lands were ideally suited to ranching and rice farming.

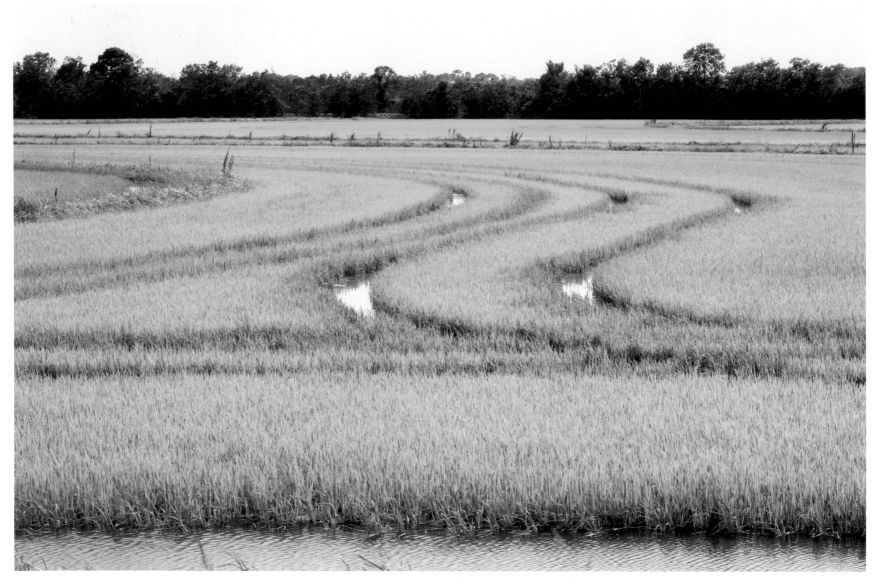

The rice economy took firm root in the prairie region in the late nineteenth and early twentieth centuries. The introduction of steam- and then gasoline-powered implements and improved transportation made it possible for local farmers to move their crops from the field to local mills.

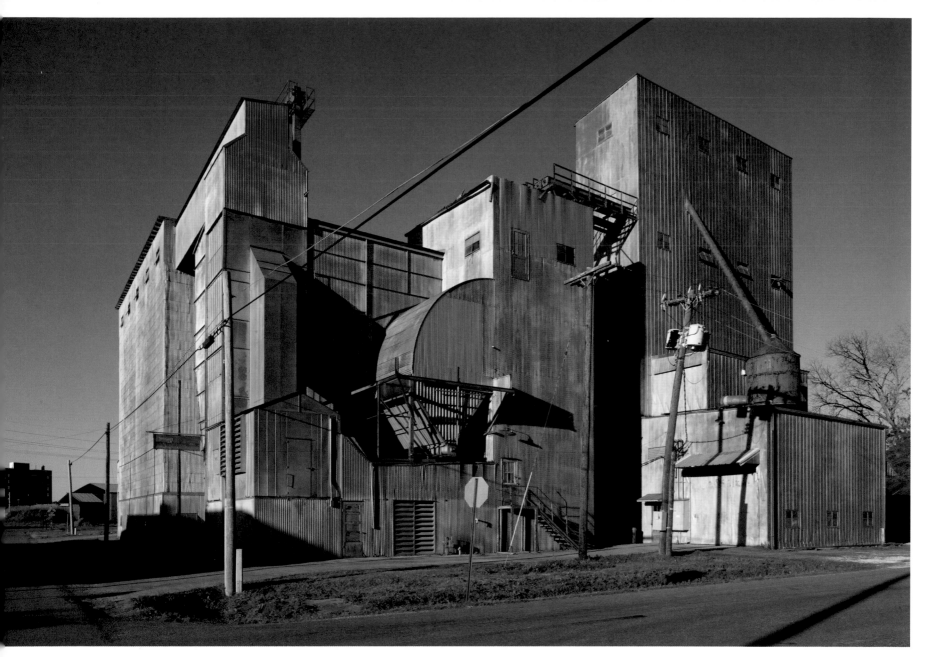

This early Louisiana Irrigation and Milling Company facility stored rice prior to distribution for national and international markets via the local rail network.

A school bus crosses the main east-west railroad line in Rayne. Rice dryers loom on the horizon as they do in numerous south Louisiana prairie communities.

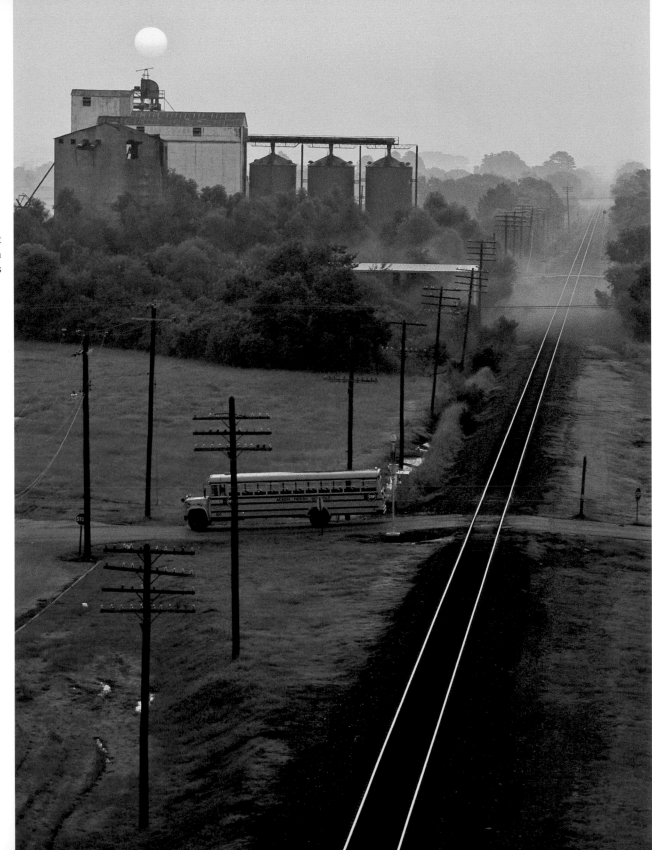

7 World War II to the Present

Like the post–Civil War era (1865–1941) that preceded it, the post–World War II period was characterized by political, technological, social, and cultural change on an unprecedented scale. This tumultuous period was not—as some writers have maintained—a radical departure from the "changeless" world that came before, nor was it a direct consequence of the disruptive forces of Americanization introduced during World War II. The post–World War II era instead merely constituted the dénouement of a historical chapter begun during Reconstruction (1862–77). Though the postwar period was not revolutionary, it was most decidedly evolutionary, and the forces of change during this era were precisely those that had been introduced into Acadiana decades earlier. The lingering influence of these catalysts played a fundamental role in shaping the region's late twentieth-century development.

The economic crisis that gripped Acadiana from circa 1920 to 1941—with only sporadic respites occasioned by Depression-era federal make-work programs and increased oil-drilling activity—did not relent until the beginning of World War II. The conscription of tens of thousands of Acadiana residents into the American armed forces and the emergence of thousands of wartime construction jobs—mostly in the southeastern Texas shipyards and refineries, at the military training camps in central Louisiana, and at New Orleans–area shipyards—resulted in a large infusion of desperately needed cash into the Acadiana region. As during the World War I, military training and combat transformed the men and women who experienced it, and Acadiana's GIs and sailors of all backgrounds served with distinction in every major military theater. But the region's estimated 24,500 Cajun recruits—typically known individually as "Frenchie" in their respective units—particularly distinguished themselves in the North African and European theaters, where they functioned as translators, serving as the principal linguistic interface between the United States military and the regions' Francophone populations. But regardless of their branch and geographical sphere of service, Acadiana's service personnel were profoundly changed by their wartime experiences.

On the home front, Acadiana residents were also transformed by wartime experiences. Victory gardens, rationing, and all other manifestations of local residents' patriotism were catalysts for rapid Americanization as area residents readily embraced the post–Pearl Harbor crusade for national unity. Indeed, the historian Shane K. Bernard notes that in St. Martin Parish alone, approximately 6,500 people—fully one-fourth of the population—volunteered for "home front defense." This was not a hollow gesture, for in 1942 German submarines lurked off the Acadiana coast, and mandatory blackouts and coastal patrols were established in response to U-boat activities. In addition, scrap-metal drives, "I Am an American Day" school celebrations, wartime propaganda movies and newsreels, and radio programs designed to mobilize everyone on the home front to do their utmost for the war effort became commonplace components of weekly routines.

The hyperpatriotism born of the national war effort endured in Acadiana throughout the ensuing Cold War, in part because the abundance of strategic targets in southern Louisiana made the region particularly vulnerable to Soviet nuclear attack. Indeed, this vulnerability was never far from Acadiana residents' minds, thanks to frequent nuclear attack drills, the designation of nearly four hundred public facilities as fallout shelters, daily news reports regarding the Soviet menace, and the Cuban missile crisis.

Hyperpatriotism facilitated and nurtured the local residents' rapid postwar march toward the nation's cultural mainstream. This regional metamorphosis was profoundly shaped by dramatic changes to Acadiana's economic and cultural landscapes wrought by advances in communications, the revolutionary transformation of local material culture, the pervasive impact of the burgeoning regional oil economy, and the civil rights and ethnic revival movements of the mid- to late twentieth century.

A striking advance in material culture was perhaps the most immediate and tangible manifestation of these modernizing processes. Demand for the technological amenities introduced in the early twentieth century—radios, refrigerators, automobiles, indoor toilets, and telephones—had been dampened in Acadiana by the regional agricultural depression of the 1920s and the Great Depression of the 1930s. However, the economic revival initiated by the onset of World War II and sustained in the postwar era by the region's rapid industrialization provided local families with sufficient disposable income to join in the national shift to consumer culture, which significantly closed the material culture gap between Acadiana's urban and rural residents. This transformation is seen perhaps most clearly in postwar Lafayette Parish. As Bernard notes, in the early 1940s, only 15 percent of households had electricity or running water, and only 20 percent had indoor bathrooms. But, a decade later,

virtually all homes had electricity, and nearly 60 percent had running water. Horse- and mule-drawn buggies and wagons were commonplace at the end of the Great Depression, but by the early 1950s, 85 percent of all parish households had an automobile or truck.

And the pace of change accelerated throughout the 1950s. By 1960, 85 percent of all Acadiana residences had radios, 80 percent had clothes washers, 64 percent had telephones, and 77 percent had one or more automobiles. By the mid-1960s, virtually every household owned at least one television. These figures track very closely the national norms for the era, and, in the case of air conditioners and deep freezers, Acadiana households actually exceeded the national standards.

This remarkable metamorphosis was engendered and sustained by the equally extraordinary growth in local disposable income—a direct result of greater employment opportunities for veterans, who willingly took advantage of the GI Bill, and blue-collar workers to adapt to the demands of a rapidly changing labor marketplace. The most lucrative new jobs were generated by the region's burgeoning petroleum and petrochemical industries. Louisiana's first successful oil wells were completed in Acadiana's Evangeline field in 1901, and with the exception of a few wells completed on platforms over inland lakes, exploration and development were confined to onshore fields. However, in 1947, the Kerr-McGee oil company completed a well 10.5 miles from shore in Ship Shoal Block 32. This first successful offshore oil well engendered a veritable industrial stampede as major oil companies shifted their interest—and drilling platforms—to Louisiana's coastal waters. Within a decade, traditional fishing and trapping centers at Morgan City and Cameron became major staging areas for offshore oil exploration. Many fishing operations quickly adapted, morphing into logistical supply companies for offshore rigs, and, by the mid-1950s, entrepreneurs had begun to establish fabrication yards to build offshore drilling platforms. By the late 1990s, these fabrication companies had completed approximately 5,500 of these massive units.

Oil exploration and development reached a fever pitch along the Louisiana coastline by the early 1960s, when, according to the cultural geographer Donald W. Davis, "the Gulf of Mexico quickly became one of the hottest spots in the oil patch." Indeed, between 1950 and 1969, oil companies completed 14,179 wells in Louisiana's coastal parishes. The frenzied pace of this regional exploration activity resulted directly from the explosive postwar growth of suburbs, the suburbanites' resulting dependence on the automobile, and America's consequent appetite for petroleum products.

The explosion in Acadiana's offshore drilling activity produced a corresponding increase in oil companies' demand for labor. The lure of steady employment and high wages—and the resulting promise of a better life for them-

DESEGREGRATION IN ACADIANA

Civil rights activism in Acadiana began in earnest during World War II and escalated in the two decades following the war as African American plaintiffs filed suit against segregated educational institutions in an ultimately successful quest for equal opportunity of access. The first notable milestone in Acadiana's local civil rights movement was achieved in 1954, when four African American plaintiffs filed suit to secure admission to Southwest Louisiana Institute (now the University of Louisiana at Lafayette), a four-year college founded in 1900. When the initial unfavorable decision was appealed, federal judges Wayne S. Borah, Edwin F. Hunter, and Ben C. Dawkins ruled in the plaintiffs' favor in April 1954. By November of that year, approximately eighty African American students had been admitted without incident—the first full-scale desegregation of a southern institution of higher learning in the wake of the U.S. Supreme Court's *Brown v. Board of Education* decision. McNeese State College of Lake Charles was likewise integrated by year's end. Desegregation of the region's public school systems, however, was far more protracted and confrontational. The Acadiana-area public schools became fully integrated in September 1969, and desegregation of other local public facilities followed hard on the heels of this watershed event.

selves and their families—lured thousands of Acadiana small farmers into the oil patch in the 1950s, despite the industry's notoriously dangerous working conditions. The exodus was spurred in 1957 by Hurricane Audrey, an unseasonably early storm that destroyed the prairie farmers' vital cotton and rice crops; the resulting economic desperation compelled most to make a new start in the oil industry.

The burgeoning offshore oil industry required ever-greater degrees of onshore direction and coordination. By the early 1960s, New Orleans had become home to numerous district oil company offices, and Houma and Lafayette had become satellite administrative centers coordinating offshore oil activities, thanks to the efforts of visionary local businessmen such as Lafayette's Maurice Heymann. Heymann established the Oil Center in the Hub City as early as 1952. The fortunes of the Oil Center served as an accurate barometer for those of the regional petroleum industry. From its inception as a modest four-building development, the Oil Center rapidly evolved into a sprawling complex boasting more than 300,000 square feet of office space by the 1970s.

The vast quantities of oil produced by the mushrooming offshore oil activity required transportation, refining, and processing/by-product facilities. In the postwar era, most of this oil-related industrial development was concentrated in the Lake Charles area and on the German and Acadian coasts along the Mississippi River. The most extensive development was along the Mississippi, which witnessed an economic revolution as heavy industry largely supplanted agriculture as the mainstay of the regional economy.

Industrial development was initially confined to the region's east-bank settlements. In 1914, the Mexican Petroleum Oil Company purchased 1,050 acres as a refinery site. Between 1916 and 1929, petroleum companies acquired additional refinery and petrochemical plant sites at Sellers, Good Hope, St. Rose, and Norco. The heavy industries were complemented by a growing number of riverside grain elevators and trans-shipment facilities. By the late 1930s, twelve to fourteen oceangoing tankers and freighters docked weekly at the German Coast's burgeoning export complex.

The refineries steadily drew critical farm laborers and sharecroppers away from the region's agricultural sector with wages nearly twice those customarily accorded local farmhands. The ready supply of labor only hastened heavy industry's development at the expense of local agriculture.

Local industrial development surged again in the post–World War II era, the Golden Age of Louisiana's petroleum-based economy. In 1952, Lion Oil Company began construction of a refinery at Luling, and Shell Oil Corporation built a petrochemical plant at Norco in 1955. Industrial development continued apace throughout the 1960s and 1970s, including a major facility at Taft, thanks to Louisiana's tax incentives for petroleum-related industries and, under Governor Edwin Edwards's administrations, lax enforcement of the state's already lenient environmental regulations. By the dawn of the new millennium, the area along the Mississippi River between Baton Rouge and New Orleans had become home to fully one-fourth of the nation's petrochemical industry, and these new industrial complexes served as economic magnets, drawing workers from rural Francophone parishes west of the river, where agriculture was rapidly dying.

The inevitable results of the region's rapid industrial development and concomitant lax governmental regulation have been short-term gains and long-term costs. High wages provided heavy industries' employees a standard of living much higher than that enjoyed by their neighbors from other walks of life. But this prosperity has come at a high cost: extensive environmental damage from pollution, persistent charges of environmental racism, sporadic labor disputes, loss of the area's rich architectural heritage to the builders' bulldozers, and persistence among the local population of some of the world's highest cancer rates—attributed by many to environmental factors.

The high cost of industrialization—and its attendant modernization and Americanization—was by no means restricted to "cancer alley," as Acadiana's petrochemical corridor came to be known. As indicated above, in the three decades after World War II, change permeated every facet of local life as the region's residents, like their contemporaries throughout the nation, marched in lockstep toward the national mainstream culture. However, access to the mainstream—and the economic benefits and social mobility that it afforded—

was restricted to Anglophones, whose fluency in English and neutral accent helped counteract now deeply rooted ethnic and regional biases against Acadiana residents, and it is thus hardly surprising that the downturn in French-language usage that began during the depths of the Great Depression accelerated with alarming speed. During the Korean War (1950–53), 67 percent of the estimated 13,200 Cajun troops who served in the conflict were mother-tongue French-speakers, but according to Shane Bernard, only 21 percent of Acadiana residents born between 1956 and 1960 used French as their first language. This statistic is particularly significant, for Canadian linguistic studies undertaken after Quebec's "Quiet Revolution" of 1968 demonstrate that 25 percent is the minimum critical mass necessary to sustain a language in any society, but particularly among ethnic minorities.

Language loss was especially pronounced within Acadiana's swiftly growing urban communities, particularly Lafayette and Houma, the onshore bases for offshore oil operations. Postwar urban growth resulted from myriad factors, but two are particularly noteworthy. First, the mechanization of local agriculture during and immediately after World War II obviated the need for tens of thousands of tenant and sharecropper families, who generally congregated in new working-class real estate developments—like Lafayette's Northside—in Acadiana's principal towns. These new urbanites set out to start life afresh in pursuit of the American dream.

They were followed by smaller numbers of farm families as Acadiana's yeomen, like their counterparts throughout the nation, found it increasingly difficult to support their families. By the mid-1960s, the vast majority of Acadiana's small farmers had suspended production and actively pursued blue-collar jobs, usually in urban areas.

Once a part of the urban landscape, the transplants faced major challenges, not the least of which was the open disparagement of their ethnic and linguistic backgrounds, which were viewed as archaic, crude ("low-class"), or absurd. This is particularly true of Cajuns. Indeed, the very term "Cajun" came, by the late 1960s, to be seen as the supreme insult to persons of French descent in Acadiana and use of this "epithet" often produced a strongly negative, if not violent, response. As a consequence, many neo-urbanites—and especially their children—readily abandoned traditional cultural practices to secure admission to the cultural mainstream and the promise of the good life that it offered. Rejection of the past was also manifested in more subtle ways, such as in naming practices. Children born to Cajun parents between the onset of the Great Depression and the end of the Baby Boom were generally christened with given names deemed typically "American"—particularly Anglo or Irish surnames such as Brent, Murphy, and Barry—to facilitate their passage into the American promised land.

ACADIANA'S CULTURAL RENAISSANCE SINCE 1968

For much of the twentieth century, "progress" in south Louisiana was synonymous with cultural eradication. Although they constituted at least a plurality throughout rural Acadiana, the region's French-speaking populations—black (Creole of Color) and white (Cajun)—were the subject of almost universal denigration by outsiders and the local English-speaking elite as a result of the era's hyper-Americanization. The area's Cajun community, which occupied the bottom rung of local white society, was particularly demonized. By the 1950s, the term "Cajun" had degenerated into a gross insult with overtones of ignorance, poverty, and backwardness. Unfortunately, persons of Cajun ancestry came to accept this negative view of themselves and their cultural milieu. Poor self-esteem, compounded by the de facto economic disenfranchisement of the Francophones, engendered loss of ethnic pride, the decline of traditional cultural institutions, and rapid language loss. Within three generations, Acadiana's rural communities moved from being monolingual French-speaking to monolingual English-speaking.

These developments were viewed with increasing alarm by many culturally conscious Cajuns, and by the 1960s, there was a growing Cajun backlash against the negative consequences of Americanization. State legislator Dudley J. LeBlanc—who had lobbied since the 1930s to rehabilitate the Cajuns' image—helped stimulate a top-down Louisiana French movement championed by Acadiana's middle and upper classes. In July 1968, LeBlanc and his supporters successfully introduced legislative acts to safeguard the region's French language and culture. Act 409 established the Council for the Development of French in Louisiana (CODOFIL) to "further the preservation and utilization of the French language and culture of Louisiana by strengthening its position in the public schools of the State." Operated by college-educated members of the professional class led by former congressman Jimmy Domengeaux, the political organization alienated legions of early blue-collar supporters by imposing standard (international) French upon the local population through bilingual programs conducted in Acadiana's public schools by often-uncertified educators imported from France and Belgium. The importation of Francophone educators in lieu of native French-speaking teachers and the imposition of the metropolitan variety of the language in place of the homegrown variant sent a clear message to local Cajuns, who were interested only in bridging the gap between Francophone grandparents and their Anglophone grandchildren. And that message was: Anglo-Americans were right all along—local Francophone culture and language are inferior. European instructors took no pains to conceal their condescension toward native French-speakers and the children in their charge. Locals balked. The inevitable result was grassroots backlash and the widespread dismantling of bilingual programs at the behest of Cajun school board members in the late 1970s and early 1980s.

Young Cajuns—especially those enrolled in university—were monitoring these developments. Inspired by the so-called "Age of Ethnicity"—and riding the enduring turbulent momentum of the antiwar and politicized student movements of the 1960s—this new generation of Cold War Cajuns began a countermovement. Participants shared two fundamental concerns: restoration of ethnic pride and reversal of language loss. Their efforts, encouraged by the Smithsonian's resident folklorist, Ralph Rinzler, culminated in the first Hommage à la Musique Acadienne (predecessor of today's Festivals Acadien et Creole) in 1974.

Capitalizing on a concurrent assemblage of French-language journalists in Louisiana, Domengeaux authorized the event as a means of generating publicity for CODOFIL. Barry Jean Ancelet, a young Cajun academic/activist charged with organizing the event, viewed the concert as an opportunity to provide validation for the then widely denigrated Cajun music and, by extension, speakers of Cajun French. The concert, the first of its kind in Acadiana, exceeded Ancelet's wildest expectations. Despite a torrential downpour, twelve thousand eager concertgoers flocked to Lafayette's Blackham Coliseum. The concert's overwhelming success produced two notable interconnected results. First, it demonstrated unequivocally that the vast majority of Cajuns supported conservation of *local* cultural institutions, including Cajun music, which had been the subject of derision by outsiders—and by many members of the CODOFIL elite. Second, it served as the springboard for increased activism by scores of college-educated Cajuns of blue-collar backgrounds who clearly identified with the predominantly blue-collar audience at Blackham Coliseum.

Baby-boomer activists quickly made their mark in three areas that did much to sustain the countermovement that, by the 1980s, had effectively moved to an ascendant position through sheer force of numbers and popular support. Michael Doucet, Zachary Richard, and other talented musicians reinvigorated Cajun music by infusing it with new influences (including jazz, rock, zydeco, and reggae), increasing its appeal to a new generation raised on swamp pop, R&B, and the British Invasion. Other activists, led by Ancelet, launched a literary movement to protest unbridled Americanization, vilification of local Francophones in the popular media, and language loss. This literary movement reached its apex with the establishment of Les Editions de la Nouvelle Acadie series, published by the Center for Louisiana Studies of the present University of Louisiana at Lafayette in 1983. The literary movement was complemented by an explosion of scholarly research and publishing in the emerging field of Acadian/Cajun studies. Many of the scholars in this new field, who were also often participants in the literary movement, began to explore aspects of the community's past and present, topics long deemed unworthy of scholarly endeavor. The resulting publications provided the movement important early validation and credibility, which helped to generate a sense of worth and pride essential to sustaining the movement's momentum.

The rehabilitation of the Cajuns' public image created the backdrop against which a Cajun culinary phenomenon drew international attention to the formerly "invisible" community. In 1985, Paul Prudhomme, a native of Acadiana's Coulée Croche area, undertook a triumphal West Coast tour that created an immediate national sensation, leading to America's infatuation with the nation's "exotic" indigenous culinary tradition and, in the process, the cultural group that spawned it. The resulting international media attention sustained the grassroots insurgency, which culminated in the early 1990s with the selection of the first native Louisiana French-speaker as the director of CODOFIL's daily operations, and the establishment of numerous immersion programs to replace the largely ineffective bilingual programs of earlier decades.

The efficacy of the immersion programs has yet to be determined (sadly, the total number of Acadiana's French-speakers continues to decline), but the impact of the so-called French Renaissance is indisputable. Proponents of cultural pluralism consider the cultural revival of Cajuns and Creoles to be one of America's great ethnic success stories. The Cajun and Creole communities, which were on the verge of extinction in the mid-twentieth century following decades of protracted decline, have rebounded vigorously, exhibiting great cultural vibrancy and resiliency.

Survival in the mainstream, however, required a broad range of educational and occupational skills that blue-collar parents themselves could not provide, and they, like their opposite numbers throughout the nation, stressed education as the key to financial success in the 1950s and 1960s. Indeed, parents pressured young Cajuns to attend college, and the student populations at south Louisiana universities doubled in size during this period. The resulting wave of Cajun college graduates tended to congregate in the college towns, where they came to constitute a notable segment of Acadiana's urban population.

Unlike upwardly mobile members of previous south Louisiana generations, these white-collar Cajuns did not abandon their parent culture entirely. Indeed, like other minorities throughout the United States, many urban Cajuns found that their Anglo-Protestant neighbors simply would not let them forget their past, and many others became deeply disillusioned with homogenization into the great, rootless American mass. These young Cajun urbanites, in the late 1960s and early 1970s, came to resent the fact that they had ever been made to feel ashamed of their heritage. This is particularly true of those individuals who left Acadiana for an extended period before returning.

The resulting backlash contributed to the establishment of the Council for the Development of French in Louisiana (CODOFIL) in 1968. Under the leadership of former congressman Jimmyw Domengeaux, CODOFIL gave voice to this long-suppressed resentment and did much to rehabilitate the Cajuns' self-image. By the early 1970s, placards in business places throughout south Louisiana proclaimed, for the first time since World War II, "ici on parle français" [French spoken here].

Though centered in Lafayette, the self-proclaimed cultural capital of Acadiana and home of the region's largest urban Cajun community, this ethnic revival was by no means exclusively an urban, white-collar phenomenon. By the early 1970s, the movement enjoyed the unspoken popular endorsement of blue-collar Cajuns who had traditionally been the community's main cultural guardians. Their renewed sense of pride and their disdain for those Ca-

Founding CODOFIL chairman Jimmy Domengeaux uses the organization's French language signage at a press conference in his Lafayette law office.

juns who had until recently disowned their cultural roots were brought home graphically in the early 1970s when members of this group began to identify themselves as "coonasses"—a term of disputed origin that had displaced "Cajun" as the ultimate local epithet in the 1960s—much to the horror of "genteel," upwardly mobile individuals of French ancestry. Indeed, in the early 1970s, many blue-collar Cajuns began to sport tee shirts and bumper stickers identifying themselves as "proud coonasses."

Blue-collar Cajun attitudes are particularly significant because of the group's tremendous growth—relative to other segments of the Cajun population—in the 1960s, 1970s, and 1980s. The rise of this socioeconomic group was tied directly to late twentieth-century developments in the oil industry. Following the 1973 oil embargo, the Louisiana petroleum industry experienced unprecedented growth. The expansion created a tremendous demand for skilled blue-collar workers, particularly welders, pipefitters, roustabouts, mud engineers, and drillers. In fact, a welder typically made approximately twice the salary of a high school principal. Recognizing this, thousands of teenage Cajuns abandoned the classroom for the job market, and by 1980 Louisiana led the nation in the number of high school dropouts.

Though the short-term benefits of this socioeconomic development were high, the long-term costs to the affected individuals—and the region as a whole—were great as well. Over the past three decades, Acadiana has experienced the peaks and valleys of business cycles as national needs and international pressures have alternatively shaped the destiny of the Gulf Coast oil industry. Oil prices, once regulated by federal legislation, remained relatively stable until the 1973 oil embargo crisis. The subsequent meteoric climb in global oil prices engendered a tremendous increase in domestic oil exploration, particularly in Louisiana's coastal waters. The beginning of phased deregulation of American oil prices in 1980, the acceleration of the deregulation timetable by President Ronald Reagan in 1981, and the continued rise in crude oil prices caused a second major spurt in oil-drilling activity. In Lou-

isiana, where the oil labor force had grown to 165,000, 6,231 drilling permits were issued in 1981, and 4,610 wells were completed. The median number of active rigs in the state was 387 per month.

At the height of the oil boom, a sense of euphoria pervaded Lafayette, Houma, and other cities with notable connections to the petroleum production, and many individuals with no previous ties to the oil industry flocked to the oil patch to cash in on the bonanza. Those who had financially overextended themselves were the first victims of the ensuing oil recession.

Expanded drilling activity in the United States and elsewhere and a simultaneous global decline in petroleum consumption produced a massive global oil glut, with catastrophic economic consequences for Louisiana—and particularly for the state's offshore oil centers. Between 1982 and 1983, eighteen thousand oil workers lost their jobs statewide, and a disproportionately large number of those job losses were concentrated in Acadiana. By late 1983, business failures were becoming commonplace in Louisiana's French Triangle.

In the ensuing years, this already bleak situation deteriorated as price volatility continued to take a toll. By December 1985, oil prices had fallen to $14 per barrel, down from $25.13 per barrel two years earlier, and the number of active rigs consequently dwindled to fewer than 200 in Louisiana. Prices soon dropped significantly below $12 per barrel, the theoretical "break-even" point for most domestic producers. By mid-July 1986, only 122 rigs remained active in Louisiana, with a mere 59 in the offshore area coordinated by Lafayette's Oil Center.

The effect of this decline in exploration and development activity was compounded by the devaluation of oil stocks. The result was a wave of mergers and takeovers. This corporate activity, which began in earnest in 1984, would not only radically transform the face of the regional oil industry but would also create the most significant regional economic and demographic upheavals of the late twentieth century. In 1984 and 1985, Acadiana witnessed an upsurge in layoffs as consolidated companies began to eliminate duplicate positions, usually in the lower administrative echelons at first. Layoffs continued in 1985 as companies, reeling under the debts accrued through the recent mergers and buyouts, sought to eliminate many midlevel administrative positions to reduce their operating overhead. The sudden and dramatic slide in oil prices in 1986, however, forced the major oil companies to take far more drastic action. In May 1986, Exxon announced the closure of its Lafayette office and the transfer of 115 employees to New Orleans. Amoco, Marathon, Arco, Tenneco, and Mobil—whose operations represented 3,015 local jobs—subsequently announced plans to lay off workers.

The virtual suspension of exploration and development activities by the major oil companies overwhelmed the small independent companies that provided the majors with vital logistical and technical support, forcing the latter to lay off tens of thousands of blue-collar oilfield workers—with devastating effects for Houma, Morgan City, New Iberia, Intracoastal City, Cameron, and Lafayette. Lafayette's subsequent experience is representative: the Hub City, which had experienced full employment during the oil boom of the late 1970s and very early 1980s, saw its unemployment rate rise to 14.6 percent by mid-July 1986. During the same time frame, the rate of bankruptcies in Lafayette exceeded that of the Great Depression.

Desperate unemployed former oil employees and their families felt compelled to seek greener pastures elsewhere, and tens of thousands of Acadian residents migrated to more prosperous communities in the South and Southeast, including Atlanta, Charlotte, Orlando, Houston, Austin, and Dallas–Fort Worth. The exodus was so massive and sustained that, for a time, truck-rental companies imposed a surcharge on vehicles leaving the Acadiana area.

The oil bust created a devastating ripple effect felt throughout the region. In Lafayette, home sales had declined by 35 percent between 1981 and 1984, and by mid-1986, some subdivisions were transformed into virtual forests of "for sale" signs. Between March 1985 and March 1986, Lafayette's retail sales fell 25 percent. The resulting shortfall in property and sales tax revenue created a cash-flow crisis for the local governmental and educational systems.

Facing the worst economic disaster since the Great Depression, Acadiana found itself at a crossroads. Communities with more visionary leadership resolved to avoid a recurrence of the emergency by embarking upon crash economic diversification programs to lessen their dependence upon the oil industry. Economic diversification programs generally focused upon five areas of development: (1) cultural and, to a much more limited extent, environmental tourism; (2) research and manufacturing, particularly in the area of digital technology; (3) international commerce; (4) health care; and (5) local retail development.

The results have been mixed. National and international interest in all things Cajun fueled spectacular tourism growth in the regional tourism industry in the late 1980s and 1990s, but income levels in this service industry have been abysmally low in comparison to the blue-collar oil-industry jobs they replaced. The rapid encroachment of "big box" retailers and the growing dominance of suburban malls have transformed Acadiana's oil-center towns—particularly Houma and Lafayette—into regional commercial centers, but this generally welcome development has too frequently come at the expense of locally owned businesses in rural communities. The once-beleaguered regional oil industry enjoyed a quiet resurgence in the 1990s as global oil prices gradually rebounded and as new petroleum reservoirs were discovered in deep Gulf waters far offshore, but the oil patch nevertheless remained dangerously vulnerable to the vagaries of the global oil market. And the region's enduring dependence upon the petroleum industry—and the undereducated work force that it engendered and sustained—effectively undermined its efforts to attract white-collar technology jobs following the oil bust of the mid-1980s.

Yet, by the dawn of the new millennium, the challenges of Acadiana's oil depression generally had been overcome and the widespread dislocation that it caused was a fading memory. Despite growing disparities in income, education, and employment levels between Acadiana's urban and rural populations, as well as the inability of many expatriates to return home because of the continuing dearth of white-collar job opportunities, the typical Acadiana resident had come to terms with the new status quo. This new normalcy, however, was shattered in 2005 by Hurricanes Katrina and Rita, the generational

benchmark storms respectively for southeastern and southwestern Louisiana. Making landfall approximately a month apart, these monstrous Category 5 hurricanes ravaged Acadiana's coastal parishes, inundating huge swaths of the coastal plain stretching from Lafourche to Cameron parishes, flooding the New Orleans metropolitan area twice, inflicting widespread wind damage in the Lake Charles area, and together displacing more than 1.5 million people. Many evacuees opted to ride out the hurricanes and their aftermath with friends and relatives in Acadiana outside the respective storms' "cones of destruction." Hundreds of thousands of evacuees ultimately opted to remain permanently. Lafayette, Acadiana's greatest beneficiary of this demographic shift, increased in population from approximately 115,000 in early 2005 to about 210,000 in 2008. This rapid population growth has presented Acadiana's established population and political leadership with a fresh set of challenges, including spiraling real estate prices, overburdened transportation infrastructures, and overcrowded schools. Challenges, of course, are also opportunities, and most American communities would be envious of the low unemployment rates in Acadiana's most prosperous municipalities (Houma, 2.7 percent; Lafayette, 3.1 percent in early December 2008).

But not all of Acadiana has shared in the latest wave of prosperity. With the exception of Charenton, Marksville, and Kinder—communities where Native American populations established flourishing casinos in the 1990s—many rural areas are mired in stagnant or failing economies. This is particularly true of storm-ravaged communities in the coastal plain, where a way of life more than two centuries in the making is dying as a result of coastal erosion, hurricane-induced environmental damage, rising sea levels, the virtual demise of the once-prosperous fur, ranching, and fishing industries, and a rapidly graying population.

Acadiana thus finds itself on the cusp of a new era—one in which tradition and change will alternately compete and collaborate in shaping the course of future development. And while the direction of this evolutionary trajectory is uncertain, two things remain clear: First, the state's own demographic and economic studies project Acadiana to become one of Louisiana's two most densely populated and economically important regions by midcentury. Second, the region's population will rise to current and future challenges precisely as it has in the wake of previous historical watersheds—by embracing the concept of change while eschewing specific changes incompatible with its core values. Thus, although Acadiana will unquestionably be a very different place in 2050, it will also be a place in which shared cultural traits and values will be immediately recognizable to today's Acadiana residents.

For most of the twentieth century, Evangeline was the region's most powerful cultural icon. The icon's legacy endures in numerous regional business and trade names. Evangeline Maid bread, a case in point, was first baked by Joe Huval, a Cajun. In 1947 he sold his interest in the company to Frem and Albert Boustany, two immigrant Lebanese Christian brothers who settled in south Louisiana. Frem managed the company and worked to make the brand name immensely popular throughout Acadiana. The Boustanys are one of many Lebanese families who settled in Acadiana in the twentieth century and prospered here. The large bread loaf, while no longer attached to the bakery itself, still spins on a billboard next door.

Dramatically improved transportation and communications helped transform Acadiana in the twentieth century. Early bridges, such as this one crossing the Atchafalaya River in Morgan City, were viewed by many who lived through this era as perhaps the most important symbols of south Louisiana's march of "progress."

The birth of Louisiana's oil industry occurred in Acadia Parish's Evangeline field in early 1901, and fabrication, exploration, and drilling activities throughout the region's "energy corridor" remain a critically important source of employment and income for a large portion of the area's overwhelmingly blue-collar work force.

Offshore rigs such as the one being built at the McDermott fabrication yard in Amelia
are indicative of south Louisiana's global impact on the oil industry.

The present Iberia Parish Courthouse was designed by the famed architect A. Hays Town and constructed in 1939 by Gravier and Harper. The building is one of Acadiana's finest examples of art deco architecture and a fitting monument to the era's Americanization.

The last dance at Hamilton's Zydeco Club in Lafayette. Adam Hamilton built Hamilton's Club in the early 1950s, according to his son William. The club was a vital part of the Creole community in the Long Plantation area. In the late 1970s, Hamilton's Club started "white night," opening its doors to white college students to permit them to hear zydeco bands. The club remained integrated until its closure in 2005.

An interior view of Hamilton's Club

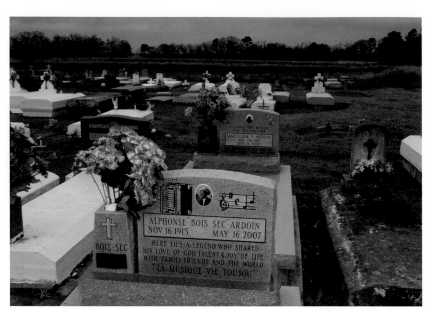

The gravesite of Alphonse "Bois Sec" Ardoin, near his home in Soileau. Ardoin, cousin and musical heir to the legendary Amédé Ardoin, was a pivotal figure in the development of La-La, zydeco, and, to a more limited extent, Cajun music.

Zydeco dancers after the Grand Marais trail ride. The signature music of Louisiana's Creole of Color community is, like its Cajun cousin, largely a product of the twentieth century, evolving from jurés to bluesy La-La music to heavily R&B-infused zydeco. In the early twenty-first century, the genre continues to evolve through its absorption of myriad influences from contemporary American popular music—from hip hop to rap.

An early 78 rpm recording by Cajun fiddler Dennis McGee and Creole accordionist Amédé Ardoin bespeaks the musical interconnectedness between races in the early twentieth century, all in the face of Jim Crow laws and segregation.

An accordion made by Marc Savoy for Danny Poullard, a Creole musician. When asked one time too often about the differences between Cajun and Creole music, Poullard said in exasperation: "It's all French music." Current owner Jesse Leger inscribed these words on the bellows.

The Magnolia Sisters, a traditional Cajun band, play at Café des Amis in Breaux Bridge. Café des Amis occupies a century-old former department store in this quintessentially Cajun town. Nestled along Bayou Teche, Breaux Bridge—or Pont Breaux, as it was more commonly known for more than a century—is one of St. Martin Parish's oldest communities. Incorporated in 1859, it was designated the "Crawfish Capital of the World" by the Louisiana legislature during its centennial celebration, and has been home to an annual crawfish festival since 1960.

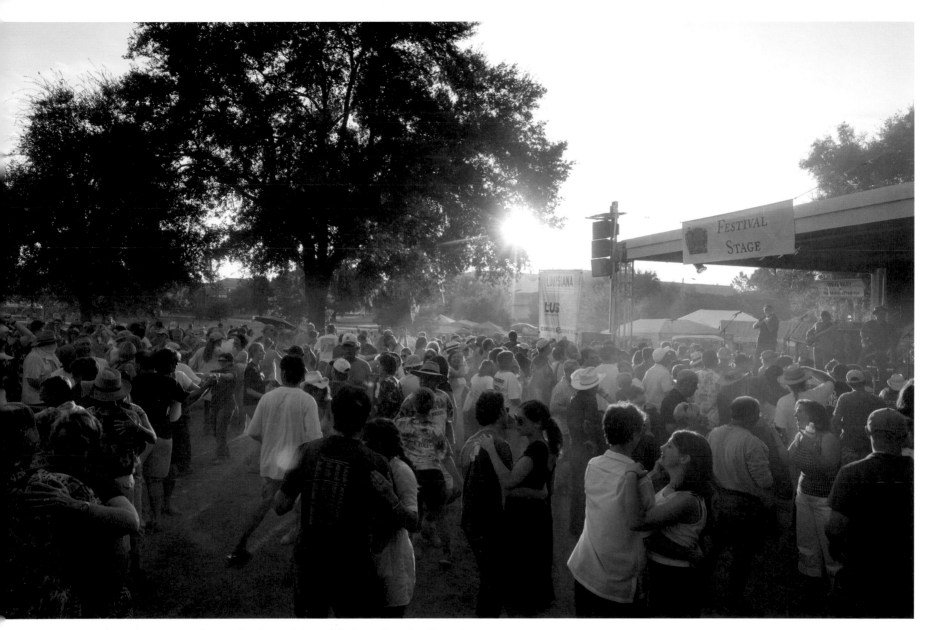

Dance culture was an integral part of traditional Cajun life throughout Acadiana. As early as 1803, Louisiana Cajuns were gathering for weekly house dances, a practice that persisted until after World War I. Between 1919 and the beginning of World War II, however, dance halls replaced homes as the principal venues for social gatherings. The popularity of these dance halls waxed and waned with the generation that grew up with them. *Above:* Dance culture remains an essential part of the local landscape, as this image of dancers at Festivals Acadiens demonstrates.

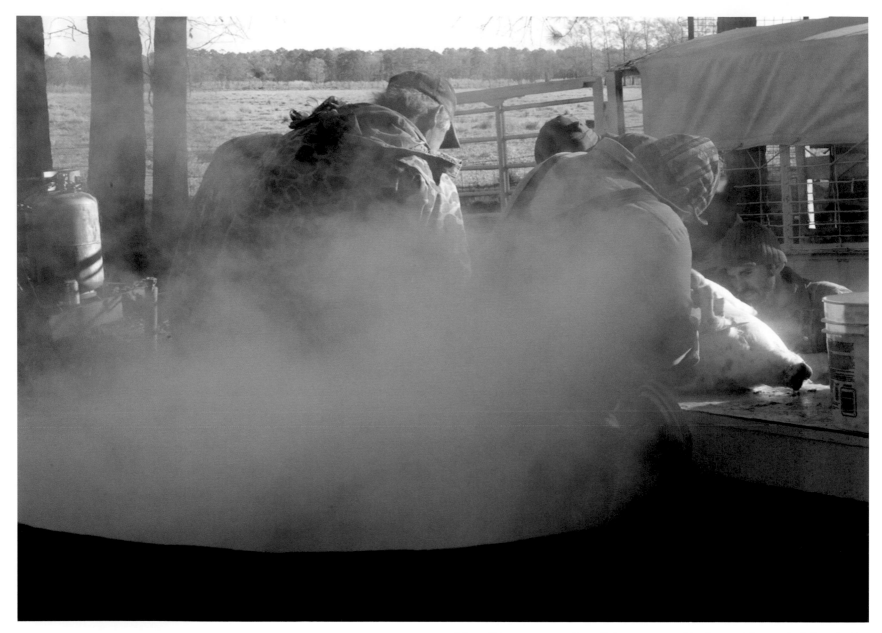

Many Cajun gastronomic traditions are rooted in the need for survival. Boucheries, like the one at Lakeview Campground between Eunice and Mamou, were historically a vital means of providing meat for a community prior to refrigeration.

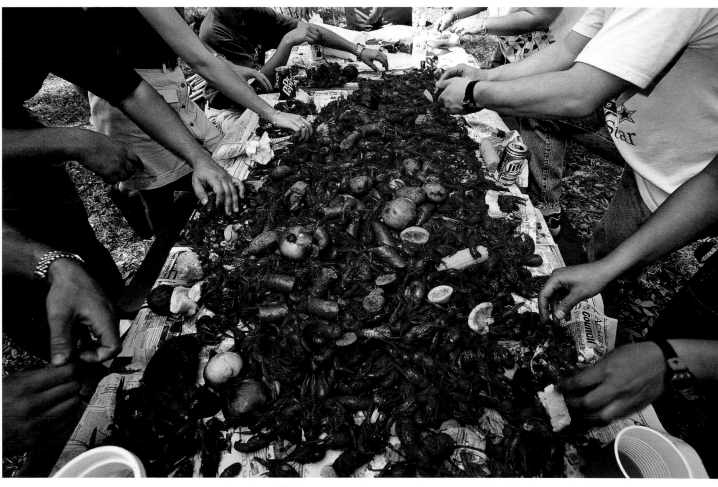

Cajuns and Creoles love to eat—perhaps even more than they love to dance—and Acadiana's well-spiced cuisine is world renowned. As with working populations throughout the world, pork is the basis of much of the diet, and locals appreciate both quantity and quality. *Above:* One of the many delicacies that come from boucheries is cracklins, deep-fried pig skin and fat.

Acadiana's foodways are as diverse as the region itself, and subregional culinary traditions, such as this family crawfish boil in Catahoula, were shaped by the seasonal availability of ingredients.

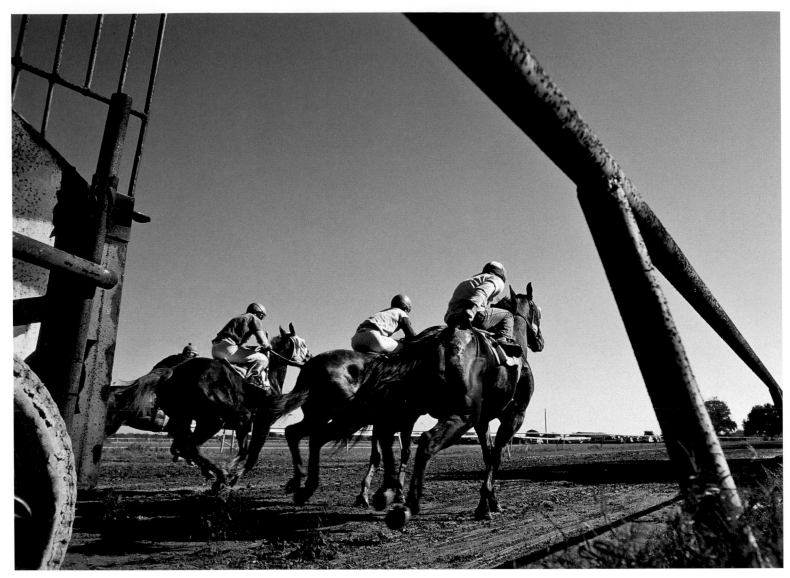

Acadiana's horse-racing tradition extends to the late eighteenth century, when Anglo-American immigrants introduced the sport to the area. In the nineteenth century, the "sport of kings" set down deep roots in the region, and although blooded horses graced the turf at gatherings of the local elite, quarterhorses and working stock competed on straight quarter-mile tracks in pastures owned by blue-collar families. These "bush tracks" persisted in Acadiana, particularly western Acadiana, until the late twentieth century. They have been replaced by state-regulated tracks like Evangeline Downs (formerly of Carencro, now in Opelousas).

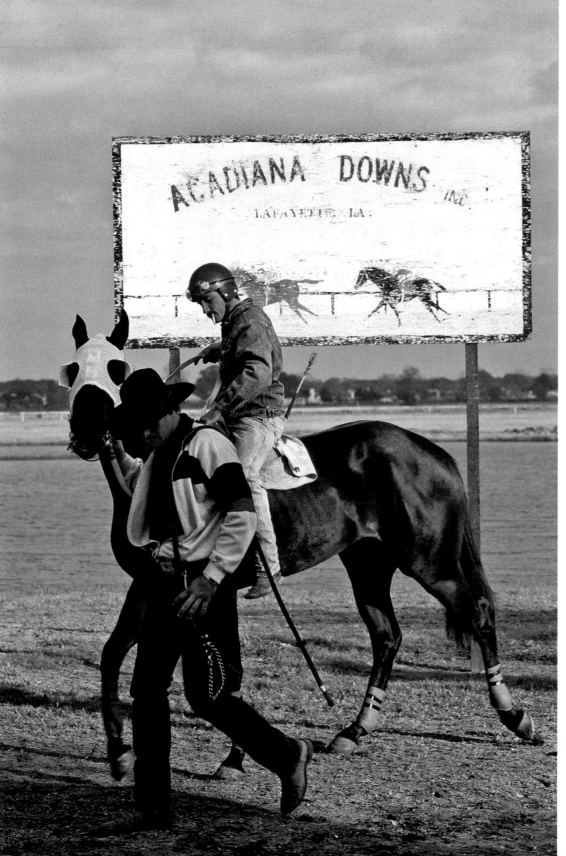

A horse and jockey leave the winner's circle at Acadiana Downs's bush track.

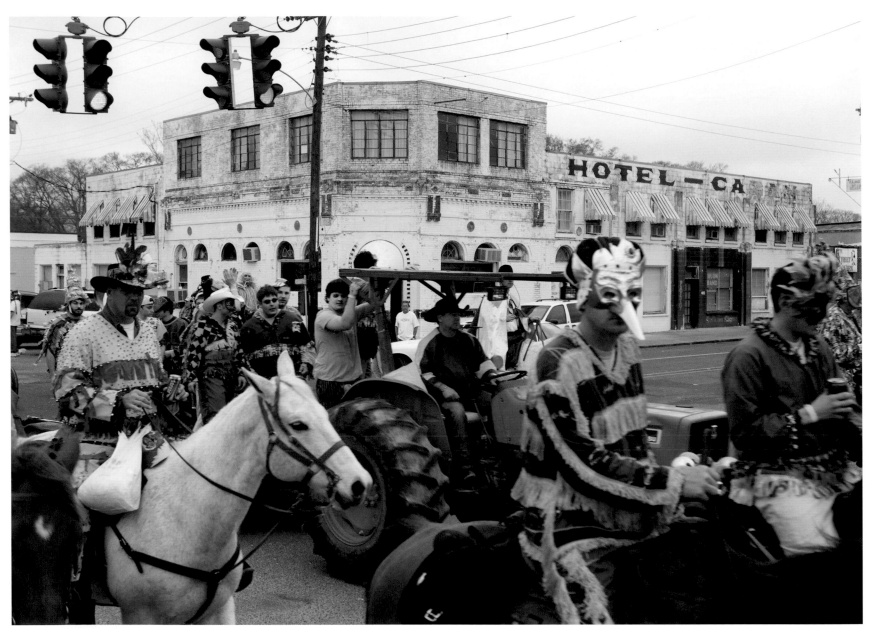

Acadiana boasts two Mardi Gras traditions—urban and rural. Both represent recent Louisiana adaptations of ancient traditions transported from Europe to Louisiana in the colonial era. *Above:* Riders in the Mamou Courir pass in front of the Hotel Cazan.

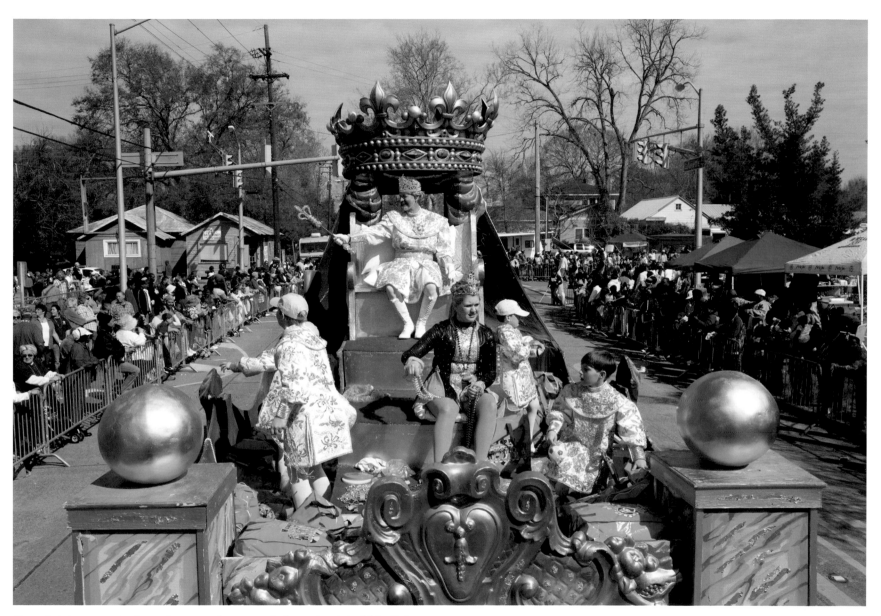

Since their inception in the early twentieth century, Lafayette's original Mardi Gras krewes have consciously modeled themselves upon their older New Orleans counterparts. As in the Crescent City, Fat Tuesday festivities are centered upon balls, parades, and pageantry. *Above:* Lafayette's King Gabriel (Mark Judice) waves to crowds along the parade route on Mardi Gras Day, 2009.

Acadiana's largest institution of higher learning—and Louisiana's second-largest university—is located in Lafayette. Established in 1900 as Southwestern Louisiana Industrial Institute, the school has experienced three name changes over the course of its existence: Southwestern Louisiana Institute (1921), University of Southwestern Louisiana (1960), and University of Louisiana at Lafayette (1999). The school's mascot, initially the bulldog, is now the "Ragin' Cajun." *Left:* Colonnaded walkways on the edge of the quadrangle.

Cypress Lake, at the center of campus

Louisiana Immersive Technologies Enterprise, or LITE Center

Memorabilia for two of Acadiana's most historically significant politicians. *Above:* Souvenirs from Edwin Edwards's first campaign for governor in 1971. Edwards was the first south Louisiana Cajun elected to the office. During his four terms as governor, he witnessed the shifting of a political balance of power in the state from the Anglo-Protestant north to the French Catholic south.

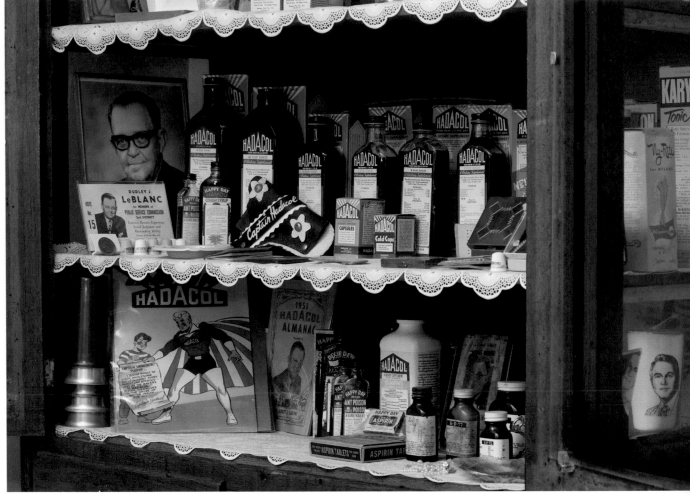

Longtime legislator and cultural activist Dudley LeBlanc is also remembered for Hadacol, a patent medicine that he developed and marketed nationally. Artifacts are part of the Robert Vincent collection.

Louisiana politics, the "world's greatest free show," is particularly intense in the Acadiana region. *Left:* The Chêne à Cowan in Galliano is a gathering place along the bayou for political discussions, or, as one expatriate put it, "The Chêne à Cowan is the New Hampshire primary of Lafourche Parish politics." *Above:* Regional politicians must universally submit to the following maxim—go there or lose. In western Acadiana, small towns like Parks in St. Martin Parish are virtually awash in campaign signage during campaign season.

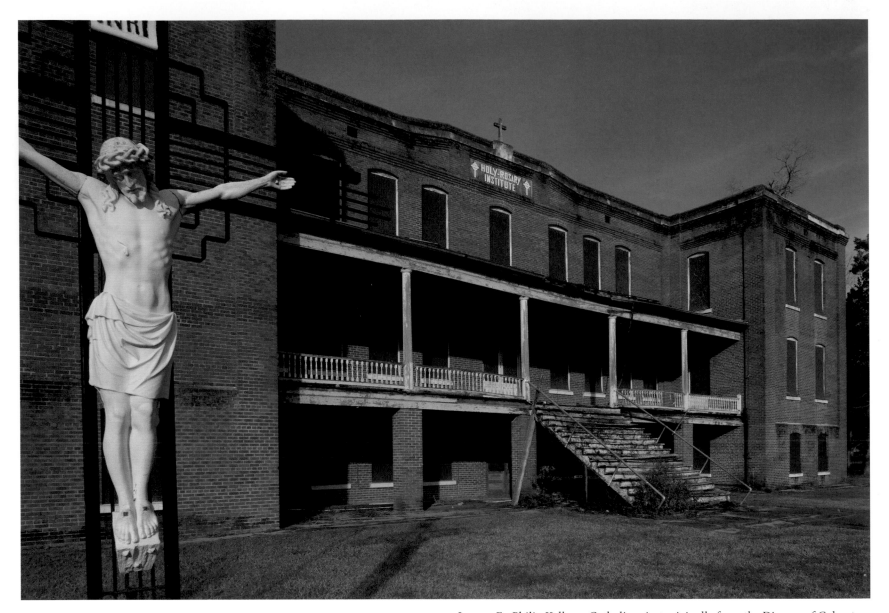

In 1913, Fr. Philip Keller, a Catholic priest originally from the Diocese of Galveston, established the Holy Rosary Institute in Lafayette to provide vocational education to local blacks. Staffed by the Sisters of the Holy Family, the school provided critical educational opportunities to African Americans throughout the remaining Jim Crow era, and its legions of graduates formed the leadership element in the area's influential Creole of color community. The school closed its doors after eighty years of service, but the alumni association has mounted a grassroots effort to rehabilitate the now rapidly deteriorating structure.

Built by the True Friends Association in Lafayette's Freetown section between 1902 and 1904, Good Hope Hall effectively served as the Hub City's African American community center in the early twentieth century. Over the course of its existence, the facility is reputed to have served as a vaudeville theatre, dance hall, Catholic chapel, barbershop, and pool hall, but it is perhaps best remembered as the venue for performances by some of the nation's leading black musicians. The structure is presently listed on the Lafayette register of historic properties and houses the law offices of the Glen Armentor law firm.

Acadiana's coastal wetlands are disappearing at an alarming rate. Erosion is particularly acute in the Lafourche-Terrebonne area. *Above:* An old grave in Leeville photographed in 1981 is now underwater.

Coastal engineers placed rock barriers along the Barataria waterway to help block marsh erosion caused by the wakes of boats.

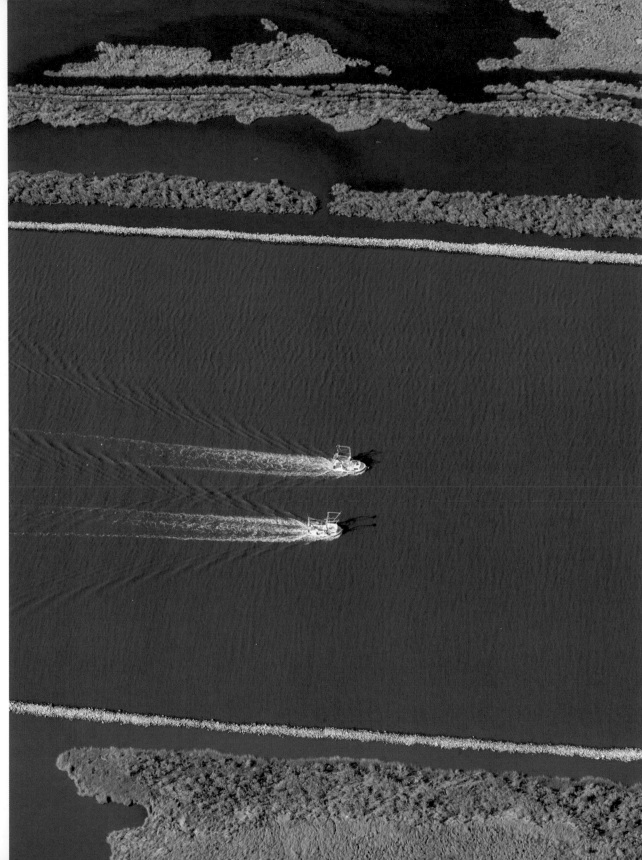

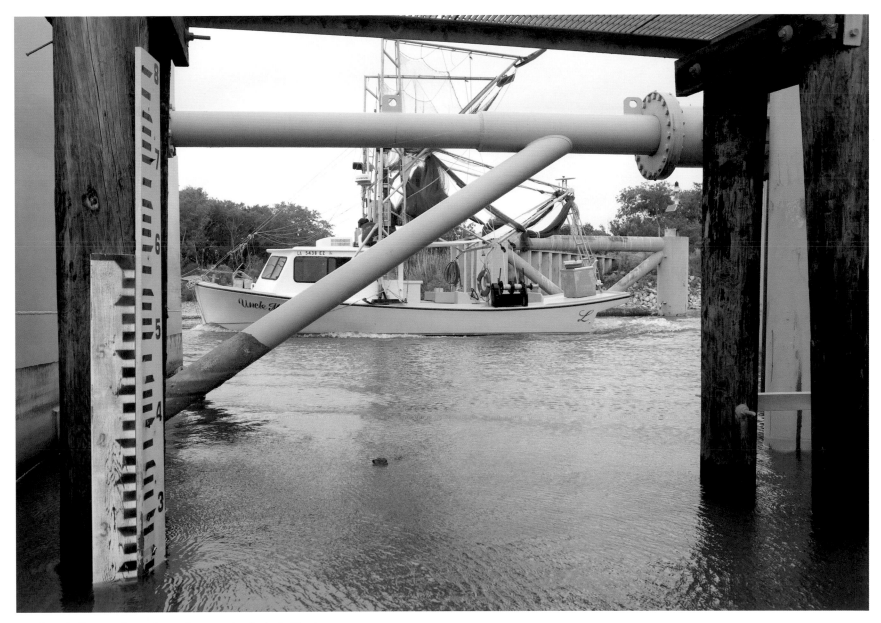

A Lafitte skiff passes through marsh-protection locks in Theriot.

Overleaf: Acadiana's coastline represents an uncomfortable—often incompatible—mix of competing priorities. Here, massive offshore oil platforms overshadow swimmers near Port Fourchon in Lafourche Parish. In recent years, rock formations were placed along the beach as a buffer against gulf storms.

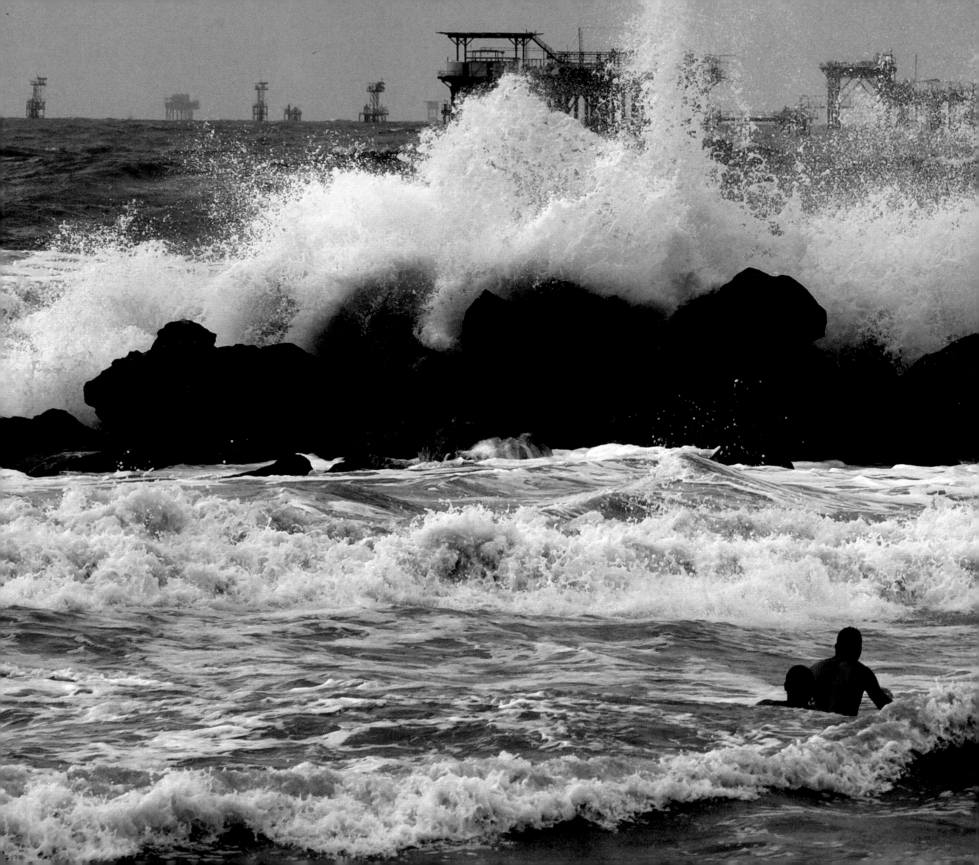

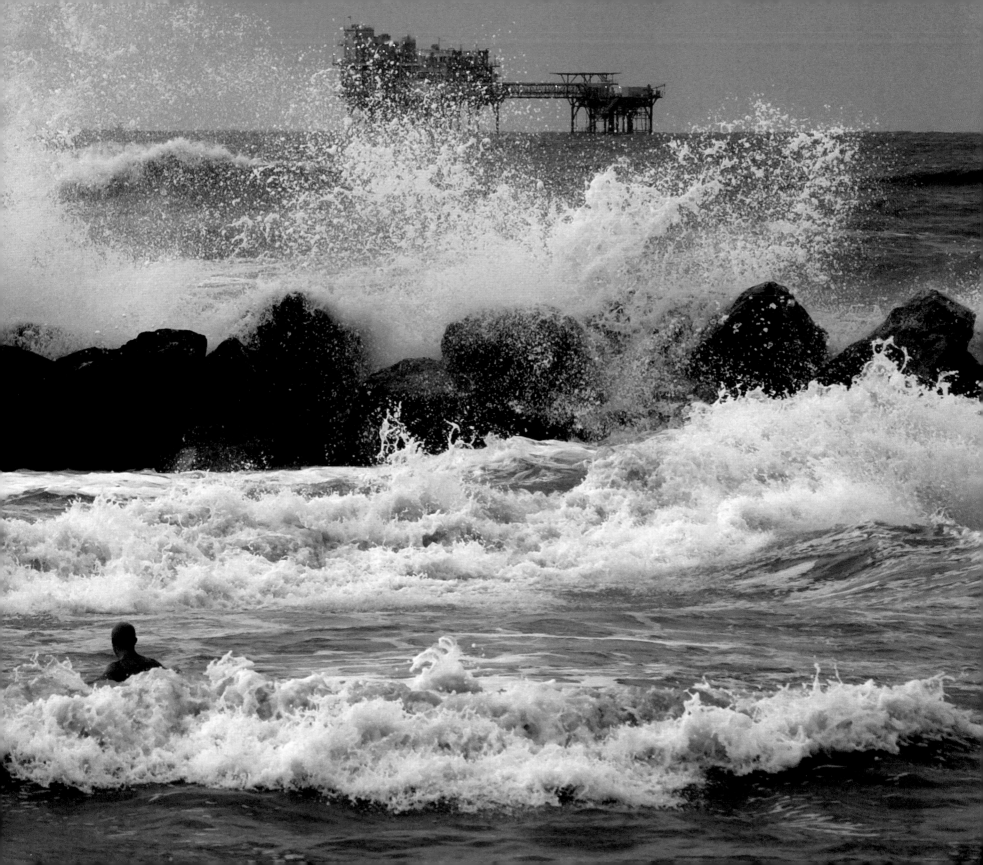

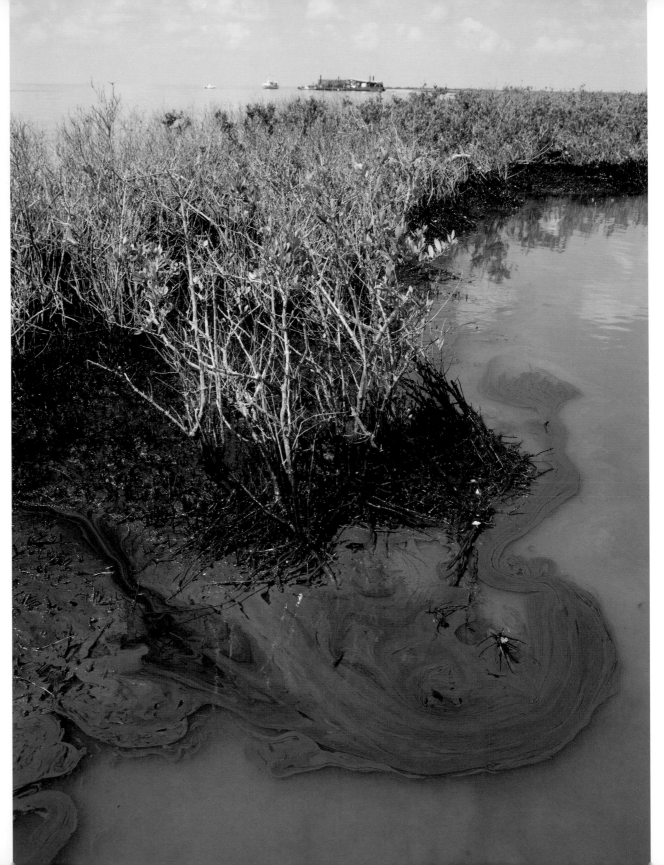

Oil from the April 2010 British Petroleum spill reaches Grand Isle in the greatest manmade disaster in United States history to date. The oil spill severely impacted Louisiana's coastal environment and way of life.

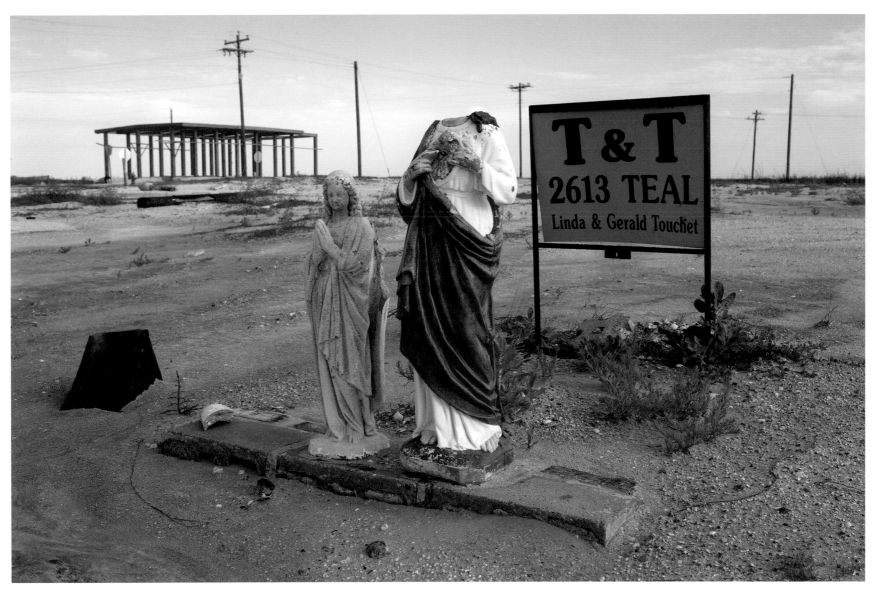

Holly Beach, located in Cameron Parish close to the Texas border, was known locally as the Cajun Riviera, a beachfront getaway featuring modest "camps" for working-class families. Everything changed when Hurricane Rita's massive tidal surge in 2005 swept this seasonal community from the face of the earth. Statues and pilings were all that remained of Holly Beach after the hurricane.

Friends and family gather in front of a barn dating to 1900 for music and camaraderie at Marc and Ann Savoy's home near Eunice.

Selected Bibliography

Allain, Mathé, and Vincent H. Cassidy. "The Attakapas Country: Cabeza de Vaca." *Attakapas Gazette* 2 (1967): 4–6.

———. "The Attakapas Territory, 1699–1721." *Attakapas Gazette* 2 (1967): 31–34.

———. "Beranger's Trips to the Attakapas Shore." *Attakapas Gazette* 5 (1968): 32–38.

———. "Blanpain, Trader among the Attakapas." *Attakapas Gazette* 3 (1968): 32–38.

———. "The De Soto Expedition." *Attakapas Gazette* 2 (1967): 17–19.

———. "Reluctant Visitors from *La Superbe*." *Attakapas Gazette* 3 (1968): 13–18.

Ancelet, Barry Jean. *Cajun and Creole Folktales: The French Oral Tradition of South Louisiana*. New York: Garland, 1994.

———. *Cajun Music: Its Origins and Development*. Lafayette: Center for Louisiana Studies, 1989.

———. *"Capitaine, voyage ton flag": The Traditional Cajun Country Mardi Gras*. Lafayette: Center for Louisiana Studies, 1989.

———. *One Generation at a Time: Biography of a Cajun and Creole Music Festival*. Lafayette: Center for Louisiana Studies, 2007.

Ancelet, Barry Jean, Jay D. Edwards, and Glen Pitre. *Cajun Country*. With additional material by Carl A. Brasseaux et al. Jackson: University of Mississippi Press, 1991.

Barde, Alexandre. *The Vigilante Committees of the Attakapas. An Eyewitness Account of Banditry and Backlash in Southwestern Louisiana*. Translated by Henrietta Guilbeau Rogers. Edited by David C. Edmonds. Lafayette, La.: Acadiana Press, 1981.

Barry, John M. *Rising Tide: The Great Mississippi Flood of 1927 and How It Changed America*. New York: Peter Smith, 2006.

Baudier, Roger. *The Catholic Church in Louisiana*. New Orleans: Hyatt, 1939.

Bauer, Craig A. *A Leader among Peers: The Life and Times of Duncan Farrar Kenner*. Lafayette: Center for Louisiana Studies, 1993.

Becnel, Thomas A. *The Barrow Family and the Barataria and Lafourche Canal: The Transportation Revolution in Louisiana, 1829–1925*. Baton Rouge: Louisiana State University Press, 1989.

Bergerie, Maurine. *They Tasted Bayou Water: A Brief History of Iberia Parish*. New Orleans: Pelican, 1962.

Bernard, Shane K. *The Cajuns: Americanization of a People*. Jackson: University Press of Mississippi, 2003.

———. *Swamp Pop: Cajun and Creole Rhythm and Blues*. Jackson: University Press of Mississippi, 1996.

———. *Tabasco: An Illustrated History*. Jackson: University Press of Mississippi, 2007.

Bienvenu, Marcelle, Carl A. Brasseaux, and Ryan A. Brasseaux. *Stir the Pot: The History of Cajun Cuisine*. New York: Hippocrene, 2005.

Blume, Helmut. *The German Coast during the Colonial Era, 1722–1803*. Translated, edited, and annotated by Ellen C. Merrill. Destrehan, La.: German-Acadian Coast Historical and Genealogical Society, 1990.

Boutwell, A. P., and G. Folse. *Terrebonne Parish: A Pictorial History, Then and Now*. Houma, La.: The Courier, 1997.

Bradshaw, Jim. *Our Acadiana: A Pictorial History of South Louisiana*. [Lafayette, La.]: Thomson South Louisiana Publishing, 1999.

Brasseaux, Carl A. *Acadian to Cajun: Transformation of a People, 1803–1877*. Jackson: University of Mississippi Press, 1992.

———. *The Founding of New Acadia: Beginnings of Acadian Life in Louisiana, 1765–1803*. Baton Rouge: Louisiana State University Press, 1987.

———. *France's Forgotten Legion: Service Records of French Military and Administrative Personnel Stationed in the Mississippi Valley, 1699–1769*. Baton Rouge: Louisiana State University Press, 2000.

———. *In Search of Evangeline: Origins and Evolution of the Evangeline Myth*. Thibodaux, La.: Blue Heron Press, 1989.

———. *Lafayette, Where Yesterday Meets Tomorrow: An Illustrated History*. Chatsworth, Calif.: Windsor, 1990.

———, ed. *Quest for the Promised Land: Official Correspondence Regarding the First Acadiana Migration to Louisiana, 1764–1769*. Lafayette: Center for Louisiana Studies, 1989.

———. *"Scattered to the Wind": Dispersal and Wanderings of the Acadians, 1755–1809*. Lafayette: Center for Louisiana Studies, 1991.

Brasseaux, Carl A., and Glenn R. Conrad. *Crevasse! The 1927 Flood in Acadiana*. Lafayette: Center for Louisiana Studies, 1994.

Brasseaux, Carl A., and Keith P. Fontenot. *Steamboats on Louisiana's Bayous: A History and Directory*. Baton Rouge: Louisiana State University Press, 2004.

Brasseaux, Carl A., Keith P. Fontenot, and Claude F. Oubre. *Creoles of Color in the Bayou Country*. Jackson: University Press of Mississippi, 1994.

Brasseaux, Ryan André. *Cajun Breakdown: The Emergence of an American-Made Music*. New York: Oxford University Press, 2009.

Brasseaux, Ryan André, and Kevin S. Fontenot. *Accordions, Fiddles, Two-Step and Swing: A Cajun Music Reader*. Lafayette: Center for Louisiana Studies, 2006.

Broussard, Bernard. *A History of St. Mary Parish*. Baton Rouge: Claitor's, 1977.

Butler, Joseph, Jr. "The Atakapas Indians: Cannibals of Louisiana." *Louisiana History* 11 (1970): 167–76.

Casey, Powell. *Encyclopedia of Forts, Posts, Named Camps, and Other Military Installations in Louisiana, 1700–1981*. Baton Rouge: Claitor's, 1983.

Center for Louisiana Studies. *Green Fields: Two Hundred Years of Louisiana Sugar*. Lafayette: Center for Louisiana Studies, 1980.

Champomier, P. A. *Statement of the Sugar Crop Made in Louisiana*. New Orleans: Magne and Weisse, 1844.

Clay, Floyd Martin. *Coozan Dudley LeBlanc: From Huey Long to Hadacol*. Gretna, La.: Pelican, 1973.

Comeaux, Malcolm L. *Atchafalaya Swamp Life: Settlement and Folk Occupations*. Baton Rouge: School of Geosciences, Louisiana State University, 1972.

Conrad, Glenn R., ed. *Cross, Crozier, and Crucible: A Volume Celebrating the Bicentennial of a Catholic Diocese in Louisiana*. [New Orleans]: Bookcrafters, 1993.

———, ed. *New Iberia: A History of the Town and Its People*. 2nd ed. Lafayette: Center for Louisiana Studies, 1986.

———. *Saint-Jean-Baptiste des Allemands: Abstracts of the Civil Records of St. John the Baptist Parish to 1803*. 2nd ed. Lafayette: Center for Louisiana Studies, 1992.

Costello, Brian. *Devastation Unmeasured: The Tragic History of Floods in Pointe Coupée Parish, Louisiana*. New Roads, La.: New Roads Printing, 2007.

———. *A History of Pointe Coupée Parish*. [New Roads, La.]: Privately printed, 1999.

———. *The Life, Family, and Legacy of Julien Poydras*. N.p.: John and Noelie Laurent Ewing, 2001.

———. *Louisiana Mardi Gras: A Historical Guide to the State's Carnival Parades Outside New Orleans*. [New Roads, La.]: Privately printed, 1997.

———. *Quintessential Creoles: The Tounoir Family of Pointe Coupée*. New Roads, La.: Privately printed, 2003.

Daspit, Fred. *Louisiana Architecture, 1840–1860*. Lafayette: Center for Louisiana Studies, 2006.

Davis, Donald W. *Washed Away: The Invisible Peoples of Coastal Louisiana*. Lafayette: University of Louisiana at Lafayette Press, 2010.

Davis, Edwin Adams. *The Rivers and Bayous of Louisiana*. Gretna, La.: Pelican, 1968.

Delhaye, Edna. "The Chitimacha Reservation—and Its Inhabitants." *Attakapas Gazette* 2 (1967): 6–7.

Deville, Winston. *Opelousas: The History of a French and Spanish Military Post in America, 1716–1803*. Cottonport, La.: Polyanthos, 1973.

Din, Gilbert C. *The Canary Islanders of Louisiana*. Baton Rouge: Louisiana State University Press, 1999.

———. *Francisco Bouligny: A Bourbon Soldier in Spanish Louisiana*. Baton Rouge: Louisiana State University Press, 1993.

———. *Spaniards, Planters, and Slaves: The Spanish Regulation of Slavery in Louisiana, 1763–1803*. College Station: Texas A&M University Press, 1999.

Ditto, Tanya Brady. *The Longest Street: A Story of Lafourche Parish and Grand Isle*. Baton Rouge: Moran, 1980.

Dixon, Bill. *Last Days of Last Island: The Hurricane of 1856, Louisiana's First Great Storm*. Lafayette: University of Louisiana at Lafayette Press, 2009.

Dormon, James H., ed. *Creoles of Color of the Gulf South*. Knoxville: University of Tennessee Press, 1996.

———. *The People Called Cajuns: An Introduction to an Ethnohistory*. Lafayette: Center for Louisiana Studies, 1983.

———. "The Persistent Specter: Slave Rebellion in Territorial Louisiana." *Louisiana History* 18 (1977): 389–404.

Eakin, Sue. *Washington, Louisiana: Fabulous Inland Port: Historic Gateway to the Southwest*. Bossier City, La.: Everett, [1988].

Edmonds, David C. *Yankee Autumn in Acadiana: A Narrative of the Great Texas Overland Expedition through Southwestern Louisiana, October–December 1863*. Lafayette, La.: Acadiana Press, 1979.

Esman, Marjorie R. *The Town That Crawfish Built: A History of Henderson, Louisiana*. Baton Rouge: VAAPR, 1984.

Fairclough, Adam. *Race and Democracy: The Civil Rights Struggle in Louisiana, 1915–1972*. Athens: University of Georgia, 1995.

Falgout, Woody. *Rise of the Cajun Mariners: The Race for Big Oil*. N.p.: Stockard James, 2007.

Fontenot, Mary Alice, and Paul B. Freeland. *Acadia Parish, Louisiana*. 2 vols. Baton Rouge: Claitor's, 1976.

Gomez, Gay M. *A Wetland Biography: Seasons on Louisiana's Chenier Plain*. Austin: University of Texas Press, 1998.

Gremillion, William Nelson, Sr., and Loucille Edwards Gremillion. *Commentaries on Some Avoyelles Families: Bordelon, Coco, Ducote, Edwards, Gauthier, Gremillion, Joffrion, Lemoine, Normand, Rabelais*. Privately printed, 1976.

Griffin, Harry Lewis. *Attakapas Country: A History of Lafayette Parish, Louisiana*. New Orleans: Pelican, 1959.

Guidry, Anita G. *La Pointe de l'Eglise: A History of Church Point, Louisiana, 1800–1973*. Lafayette, La.: Tribune Printing, 1973.

Hallowell, Christopher. *Holding Back the Sea: The Struggle for America's Natural Legacy on the Gulf Coast*. New York: HarperCollins, 2001.

———. *People of the Bayou: Cajun Life in Lost America*. New York: Dutton, 1979.

Hays, C. *Fort Butler and Other Projects: Regional Archaeology in Southeast Louisiana*. Baton Rouge: Division of Archaeology, State of Louisiana, 1997.

Kniffen, Fred B., Hiram F. Gregory, and George A. Stokes. *The Historic Indian Tribes of Louisiana: From 1542 to the Present*. Baton Rouge: Louisiana State University Press, 1987.

Kondert, Reinhart. *Charles Frederick D'Arensbourg and the Germans of Colonial Louisiana*. Lafayette: Center for Louisiana Studies, 2008.

La Commission des Avoyelles. *Avoyelles Parish: Crossroads of Louisiana. Where All Cultures Meet*. With Sue L. Eakin. Gretna, La.: Pelican, 1999.

Martin, Michael S. *Historic Lafayette*. San Antonio: Historic Publishing Network, 2007.

Mayeux, Steven M. *Earthen Walls, Iron Men: Fort DeRussy, Louisiana, and the Defense of Red River*. Knoxville: University of Tennessee Press, 2008.

Menn, Karl Joseph. *The Large Slaveholders of Louisiana, 1860.* New Orleans: Pelican, 1964.

Michot, Stephen S. "'War Is Still Raging in This Part of the Country': Oath-Taking, Conscription, and Guerilla War in Louisiana's Lafourche Region." *Louisiana History* 38 (1997): 157–84.

Michot, Stephen S., and John P. Doucet, eds. *The Lafourche Country II: The Heritage and Its Keepers.* Thibodaux, La.: Lafourche Heritage Society, 1996.

Nardini, Louis Raphael. *No Man's Land: A History of El Camino Real.* New Orleans: Pelican, 1961.

Oubre, Claude F. *A History of the Diocese of Lafayette.* Strasbourg, France: Éditions du Signe, 2001.

Oubre, Elton J. *Vacherie: St. James Parish, Louisiana. History and Genealogy.* 2nd ed. Thibodaux, La.: Oubre's Books, [1986].

Post, Lauren C. "Some Notes on the Attakapas Indians of Southwest Louisiana." *Louisiana History* 3 (1962): 221–42.

Raphael, Morris. *The Battle in the Bayou Country.* Detroit: Harlo, 1975.

Reuss, Martin. *Designing the Bayous: The Control of Water in the Atchafalaya Basin, 1800–1995.* Alexandria, Va.: Office of History, U.S. Corps of Engineers, 1998.

Riffel, Judy, ed. *A History of Pointe Coupée Parish and Its Families.* Baton Rouge: Le Comité des Archives de la Louisiane, 1983.

———, ed. *Iberville Parish History.* Baton Rouge: Le Comité des Archives de la Louisiane, 1985.

Sitterson, J. Carlyle. *Sugar Country: The Cane Industry in the South, 1753–1950.* Lexington: University of Kentucky Press, 1953.

Spedale, William A. *Fort Butler, 1863: Donaldsonville, Louisiana.* Baton Rouge: Privately published, 1997.

Sternberg, Mary Ann. *Along the River Road: Past and Present on Louisiana's Historic Byway.* Baton Rouge: Louisiana State University Press, 1996.

Swanton, John R. *The Indians of the Southeastern United States.* Washington, D.C.: U.S. Government Printing Office, 1946.

Teurlings, William J. *One Mile an Hour: Priestly Memories.* New York: Exposition Press, 1959.

Uzee, Philip D., ed. *The Lafourche Country: The People and the Land.* Lafayette: Center for Louisiana Studies, 1985.

Vermilion Historical Society. *History of Vermilion Parish, Louisiana.* [Abbeville, La.]: Vermilion Historical Society, 1983.

Waud, A. R. "The Acadians of Louisiana." *Harper's Weekly,* October 20, 1866: 670.

Willis, Edwin E. "Notes for a History of St. Martin Parish." Typescript. 1957. Jefferson-Caffery Louisiana Room, Dupré Library, University of Louisiana at Lafayette.

Winters, John D. *The Civil War in Louisiana.* Baton Rouge: Louisiana State University Press, 1963.

Index

Abbeville, La., 135
Academy of the Sacred Heart, 76–77
Acadia Parish, 1–2, 63, 65, 67, 118
Acadian Coast, 30–45, 84, 146
Acadian Reminiscences: The True Story of Evangeline (Voorhies), 85
Acadian Village. *See under* Lafayette, La.
Acadiana: colonial era in, 12–115; culinary traditions of, 2, 148, 164–65; cultural renaissance in, 148, 149; definition of the term, 1; desegregation in, 146; Evangeline and, 85; map of, x; musical traditions of, 2, 148, 160, 163; religious history of, 32; postbellum era in, 116–44; post–World War II era in, 145–82; Shadows-on-the-Teche in, 87; shrimp industry of, 48; steamboats in, 67; topography of, 2; transportation history of, 118. *See also* Acadians
Acadiana Downs, 167
Acadians, 1, 13, 31–33, 38, 46–47, 64, 65, 84–86, 103, 122, 125; architecture of, 8, 36, 94–97, 122–25, 126
African Americans, 34, 54, 117, 119, 146, 150, 158–60, 174–75. *See also* Creoles: of color; free persons of color; slavery
Africans, 1, 30, 32, 47, 83
Aime, Valcour, 33
Albania Plantation, 110–11
Alexandria, La., 89
Algiers, La., 48
Alibamon tribe, 64
Allain, Mathé, 63
Allen Parish, 63
Alsatians, 1
Amelia, La., 155
American Red Cross, 119
American Revolution, 86
Amoco, 150
Ancelet, Barry Jean, 148
Andrews, John, 33
Andry, Louis, 84
Andry, Manuel, 33
Anglo-Americans, 1, 14, 32, 33, 86, 118, 119
Antilles, French, 13

Arceneaux, Louis, 85
Arceneaux, Thomas, 1
Architecture: Acadian/Cajun style, 13, 36, 70, 94–95, 98–99, 122–25, 126; art deco style, 157; of Baptist churches, 54; Creole style, 13, 16–20, 40–41, 68, 74, 85, 92–93; Greek Revival style, 50, 87, 104–107, 110; indigenous styles, 13; plantation homes, 15, 20, 33, 40–41, 43, 48, 50, 51; shotgun houses, 13, 25; slave cabins, 52; trappers' cabins, 48
Arco (Atlantic Richfield Company), 150
Ardoin, Alphonse "Bois Sec," 160
Ardoin, Amédé, 160
Arnaudville, La., 84
Ascension Parish, 1, 32–34, 46, 47, 117
Assumption Parish, 1, 47, 48, 120
Atchafalaya: basin, 32, 47, 66, 67, 83, 84, 89; river, 12, 46, 63, 66, 67, 82, 118, 119, 153
Atlanta, Ga., 150
Attakapas District, 32, 39, 63, 64, 71, 83, 134
Attakapas tribe, 63, 83–86, 87
Aubry, Charles Philippe, 32, 84
Audé, Mother Eugenie, 76
Austin, Tex., 150
Avery Island, La., 108–109, 118
Avoyelles Parish, 1, 10–29, 80
Avoyelles tribe, 12

Baldwin, La., 98
Banks, Nathaniel P., 49
Baptists, 54
Barataria and Lafourche Canal Company, 62
Barataria waterway, 176
Baton Rouge, La., 14, 33, 34, 47, 82, 88, 119, 147
Battles: Bisland, 89; Irish Bend, 89; Labadieville, 88; Port Hudson, 34, 49, 89; Queue de Tortue, 67, 88
Bauer, Carl W., 1
Bayou Chicot, La., 65
Bayou Goula, La., 30

Bayous: Boeuf, 14; Carencro, 85; Courtableau, 63–67; des Allemands, 48; des Ecores, 47; des Glaises, 14, 27, 28; Fordoche, 14; Fuselier, 84; Grand Caillou, 48, 49, 59; Grand Ecore, 13; Grosse Tête, 66; Huffpower, 14; Lafourche, 8, 32–34, 46–49, 58–59, 66, 67, 83, 89; Plaquemine, 44–45, 66, 67, 84; Queue de Tortue, 67, 88; Rouge, 14; St. John, 30, 46; Teche, 2, 4, 32, 49, 63–68, 71–73, 83, 84, 86, 87, 89, 90, 107, 110, 162; Terrebonne, 32; Vermilion (a.k.a. river), 67, 87; Wykoff, 64
Bayougoula tribe, 30
Beauregard Parish, 63
Beausoleil. *See* Broussard, Joseph (*dit* Beausoleil)
Begnaud, Paul, 135
Belle Grove Plantation, 33
Berchmans, St. John, 76
Bernard, Shane K., 120, 145, 147
Berwick, Thomas, 86
Berwick Bay, 49
Bienville, Jean Baptiste, Le Moyne de, 30, 83
Big Bend, La., 26
Billeaud House, 123, 138
Biloxi, Miss., 30
birding, 6
Blanchet, Anne, 138
Blanchet, Ben, 138
Blanchet House, 138
Blanpain, Joseph, 63, 83–84
Bois Mallet, 68
Borah, Wayne S., 146
Bordelon, Hypolite, 22–23
Bordelon, Valerie, 23
boucheries, 164–65
Bouligny, Francisco, 86
bousillage, 9, 139
Boustany, Al, 152
Boustany, Frem, 152
Boutté Station, La., 48
Bouyavel, Joseph, 13
Bradshaw, Jim, 1

Branch, La., 64
Brashear City, La., 48, 49. *See also* Morgan City, La.
Breaux, J. Richard, 1
Breaux Bridge, La., 162; Café des Amis in, 162
Breckinridge, John C., 48, 88
Bridges, Emily Cyr, 110
Brinkhaus, Armand J., 1
British Petroleum, 180
Brookshire, C. H., 138
Broussard, Amant, 125
Broussard, J. B., 1
Broussard, Joseph (*dit* Beausoleil), 84, 125
Broussard, La., 138
Broussard House, 124–25
Brown v. Board of Education, 146
Burnside, La., 30, 46
Butler, Benjamin F., 49

Cabahanocé post, 34
Cabeza de Vaca, Álvar Núñez, 83
Cajuns, 1, 13, 47, 85, 148, 150; cuisine of, 2, 148, 164–65; cultural renaissance of, 148; and dancing, 163; and music, 2, 148, 160, 162
Calcasieu Parish, 1, 63, 66
Cameron, La., 146, 150
Cameron Parish, 1, 63, 151, 181
Camp Pratt, 88, 89
Camp Stevens, 49
Canadian immigrants, 13
Canary Islanders. *See* Isleños
Cankton, La., 65
canneries, 118
Carencro, La., 65, 166
Carewe, Edwin, 85
Carrière, Ozémé, 68
Cassidy, Vincent, 63
Castille House, 123
Castillo Maldonado, Alonso del, 83
Catahoula, La., 102, 165
Catholics, 1, 32, 65, 84, 102, 119
cattle, 13; drives, 66
Cecilia, La., 63, 83